The Grace Kelly

years

Princess of Monaco

The Grace Kelly years Princess of Monaco

Frédéric Mitterrand

SKIRA EDITORE / GRIMALDI FORUM MONACO

Catalogue

DESIGN
Atalante, Paris

EDITORIAL COORDINATION
Vincenza Russo

EDITING
Emily Ligniti

TRANSLATION
Christopher Evans and Dick Nowell,
Language Consulting Congressi, Milan

ICONOGRAPHICAL RESEARCH
Paola Lamanna

Cover: Grace Kelly, March 1954.
© Time & Life Pictures/Getty Images/Laura Ronchi.

First published in Italy in 2007
by Skira editore S.p.A.
Palazzo Casati Stampa
via Torino 61
20123 Milano
Italy
www.skira.net

Printed and bound in Italy. First edition

ISBN-13: 978-88-6130-343-0

Distributed in North America by Rizzoli International Publications, Inc.,
300 Park Avenue South, New York, NY 10010, USA.
Distributed elsewhere in the world by Thames and Hudson Ltd., 181A
High Holborn, London WC1V 7QX, United Kingdom.

GRIMALDI FORUM MONACO

10 Avenue Princesse Grace
MC 98000 Monaco
www.grimaldiforum.com

PRESIDENT
Jean-Claude Riey

GENERAL DIRECTOR
Sylvie Biancheri

DIRECTOR OF CULTURAL EVENTS
Catherine Alestchenkoff

BUILDING DIRECTOR
Guy Caruana

DIRECTOR OF EVENTS
Gérard Nouveau

ADMINISTRATIVE AND FINANCIAL DIRECTOR
Marc Rossi

COMMUNICATION DIRECTOR
Hervé Zorgniotti
and their staff

ASSISTANT TO THE DIRECTOR OF CULTURAL EVENTS
Alfonso Ciulla

WORKSHOP COORDINATION
Laetitia de Massy

COMMUNICATION OFFICERS
Nathalie Pinto
Nadège Basile

Monaco

His Excellency Jean-Paul Proust, MINISTER OF STATE

M. Paul Masseron, GOVERNMENT ADVISOR FOR THE INTERIOR

M. Gilles Tonelli, GOVERNMENT ADVISOR FOR ECONOMY
AND FINANCE

Exhibition and Catalogue

CURATOR
Frédéric Mitterrand
ASSISTED BY Karim Maatoug

GUEST CURATOR
Martine Frésia

EXHIBITION DESIGN
Agence NC: Nathalie Crinière, Violette Cros, Nicolas Groult

EXHIBITION GRAPHIC DESIGN
C-album: Tiphaine Massari

VIDEO
ETC, Paris

LIGHTING
François Austerlitz, Mathieu Blaise

AUDIOVISUAL
Electron libre Productions

AUDIOVISUAL RESEARCH
Marie-Nicole Ferret

GENERAL COORDINATION
Catherine Alestchenkoff
ASSISTED BY Céline Vacquier

ICONOGRAPHICAL RESEARCH
Katia Montironi

REGISTRAR
Thierry Vincent ASSISTED BY Christian Selvatico

COORDINATION AND SUPERVISION
Gérard Nouveau

GENERAL EXHIBITION
CONSTRUCTION
Mostre e Fiere, Turin

GRAPHISM
Exbib'It, Nice
UNDER THE DIRECTION OF Bruce Campbell and William Chatelain

LIGHTING
TEAMS OF GRIMALDI FORUM UNDER THE DIRECTION OF
Armand di Amore

AUDIOVISUAL AND SCENERY RESOURCES
TEAMS OF GRIMALDI FORUM UNDER THE DIRECTION OF
Georges Saïd

This exhibition was supported by:

ACKNOWLEDGEMENTS

The exhibition entitled *The Grace Kelly Years, Princess of Monaco* is a unique event, one that could never have happened without the cooperation of the Palace, and its generosity in throwing open its private collections and giving permission to put its archives on display.

I particularly wish to thank the members of the Prince's Cabinet under Georges Lisimachio; Claude Palmero, Director of the Household Possessions of H.S.H. Prince Albert; Hervé Irien, General Secretary of the Artistic Commission for the Objets d'Art of H.S.H. the Prince of Monaco; Michel Granero, Director of the Administration of Royal Palace Properties; Régis Lécuyer, Curator of the Royal Palace Archives; and Carl de Lencquesaing, Royal Palace Collections Assessor, all of whom have been most generous with their time and their resources.

Vincent Vatrican, Director of the Audiovisual Archives of Monaco and his staff: Roger Badot, Stéphanie Conti, Elisabeth Kohler, Laurent Trancy and Isabelle Twarog all put their professional skills at the service of this exhibition

I should especially like Maryel Girardin, former housekeeper of the royal apartments, to be aware how deeply I appreciate her commitment and her invaluable recollections; these were the core of all my research.

Jean-Claude Occhipinti, tailor of the Royal Palace

The photographers: Jean-Jacques L'Héritier and Sebastian Rosenberg

My thanks also to two artists whose contributions offer us an original new interpretation of that style of Glamour which Princess Grace embodied:

Françoise Huguier, photographer

Leïla Menchari, Artistic Director of Hermès

Frédéric Hubin, Head of Projects – Publishing department, Hermès

I also wish to thank all the following lenders, managers of institutions and collection curators as well as the individual private collectors whose generosity has enabled this exhibition to become a reality:

Monaco

Jean-Michel Bouhours, Director
Nathalie Rosticher-Giordano,
Heritage Curator, Assistant Director
NOUVEAU MUSÉE NATIONAL DE MONACO, VILLA PALOMA
Béatrice Blanchy, Curator
NOUVEAU MUSÉE NATIONAL DE MONACO, VILLA SAUBER

PRINCESS GRACE IRISH LIBRARY.

Charlotte Lubert, Historic Heritage Manager
SOCIÉTÉ DES BAINS DE MER
Pascal Mitrano
Yves Naquin, Manager of the Veteran Car Collection
of H.S.H. the Prince of Monaco
Simone Pastor
Amedeo M. Turello
Muriel Van Oosteron

Spain

Leyre Lekuona, General Director
Miren Arzalluz Loroño, Artistic Director
Igor Uria Zubizarreta, Head of the Conservation
Department
CRISTOBAL BALENCIAGA MUSEUM, GETARIA.

United States

Anne d'Harnoncourt, Director
Alice Beamesderfer, Assistant Director, Collections
Department
Shannon N. Schuler, Registrar
PHILADELPHIA MUSEUM OF ART.
Joanne Grossman, Director, Archives and Collections
Department
DREXEL UNIVERSITY COLLEGE OF MEDICINE, PHILADELPHIA.
Mr. and Mrs. John Lehman, New York
Maguy Maccario-Doyle, Consul of Monaco in New York
Assisted by Miss Karla Modolo
Monica McMurry
DEAN OF THE SCHOOL OF DESIGN AND FASHION
STEPHENS COLLEGE, COLUMBIA.
Peggy Nestor
OLEG CASSINI INC., NEW YORK.
Rita Gam
Sally Parish Richardson

France

Menehould de Bazelaire,
Heritage Director,
HERMÈS, PARIS.
Marc Bohan.
Catherine Cariou,
Head of Collections,
VAN CLEEF & ARPELS, PARIS.
Aline Dandrieux,
GUCCI.
Maître Jean-Bernard Fournaise,
executor of André Levasseur.
Didier Jovenet, President,
Monsieur Romain Leray, Curator,
CINÉ COSTUM'S.
Barbara Jeauffroy,
Project Manager,
MUSÉE CHRISTIAN DIOR, GRANVILLE.
Philippe Le Moult,
Institutional Relations Director
CHRISTIAN DIOR COUTURE, PARIS.
Soizic Pfaff,
Head of Archives
CHRISTIAN DIOR COUTURE, PARIS.
Bernard Minne,
COSTUME & COSTUMES.
Hélène de Rochas.
Nathalie Vidal,
Head of Archives and Videotheque Department,
HERMÈS, PARIS.

Italy

Gina Lollobrigida

United Kingdom

Phyllis Earl

Switzerland

Patricia Reymond, Head of collections, Museum Service
MUSÉE OLYMPIQUE DE LAUSANNE.

I should also like to express my warm gratitude to all those who have contributed to the exhibition's quality and scope by helping me to track down works and obtain loans, with information, or through their assistance with particular aspects of the project:

Bob Adelman
Steve Bello and Irene Halsman
Caroline Berton
Christel Boget
Mr and Mrs Bonafède
Yannis Chebbi
Nicole Devilaine
Jean Des Cars
Charles Franch-Guerra
Diane Von Furstenberg
Virginia Gallico
Christian Gasc
Pamela Golbin
Sophie Grossiord
Laetitia Guglielmacci
Melissa Harris
Sarah Hartley
Suzanne Held
Patrick Jeudy
Michael Kazan
Philippe Labro
Nadia Lacoste
Sophie Laffont
Deborah Landis
Claudine Legros
Laurent Lesourd
Louisette Levy-Soussan
Gaëtan Luci
Veronique Martingay and Hervé Mouriacoux
Leigh Montville
Terence Pepper
Muriel Rozé
Constance Ryder
Chantal Soler
James Wagner
Shawn Waldron

I am deeply moved as we honour my mother, Princess Grace, on this occasion; moved, and filled with pride in Her memory. It was my wish to make a contribution to this event by opening up the Palace archives, which will give *The Grace Kelly Years* a quite unprecedented lustre.

Any mother is, to her own children, a unique and incomparable woman; but we, my sisters and I, are particularly happy to share the material in this exhibition because it reminds us what a truly exceptional woman Grace already was when she arrived in Monaco, and illustrates the essential part she then played at Prince Rainier's side, and how she won the hearts of the people of Monaco and beyond. Indeed, she won and kept the love of so many around the world. Only the talent and enthusiasm of a writer such as Frédéric Mitterrand would have been able to tell, with skill and discretion, the story of her youth, her acting career and her destined fledging and triumph as Princess. The manuscripts, photographs and objects from our own collections help to delineate her personality as accurately as any son could wish.

Princess Grace always showed great generosity in all she undertook and all she did. Having contributed to the greatness of Hollywood, she also brought a quite exceptional radiance to the Principality, where it shone with great humanity in the service of causes on behalf of others, of the most deprived. Visitors will find in this exhibition a true likeness of Princess Grace.

I offer my thanks to all those who have made this project possible.

H.S.H. Prince Albert II of Monaco

CONTENTS

"I would like to be remembered as someone who accomplished useful deeds, and who was a kind and loving person.
I would like to leave the memory of a human being with a correct attitude and who did her best to help others."

Conversation with Pierre Salinger, 1982.

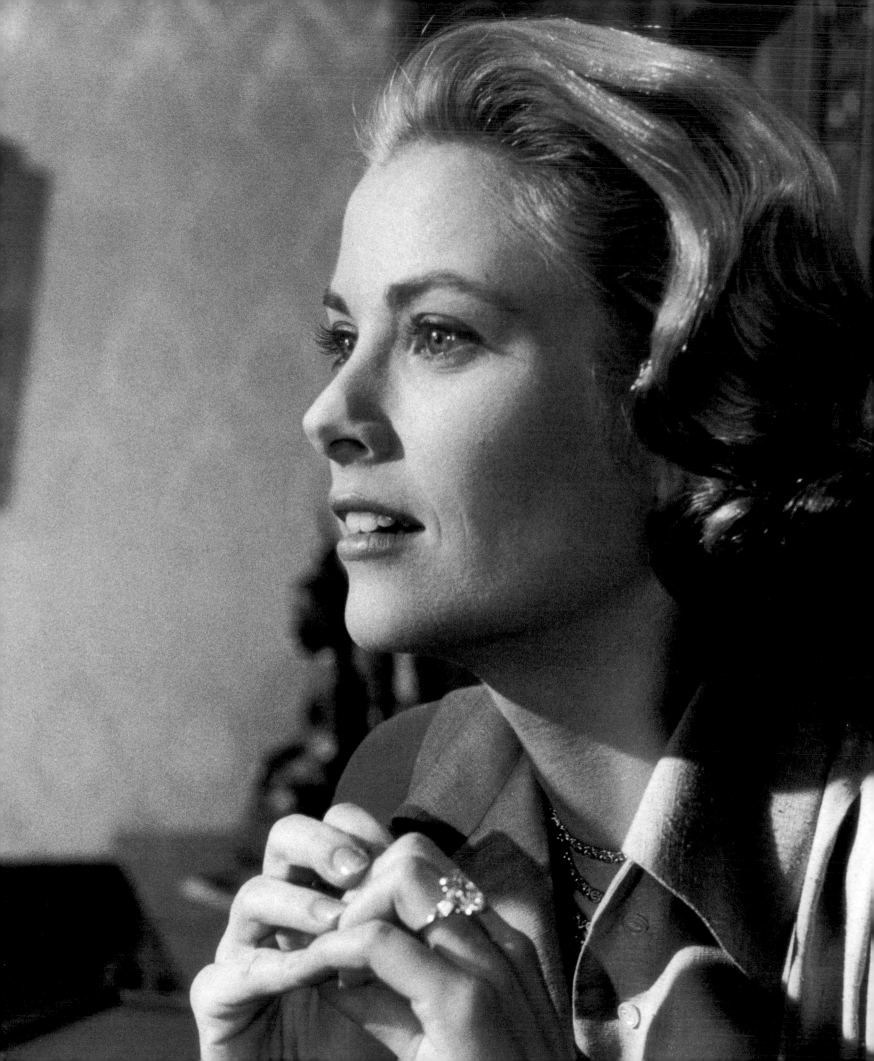

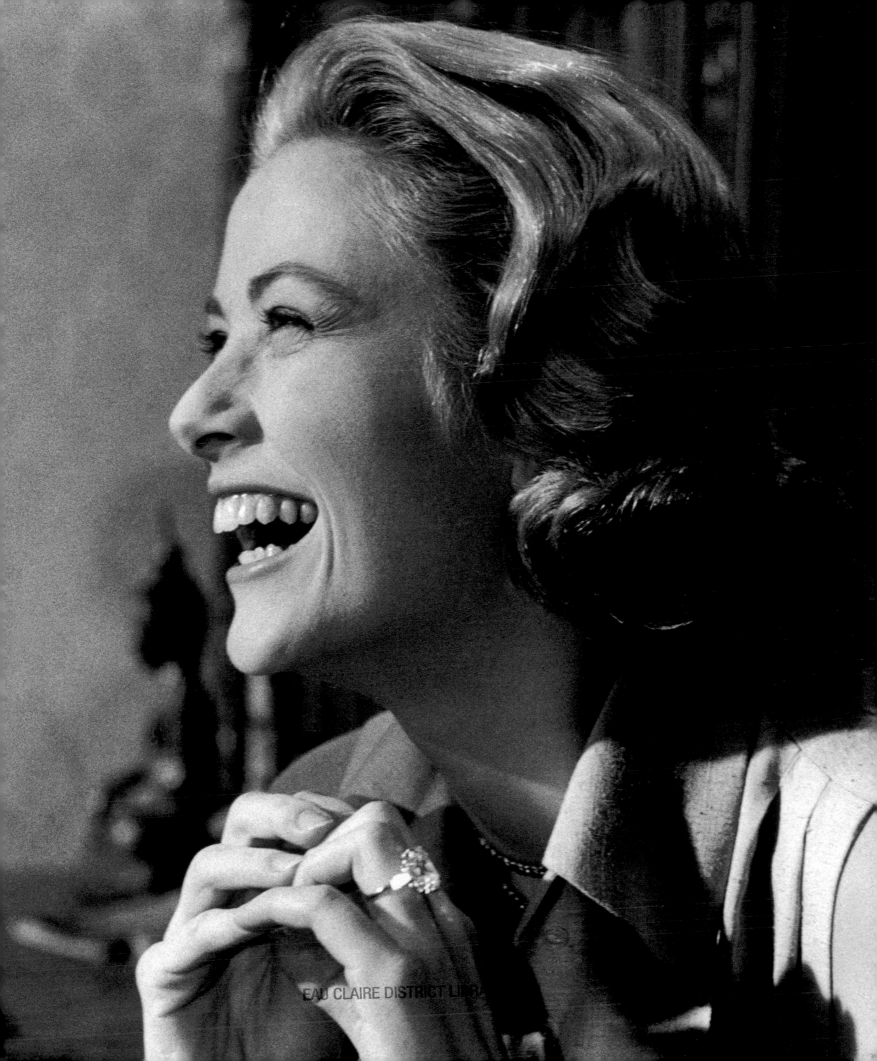

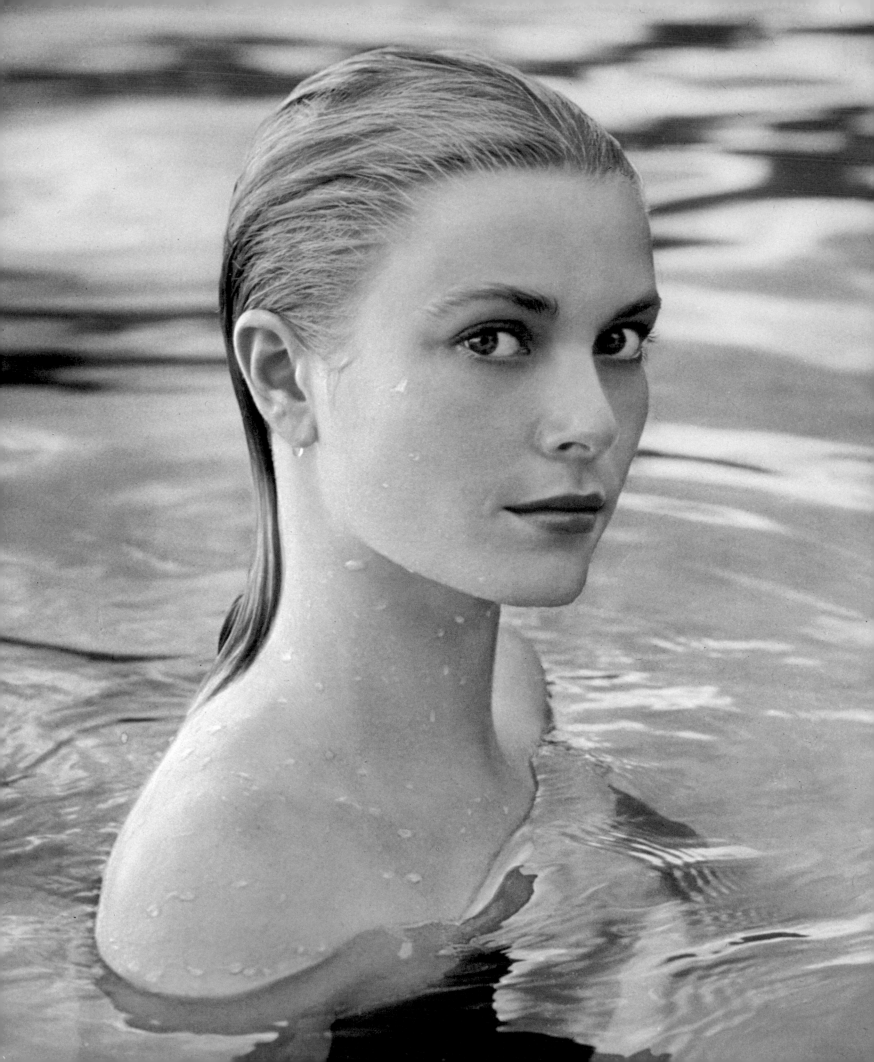

IN SEARCH OF PRINCESS GRACE

I met Princess Grace only once. It was in the spring of 1975 at the premiere of Josephine Baker's show at Bobino. Everyone loved Josephine for her talent, her charm and the nobility of her heart; she was the last of the great music-hall entertainers of old and her songs remain unforgettable. But she had gone through some very hard times, losing all her money as a result of her excessive generosity, and could not get an engagement because of her age and her fragile health. It was known that Princess Grace had helped her out, putting her up in Monaco along with the numerous children of many nationalities and that she had provided her with material and moral support. What is more, she had given Josephine back her self-confidence by asking her to perform at the Red Cross Ball, the most important event of the summer season in the Principality. Her success there had decided their common friend Jean-Claude Brialy to obtain the famous Rive gauche Music Hall for her great come back. In fact, it turned out to be a magnificent show and the smart set people referred to as *le Tout Paris* gave Josephine an ovation, for having conducted the revue with consummate skill.

While I had greatly appreciated the performance, of which I have never seen the like again, I was also deeply touched by what I could sense of the assistance of friends that had made that unexpected comeback possible. Princess Grace, Jean-Claude Brialy and Josephine Baker: the patron, the great and celebrated actor and the artist to whom they had given a helping hand. There was a great deal of kindness, enthusiasm and loyalty in this story, as well as a reflection of the America we love in her affection for legendary performers and her rejection of injustice and racism.

Later I came to learn that Princess Grace had always had a horror of all forms of segregation, as is evident from her friendship with Louis Armstrong, from her relations of esteem and affection for the widow of Martin Luther King or from an anecdote that I was told by an American television producer: apparently she had once rebelled strongly against a camera crew who had wanted to film her children, but without showing them playing with the children of one of the Palace servants who was as black as ebony.

On our way out of the premiere, Jean-Claude Brialy introduced me to Princess Grace. I was struck of course by her beauty and by her unaffected kindness, but also by a sort

Howell Conant, Grace Kelly, Jamaica, 1955.
Previous pages: **Dennis Stock**, Grace Kelly, *High Society* (Charles Walters), 1955.

of shyness that I was not expecting. Moreover, she kept in the background, as if she didn't want to take anything away from the success of the evening for her friend Josephine. Ever since that day and that brief encounter, I have loved Princess Grace and I have known that she was what is called a good person. Everything I have learned since that time has done nothing but confirm that first impression.

On Josephine's death, not long afterwards, it was she who made sure that the singer was laid to rest in Monaco and who took care of her children, showing concern for their future. Yet, I was just one admirer among many, having watched the pomp of her wedding on television as a child, an event as significant then on the black-and-white small screen as the coronation of Queen Elizabeth had been three years earlier and a fantastic stimulant for magazines like *Paris Match* and *Life*, which play on all the nostalgia of the fifties and the happy illusion of optimism that it still inspires. Later I saw most of the films she had made in Hollywood and I followed her life year after year through the reports that appeared in cinema newsreels and on television and the articles that were constantly devoted to her in the press. It seemed obvious to me that Grace Kelly, the Star who had won an Oscar and whom Alfred Hitchcock had made his ideal actress, and the Princess of Monaco who embodied to perfection the style of a modern fairy tale, belonged to that very exclusive circle of female icons of the twentieth century, along with Marilyn Monroe, Jacqueline Kennedy and Audrey Hepburn. She was at once pleasant, straightforward and simple, undoubtedly too simple, one of those people who cannot be reduced to the image that we have of them; people who, at one and the same time, live up to their legend and are even more captivating when you try to get to know them a bit better.

The fact is I didn't know much about Princess Grace before I got to work, along with my team, on organising the show. No more than the dazzling public image that was presented of her through films and the media. Moreover, this image had grown somewhat fixed since her death for all sorts of reasons that are easy to understand: a quarter of a century had gone by, a period in which the Grimaldi family, with whom public opinion has a fairly affectionate but at the same time somewhat cannibalistic relationship, has gradually taken her place in people's attention and has probably been unwilling to expose the grief of a loss which they had never really got over to the eyes of the world. And then, there is the fact that Monaco and its dynasty play, no doubt without wishing to, a role of substitute royalty for the French, who are inveterate republicans but just a bit ambiguous, tempted more by fantasies than by a

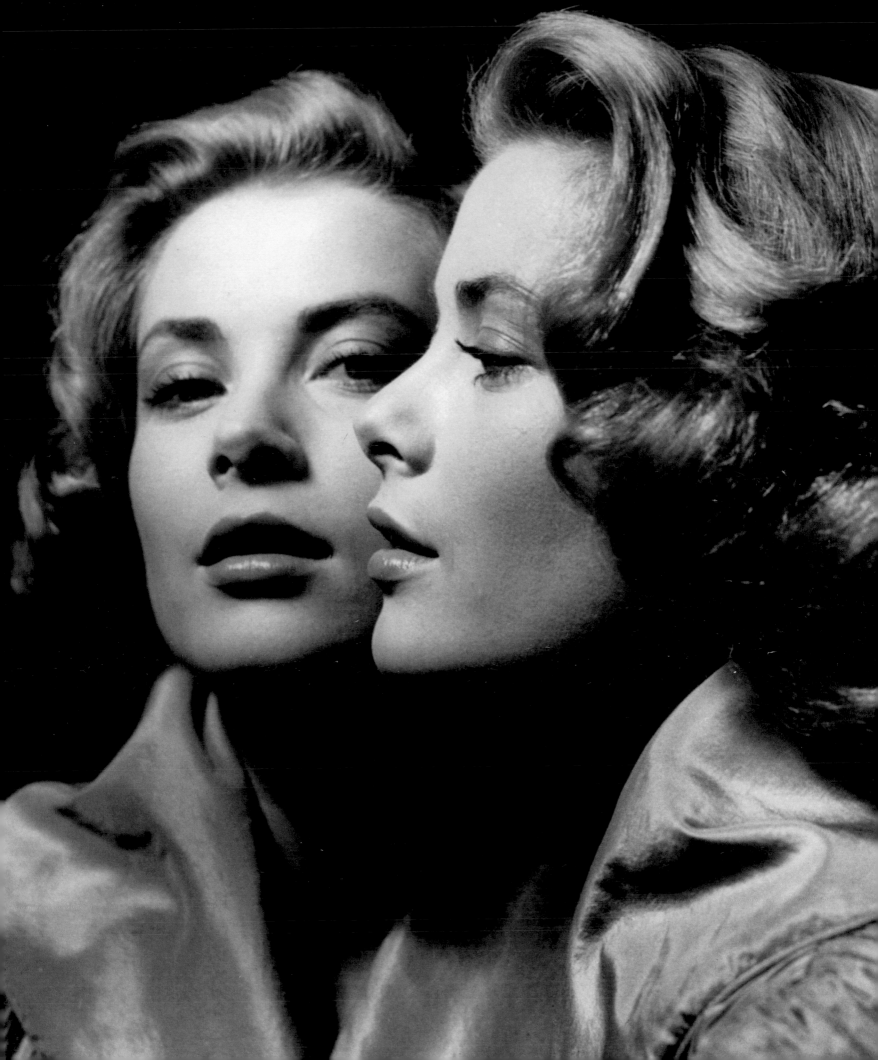

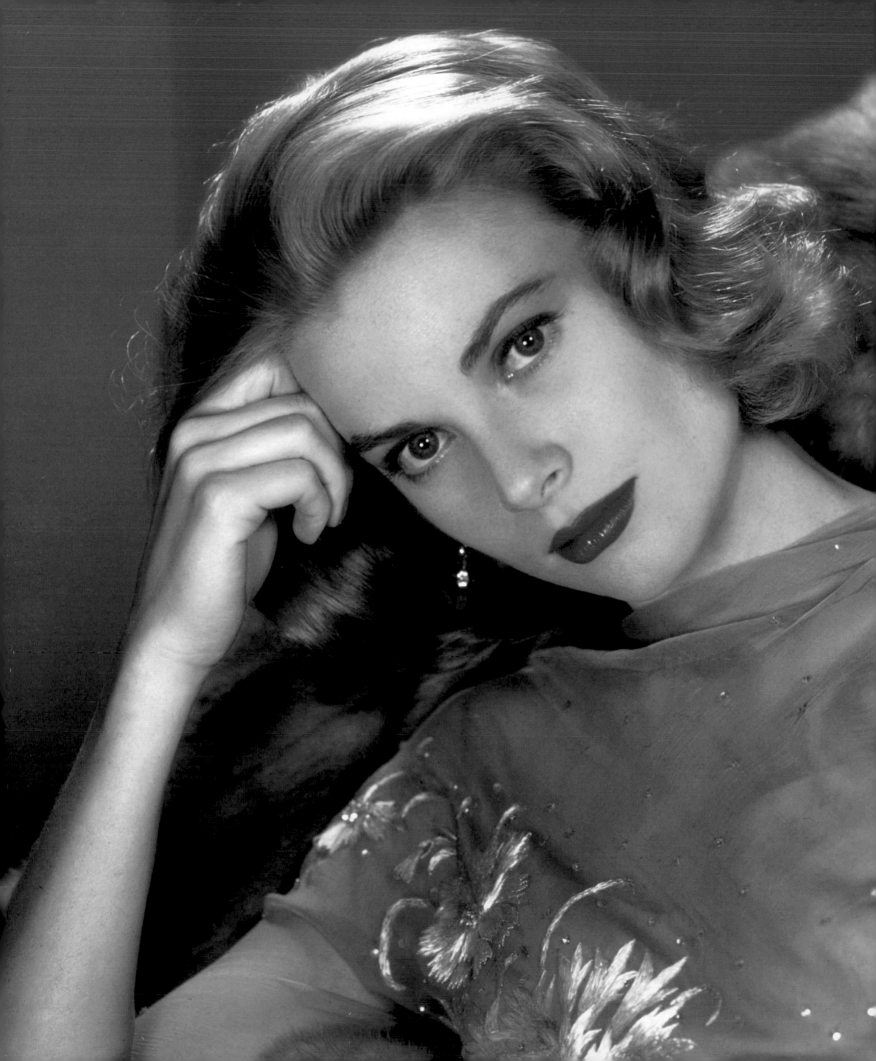

search for the truth. It is likely that the family was devastated, whatever may have been said, but you cannot pass your time explaining how you feel, for all that it is not easy to stick to the adage of "never explain, never complain" to which their colleagues in the other ruling monarchies cling with varying degrees of success.

This ideal but unchanging image of Princess Grace, inscribed forever in an exemplary destiny which is no longer questioned, has had pernicious effects: a rash of generally well-disposed books that have reproduced with the best of intentions a scenario full of charm and glamour, but one which turns their heroine into a wooden statue; others, less numerous, that have taken advantage of this to adopt the opposite approach, that of the biographies riddled with unverifiable pseudo-revelations that in the end sully their authors and potential readers more than the subject of the book. I think I have read both kinds attentively and have had no difficulty in coming to the conclusion that, apart from a few truly painstaking attempts, the essential is lacking: the existence of a profoundly good and sensitive woman who had to deal with the joys and disappointments of every human being, constructing her life with a remarkable courage and perseverance and accepting the burdens that it placed on her, of which her beauty and her charisma were not the least; a woman who was blessed with a marked sense of humour and poetry that prevented her from giving in to the melancholy of a sentimental soul, driven by a powerful ideal of moral generosity that constantly told her to care more about others than about herself. I hope that the exhibition will make this as clear as possible, even if it is certain that there will always remain an element of mystery in the depths of any heart, and all the more so in that of Princess Grace, who was the soul of modesty.

I felt, like everyone, a great sadness at the time of Princess Grace's death. I experienced that sense of injustice which accentuates the pain of any loss. A person who had never stirred anything but benevolent feelings had abruptly been snatched from our mental landscape and our imagination. We had no more than our memory and dreams that had grown sad to call her to mind. And yet, despite all the sorrow of her family which we could share all the more since they appeared truly crushed by their grief, it was impossible not to take notice of the assembly that gathered to pay her their last respects. Princess Grace was given the funeral not just of the admired consort of a respected ruler, but that of a head of state who had reigned over people's hearts. The prestige of the official delegations squeezed into Monaco's cathedral attested to the glamour that she had brought to the Principality, to the incomparable manner in which she had supported her husband in the

Clarence Sinclair Bull, Grace Kelly, *High Society* (Charles Walters), 1956.

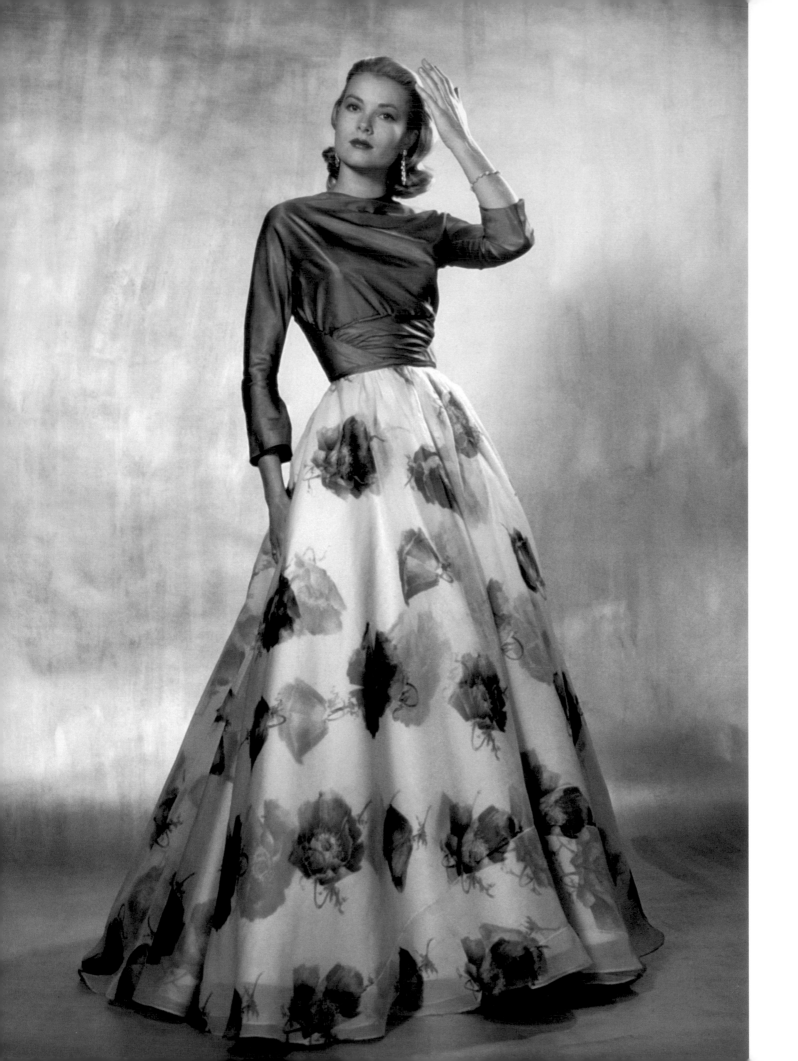

renewal of the Monegasque State and had represented one of the world's oldest ruling dynasties. We could list the names of the sovereigns, the royal families, the heads of state, the artists and the intellectuals who had come in these circumstances to support the Monegasques, suddenly dispossessed of a part of themselves. Let us just say that there were far from so many of them when the young and timid Grace Patricia Kelly had arrived for her marriage in a Principality that was certainly jubilant, but not yet conquered and submerged by thousands of paparazzi who were not renowned for their indulgence and discretion. All the same the tribute was a bitter one, since it took place at the moment of her departure, and even at that time I asked myself how it might be possible one day to reveal exactly what it was that she had brought to Monaco and the amount of work and dedication that she had lavished on the place.

T he project for the exhibition *The Grace Kelly Years, Princess of Monaco* was conceived under the reign of Prince Albert II. I see it as at once an expression of the immense love that he has for his mother and a political act. The Principality is permeated by the very strong personality of Prince Rainier III and by the reign of over fifty years in which he transformed, modernised and elevated Monaco to an incredible extent, earning the gratitude of the Monegasques and bestowing on their State an unhoped-for degree of international recognition. To associate once again the memory of Princess Grace with the radiance of that happy period, marked by a legitimate ambition and a constant progress, but also by enormous efforts and a persistence that could not be taken for granted, is to emphasise even more the human dimension of what was a considerable historic leap for the Monegasques and the Principality. To honour Princess Grace is to honour the generosity, the courage and the solidarity that she brought to the Monegasques during all these years, throughout her too short life but well beyond it, too, by the example she had set, and during all the years that followed. It goes without saying that the Princess of Hanover and Princess Stéphanie have immediately and enthusiastically endorsed this project. It is equally evident that it receives the emotional support of Princess Antoinette as well as of the members of the new generation, who have only known their grandmother through the memories of the family and the accounts of those who were close to her, from the charming Madame Gallico to her innumerable cousins and friends in America; without forgetting all the men and women who accompanied her in her activities of course, the multiple signs of her presence and her actions in the Principality, the enigma of her

incomparable beauty as she appeared in photos and portraits, and even on postage stamps challenge time. But it must be a strange and deeply distressing sensation to grow up without having been able to share even a moment with the eternally young and yet vanished woman to whom you are indebted for being what you are.

The exhibition project has taken shape with the resolute and capable backing of the Grimaldi Forum, its General Manager Sylvie Biancheri and her team, all unsparing in their time and their efforts to bring an unparalleled event to a successful conclusion. It is already difficult to organise the major exhibitions that have made the Grimaldi Forum's reputation ever since its creation, but evoking the living memory of a personality as rich and captivating as that of Princess Grace implies an undertaking of verification, stock-taking and evocation that is different from the presentation of existing works of art that are already inventoried in museums or the collections of enlightened art lovers. In this case, the work of art is the life of Princess Grace as it is reflected in the considerable quantity of mementoes that she left behind, superb in themselves, but either dispersed over time or detached from the person who had chosen them simply because for a long period she has no longer been there to give meaning to them as a whole and to explain the importance which she assigned to each of them. Happily, the Prince's Palace, the various remarkably well-kept and organised archives and numerous contributions from outside have made it possible to gradually draw up an inventory and little by little assemble what appears to have been Princess Grace's domestic world. In the process, I made some fine discoveries, some of them so moving that I was torn between the joy of having found them and the sorrow of thinking that they belonged to someone who is no longer with us.

Throughout a life illuminated by a remarkable gift for friendship, Princess Grace inspired an extraordinary degree of loyalty and devotion. Such as that of Maryel, who was in charge of the Palace's impressive linen room, looking after the Princess's wardrobe and taking infinite care over all the needlework required to adorn the linen for official use and for the private apartments. It is she we must thank for the fact that most of that wardrobe has been preserved and properly maintained. Thus, our eyes can feast on a prodigious collection of evening gowns, outfits for different times of the day and clothing for official occasions (visits, celebrations and ceremonies), private receptions (the arrival of friends from Hollywood, picnics around the swimming pool, trips to Paris), daily life and family occasions (holidays in America, sports, times when she wished to remain incognito and stays at Roc Agel, the ranch overlooking the Principality).

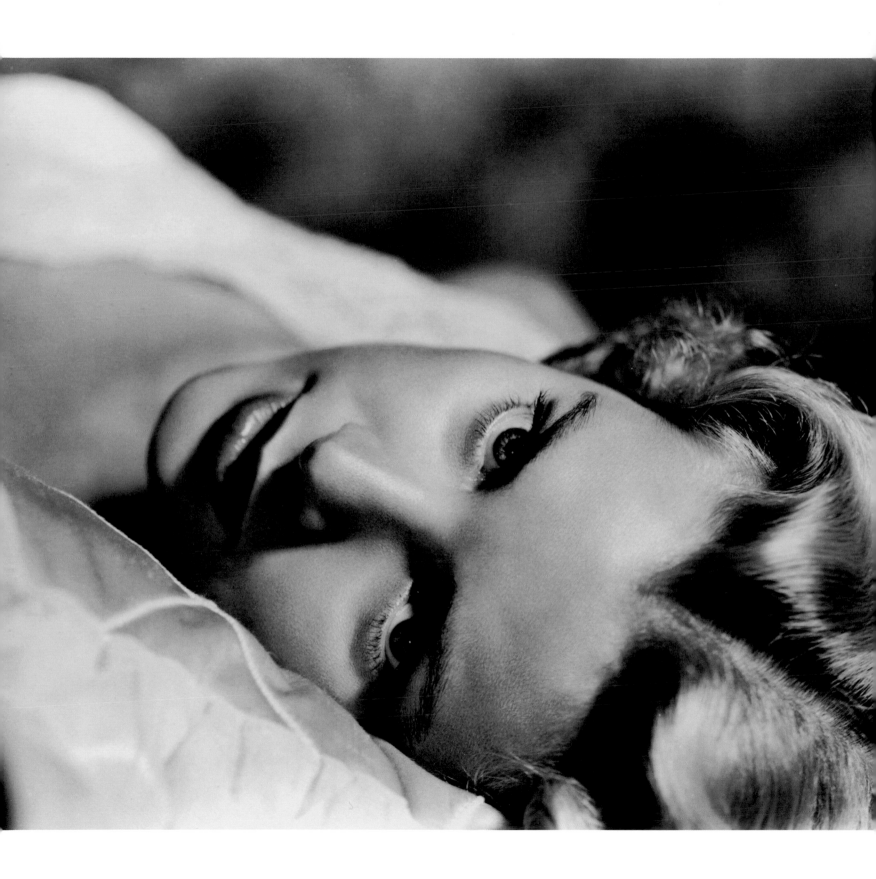

Bert Six, Grace Kelly, *Dial M for Murder* (Alfred Hitchcock), 1954.

The Marc Bohan years at Dior are most in evidence, but there are also creations by Balenciaga, Givenchy, Grès and Chanel as well as several by Helen Rose, the Hollywood costume designer, who was responsible for the marvellous wedding dress which is on loan to the exhibition from the Philadelphia Museum of Art. While discovering the innermost recesses of the labyrinthine palace, Maryel, Hervé Irien, Carl de Lencquesaing my zealous partners and I have uncovered numerous other treasures: overnight bags, luggage marked with the initials of Grace Patricia Kelly, household objects reflecting a natural and youthful taste. You'll be able to recall the flowered bathing caps, gaze at sketches of the hairstyles created by Monsieur Alexandre and rediscover her satin shoeboxes, but don't try to touch the famous Kelly handbag by Hermès which Princess Grace made a triumphant success: it will all be there, offering an extraordinary panorama of trends in fashion and refinements over a period stretching from the fifties to the seventies. While carrying out my researches, I sometimes had the impression I was reliving those sequences from Visconti's film *The Leopard* in which you lose yourself in the out-of-the-way rooms where souvenirs have been stored away. But we must not forget all the other loyal people, the other experts, who have made it possible to assemble the jewelery, the sets of tablemats and the *scrapbooks* of the adolescent Patricia Grace, as well as the superb collages of dried flowers that made up the Princess of Monaco's secret garden. I hope they will forgive me not mentioning their names, but they can be recognised without difficulty. There is a real web of affection woven around the memory of Grace of Monaco; all those who knew her have remained deeply attached to her and more than once I have become aware of looks, of silences, testifying to an emotion that has never faded.

Her letters form an entire continent whose map of the human heart we have surveyed. The ones from her American family, who used to amuse themselves by signing with pet names or names borrowed from celebrities of the entertainment world which it has taken some time to decode; the ones from Hitchcock, Bing Crosby and Cary Grant; the ones from Jacqueline Kennedy and members of royal families, the ones from Greta Garbo and so many others like so many routes leading to the crossroads of her private life and history. It would take a whole book to reproduce them all, but you will see numerous pages on sheets of notepaper of incredibly elegant design that are scarcely ever utilised now, in this time of e-mails and messages on portable telephones. The infinitely tender messages from Prince Rainier will have, as you might imagine, a prominent place.

Clarence Sinclair Bull, Grace Kelly, 1956.

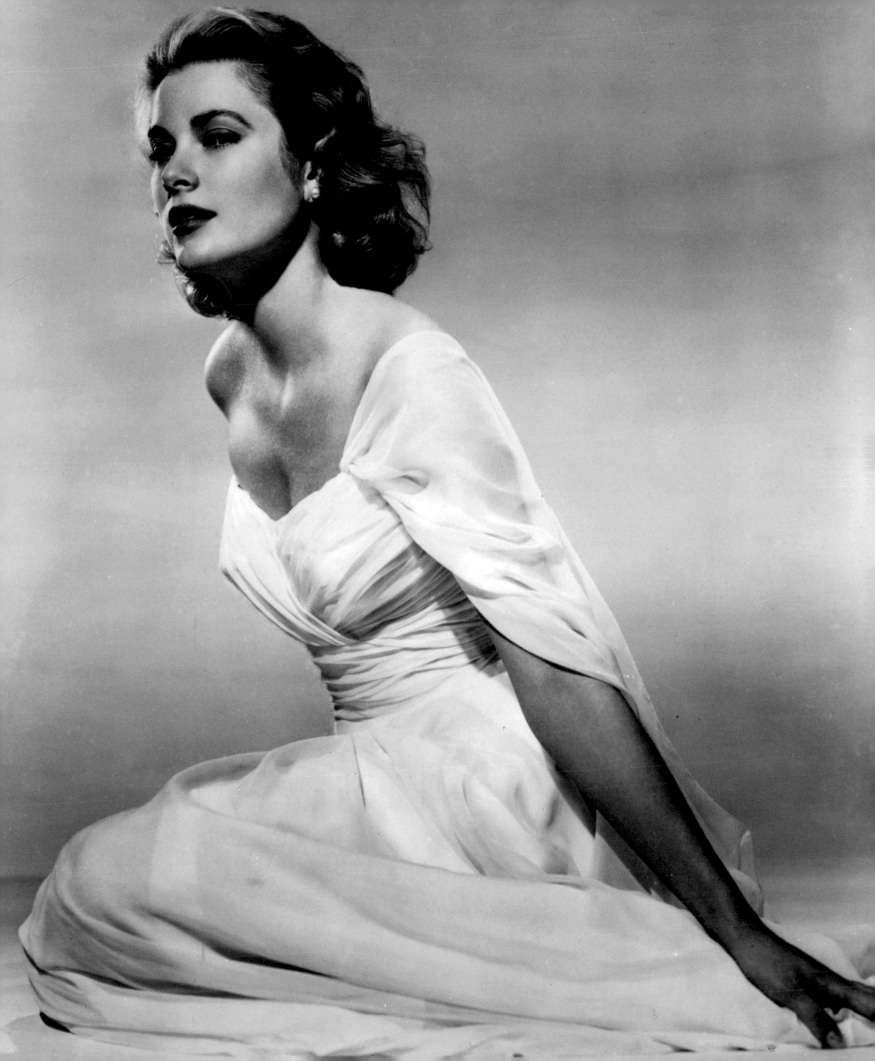

But the real surprise, and a truly astonishing one, is provided by the films made by Princess Grace herself. Shot on a small, amateur camera, but framed with the skill of a professional, scripted for the most part with a charming poetry and gaiety, they trace the life of the princely family, the games of the children, the journeys and the passing of time in a way that no illustrated account has ever been able to present. Often signed at the end of each reel by Princess Grace, who would put in an appearance herself in the way that Hitchcock himself used to do, through a reflection in a mirror or a window pane, they attest to the persistence of her love of the cinema, and perhaps even to her nostalgia for an art that she had put behind her without apparent regret. Carefully preserved in the secrecy of the Palace's movie theatre, they constitute a treasure of almost thirty hours of film that had never been shown in public. So Nathalie Crinière, the brilliant designer of the exhibition, has placed a series of screens along the itinerary followed by visitors that are used to show sequences which were chosen at the end of long hours of viewing, a time during which I was torn between admiration, nostalgia and the joy that is conveyed by the images.

And then how could we forget that Princess Grace has inspired the finest photographers, the greatest portrait painters and the wonderful decorations of that enchanter André Levasseur: images that in the end have been little clouded by the number of reportages on their subject and the clichés of the paparazzi. Irving Penn, Richard Avedon, Jacques-Henri Lartigue, Cecil Beaton, Tony Armstrong-Jones, her close friend Howell Conant on the one hand, Andy Warhol and Yvaral on the other, to mention just the ones who spring to mind. Thanks to the research carried out at the Prince's Palace, at the Château de Marchais, in the editorial offices of the big European and American magazines and in personal collections, the exhibition offers a cross-section of the history of the image in the second half of the twentieth century. Visiting *The Grace Kelly Years, Princess of Monaco*, each person will no doubt find there whatever it was he or she imagined about the personality of Princess Grace and the manner in which she embodied a name that suited her so well. And I hope that visitors will go away with a feeling of deep affection for a woman who practised the art of living and the tenderness of loving from the depths of her being.

Françoise Huguier, Christian Dior suit and Hermès "Kelly Bag". *(Loan: Prince's Palace. Monaco)*

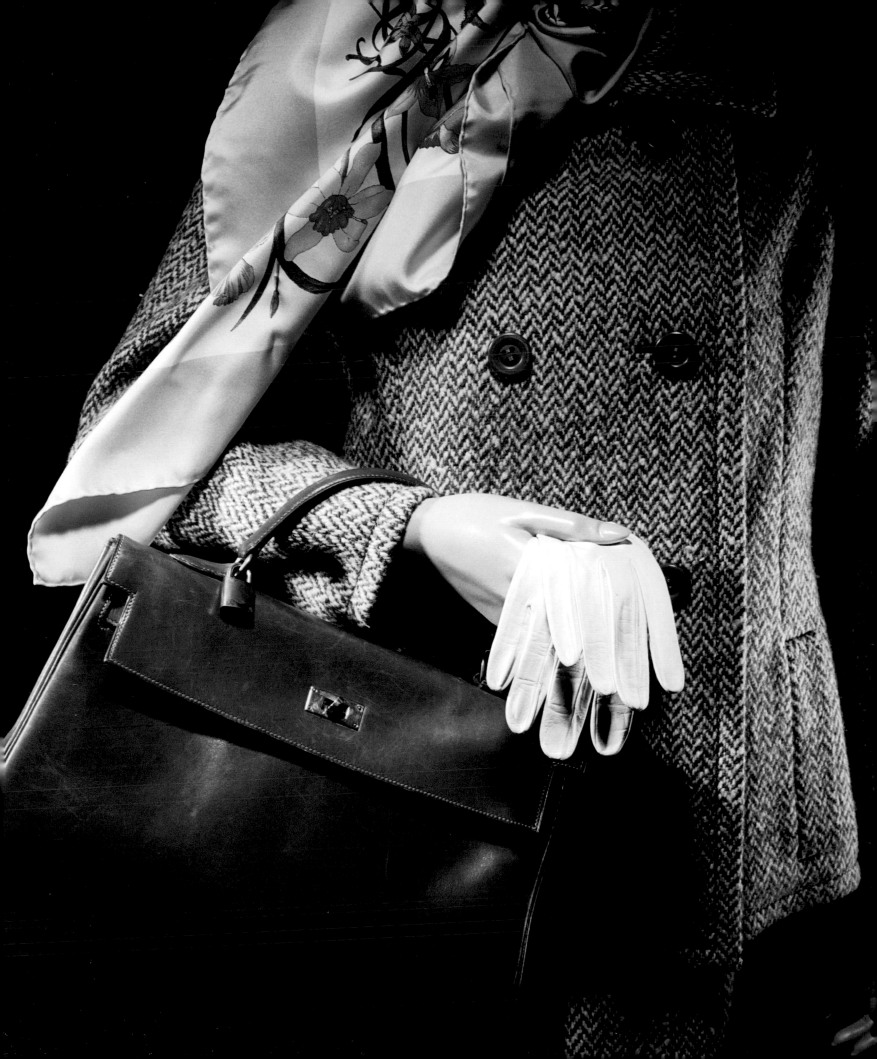

"Why getting angry? Getting angry doesn't solve anything . . . I don't like yelling and fighting, and I can't quarrel, I prefer to let it drop . . . When people use disagreeable words, I feel crushed and remember them for a long time."

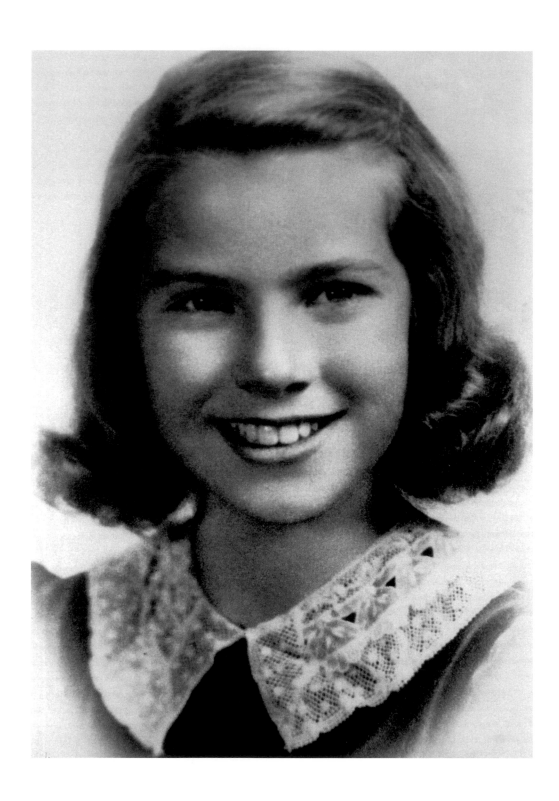

Portrait of Grace Kelly at age twelve, 1941.
Facing page, from left to right and top to bottom: Grace Kelly aged two, with her brother John B. Kelly Jr. and her sister Margaret, Philadelphia, 1931.
The Kelly family in 1936: Grace Kelly, her sister Margaret (Peggy), her parents Margaret Kelly and John B. Kelly, her sister Elizabeth (Lizanne) and brother John B. Jr.
Philadelphia, Grace Kelly, c. 1941. – Philadelphia, Grace Kelly and her brother John B. Kelly Jr. riding a bike, c. 1936. – Philadelphia, Grace Kelly
at three months with her older sister Lizanne, 1929.*(Prince's Palace Archives, Monaco)*
Ocean City, the Kelly family: *Left to right:* John B. Sr., Margaret, Peggy, John B. Jr., Grace and Lizanne Kelly.
Ocean City, Grace Kelly and her sister Peggy building a sand castle, 1935.

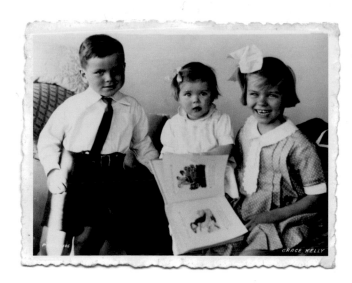

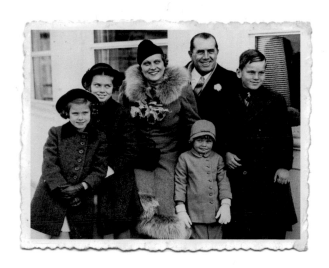

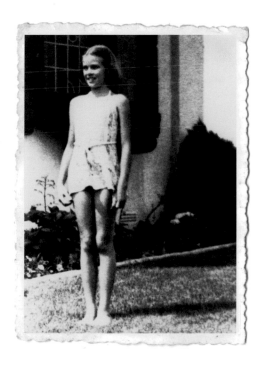

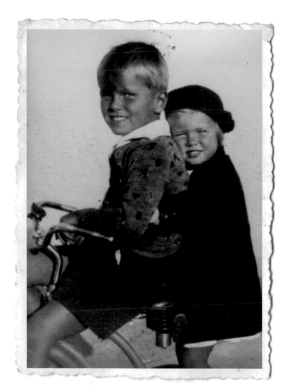

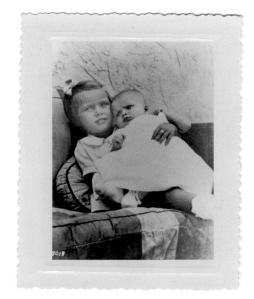

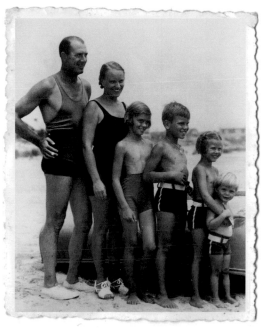

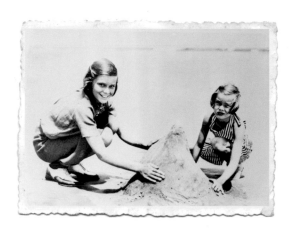

September 28, 1962

Dear Grace and Rainier:

I don't know whether I'll
ever be able to thank you properly for the won-
derful time you showed both my friends and me
when we were in Monaco. It was great to see you
and the kids and everything about our visit was
just wonderful. I just got my pictures back and
most of them came out pretty well - I'll pick out
the best, have some prints made and send them to
you.

I hope everything goes well
with the negotiations during the next few weeks
so that nothing will interfere with your planned
visit in April because we are all looking forward
to seeing you and the kids at that time.

I'm just about caught up
with things here at the office. The Track closes
next week and Mother will be home for good. She
then will be getting ready for her big trip around
the world.

I'm enclosing a letter - I
sent the same to Peg and Liz - which is self-explana-
tory.

Thanks again for everything
and I'll be sending you some pictures in a couple
of weeks.

Love,

Yab Yamagoochi
Japanese Diving Champ.

Manuscript letter from Grace's brother John B. Jr. to Princess Grace and Prince Rainier,
with pretend signature "Yab Tamagochi – Japanese Diving Champ", September 28, 1962. *(Prince's Palace Archives. Monaco)*
Facing page: Philadelphia, Grace, John B. Jr., Peggy and Lizanne Kelly form a human pyramid, c. 1945. *(Prince's Palace Archives. Monaco)*

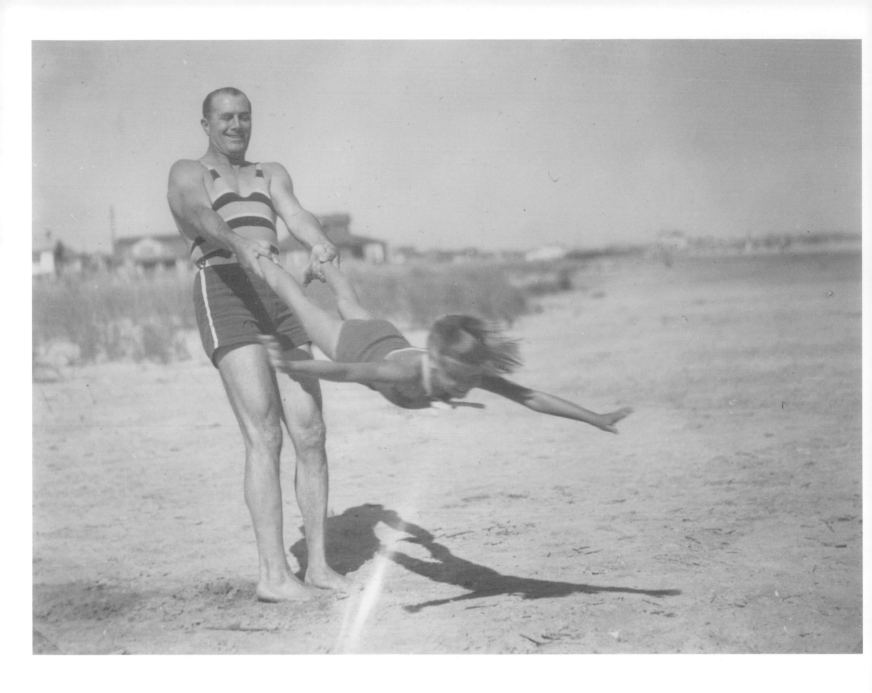

"My father had a very simple view of life: you don't get anything for nothing. Everything has to be earned, through work, persistence and honesty. My father also had a deep charm, the gift of winning our trust. He was the kind of man with whom many people dream of spending an evening."

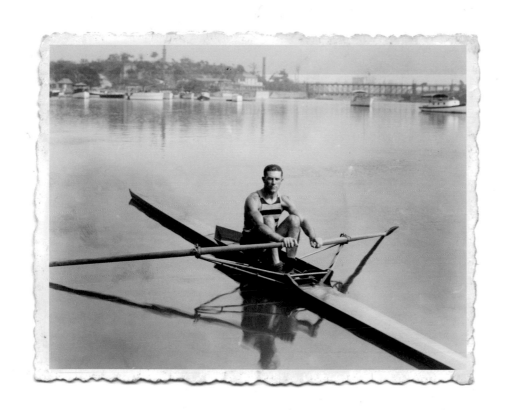

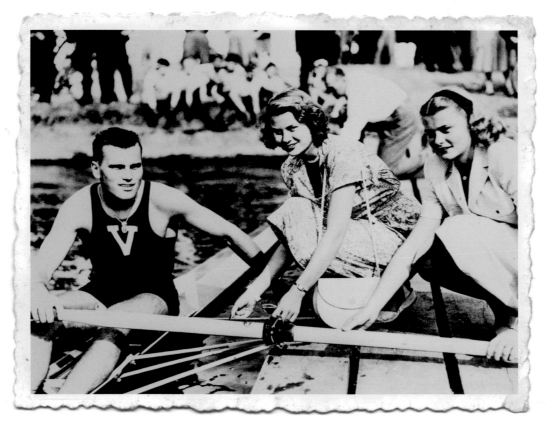

Schulykill River, John B. Kelly Sr., sculling, c. 1920. *(Collections of the University of Pennsylvania Archives)*
Henley-on-Thames, England, John B. Kelly Jr. and his sisters at the start of the Royal Henley Regatta won by him, July 1947.
Facing page: Ocean City, John B. Kelly Sr. with Grace Kelly, c. 1937. *(Loan: Prince's Palace. Monaco)*

Christmas card sent by the Kelly family, 1937. *(Prince's Palace Archives. Monaco)*
Facing page: **Jean-Jacques L'Héritier**, Cover of the *Scrapbook* in which the teenage Grace Kelly kept little mementoes of her daily life. *(Loan: Prince's Palace. Monaco)*
Following pages: **Jean-Jacques L'Héritier**, Inside pages of Grace Kelly's *Scrapbook*. *(Loan: Prince's Palace. Monaco)*

I got this napkin from Osohalcha New Year's Eve '43

"To Grace
 with Love,
 Harper

This is the card that came with the perfume Harper gave me for christmas

My Xmas Carol '43

The horn I got at the reunion

This is what Cedrian gave the cast of "Craig's Wife" for New Years

ONEKA

OUR HAND HAS NEVER LOST ITS SKILL
1842 1942
Schaefer

got this at Oechsle's

got this at Perk's party

C

got these at Perks party

WRIGLEY DOUBLEMINT CHEWING GUM WRIGLEY

chewing gum Harper gave me New Years Eve

got this off Perk's Xmas Tree —

From

Harper

Jan. 7th '44
Play & dance

Program

Steven's dance
Jan. 8th

Trident Dance
Feb. 11th
Harper Davis —

Stevens
Play & dance
Harper —
March 11th

Established 1853
BARRS
JEWELERS & SILVERSMITHS
PHILADELPHIA

This is where
Harper got
the silver
compact he
gave me for
Valentines —

This is one
of the roses
used in the
shower

Old Academy
Players present

"CRAIG'S WIFE"
A drama in three acts
BY
GEORGE KELLY
DIRECTED BY
THOMAS J. PHAYRE

Produced by special arrangement with
Samuel French, N.Y.C.

LEMON
LIFE SAVERs
REG. U. S. PAT. OFF. MADE IN U.S.A. NET WT. .96 OZ. OR 27.2 GMS.
© LIFE SAVERS CORP., MFGR., PORT CHESTER, N. Y.
LEMON

Adrian gave us each
one of these
After the show that

Christmas dance - Dec. 16th 1944
Bill D'Arcy

OFFICIAL
PROGRAM

TROPICAL
Park

CORAL GABLES
FLORIDA

3rd Day
WEDNESDAY
December 27, 1944

PRICE 10¢

tickets from the dog
track - Jan. 1st

STRAIGHT

146

BISCAYNE
FRONTON

2

F

✳ 01

STRAIGHT

151

BISCAYNE
FRONTON

2

D

✳ 01

.5 TROPICAL 8
DAILY 2 **DOUBLE**

2038

U

1st Race 2nd Race

5 FIVE 8 EIGHT

2038

✳ 04

TROPICAL PARK
22-MEZ
5 FIVE 5
DOLLARS
L'AWSO

SHOW SHOW 12 SHOW SHOW

NINTH (9) RACE

2 JAN. 1945

last horse - last
race - last day
tropical 1945 season

Dec. 9th '43
Our class went
"in to see "Kiss + Tell"

Locust Theatre
BROAD & LOCUST
★ PERSONAL DIRECTION OF LAWRENCE SHUBERT LAWRENCE ★

BEGINNING NOV. 15, 1943 Matinees Thursday and Saturday

GEORGE ABBOTT
presents

"KISS AND TELL"

A gay comedy
by F. HUGH HERBERT
with

VIOLET HEMING
WALTER GILBERT
BETTY ANNE NYMAN

Setting by John Root Staged by George Abbott

NOW
in The Record
Capt. Ralph Ingersoll's
magnificent best-seller

"THE BATTLE
IS THE PAY-OFF"

**THE BATTLE
IS THE PAY-OFF**

*"America's No.1
Book of the War!"*

PHILADELPHIA RECORD

Last Summer (Dot Germain
Stayed at our house.

Saw Lover's Leap

Daddy ~~bought~~ this
for me at ~~one~~ the
Penn Cornell game

Camp Firefly

WE SAW
THE ICE
FOLLIES Christ-
mas night
Godfreys &
Our family
& Gaby & Harp—

The War Chest — I gave a dollar
Jan. 8th

RED FEATHER or RED FACE?

NAVY

Ticket:

R 4 8
SEC. ROW SEAT
CIRCLE $3.42
THE ARENA
GOOD ONLY
SAT. EVE.
DECEMBER 25
1943
RETAIN THIS CHECK

lady. She's vice-president of her room, sings in the Lower Merion Choir and played on the varsity hockey team. She has been riding with the Riding Club that Kit still sponsors even though she has given up teaching at L. M. Shirley McConnell is in Margie's class and plays on both the hockey and basketball teams. Barbara Schmidt is also in her class.

Anne Postles is at Girls' High in Philadelphia, where she was one of the two girls from her class to be elected to the Executive Council. She is editor of the Alumnae notes of the school paper and another former Oneka camper, Pat Frank, is sports editor. Anne frequently talks to Helen Schofield over the phone, and has promised to write Henrie a letter but has been too busy with mid-year exams, but since we all know just what that is, we sympathize and send you our best wishes.

Notes from the J.C.'s

weaving throughout the throng. When the decorations were completed, everyone went in for a short dip and then to lunch.

Well rested and ready to continue our theme, we all gathered on the field, in and out of our booths, doing the national dances of each country. The music was gray and lively as were the dancers swinging rhythmically to and fro and in and out among the campers.

Following the dancing, we held our horse show for the July beginners' class. Each girl rode well and the judges were given quite a task. Dr. Rhodes was very kind in offering his services as judge for the show, and he did a grand job. The Blue Ribbon went to Rita Jerrehian; Red, to Jane Katzenbach; Yellow, to Anne Schaffer, and White, to Sarita Van Vleck. The sounding of the trumpets, the trotting of the horses, and the parade announced the opening of the Bull Fight. Into the ring paraded the horses with their riders dressed in brilliant red sashes, and they were

bacon and grilled over the fire on a stick. Some of the girls added tomatoes, onions, and mustard plus the roll which made a super special sandwich. For dessert we toasted marshmallows and had cookies and fruit.

After supper the Seniors entertained us with quite a few of their songs and then Gretchen gave us two of her very successful monologues. To add the finishing touch to an almost perfect day, Gretchen ended our stay with the last part of Calvacade.

"The iceskating is just grand. We have evening ice skating parties and it's a beautiful sight seeing the lights on the ice and the bonfire at the edge of the lake. Lots of love, Dutchie."

Dutchie had a nice letter from Miss Lucey saying "Hello" to everyone. Miss Lucey had just been to the hospital for a sudden appendectomy.

Betty Wynn writes from Bucknell University at Lewisburg that: "College life is a great experience, and

physical capacity. Unraveling in the order we had: 1. Broadstreet Station; 2. Initiation; 3. July 4th, Junior Table; 4. Trips; 5. Junior Play (Peter Pan, alias Deubie Pan); 6. Masquerade; 7. Sunday night supper on the field; 8. Crow's nest at mail time; 9. Lakeside neighbors; 10. Assembly.

At the end of the show we were all very proud to have Deubie and Henri up on the stage to receive the lovely gift from campers and Counselors in honor of their first year at Oneka. It was a lovely light fixture of wrought iron on a huge chain for the Roost. They also were presented with a lovely deer head which is also hanging in the Roost. After a thorough explanation on the correct way of saluting the flag the program came to and end and we hope everyone went down to their beds happy and proud of their talented Counselors.

PRESSURE POINTS

The Red Cross First Aid Course, under the guidance of our qualified

Grace Patricia Kelly

Grace Patricia Kelly's visiting card. (*Prince's Palace Archives. Monaco*)

"I think that anyone who saw a photo of me flicking an 'Old Gold' with my fingertips to make the ash fall off wanted immediately want to smoke 'Camels'."

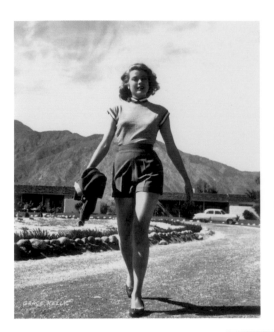

Bud Fraker, Grace Kelly, casting, c. 1950. – Grace Kelly, casting, c. 1950.
Facing page: Grace Kelly poses for "Cashmere Bouquet" soap advertisement, c. 1950. *(Loan: Prince's Palace, Monaco)*

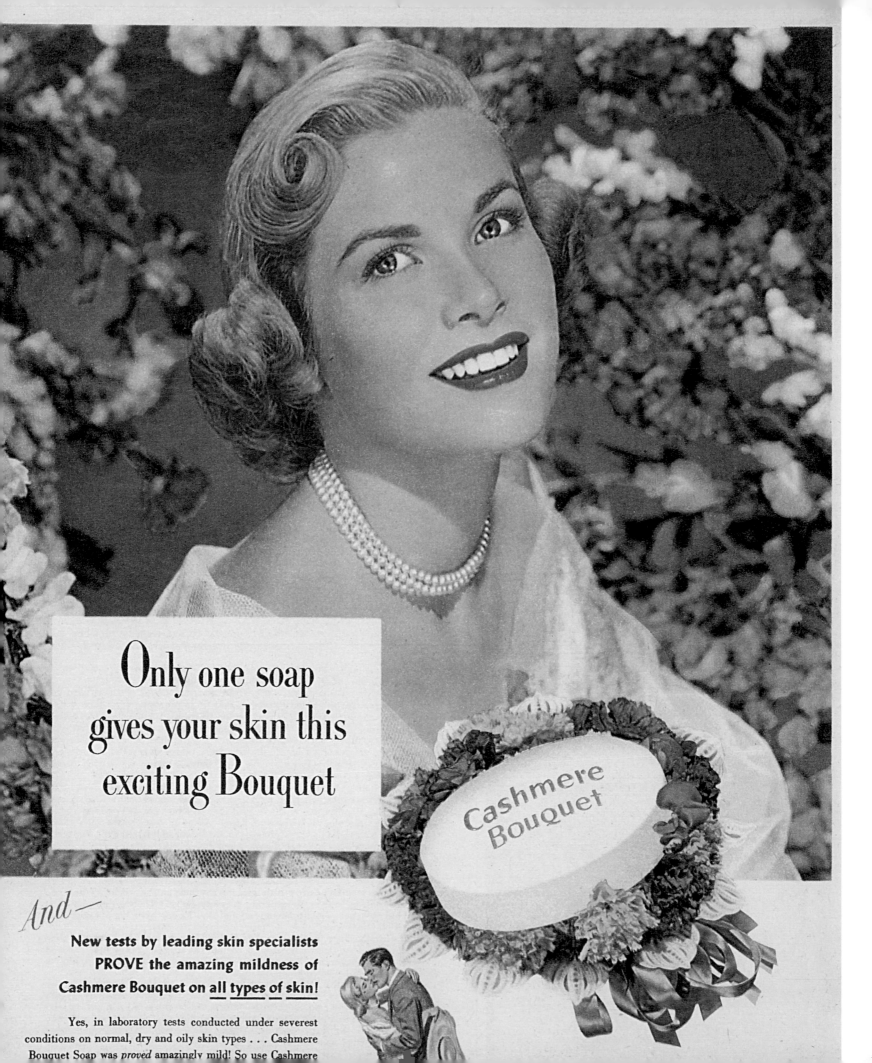

Only one soap gives your skin this exciting Bouquet

Cashmere Bouquet

And—

New tests by leading skin specialists PROVE the amazing mildness of Cashmere Bouquet on all types of skin!

Yes, in laboratory tests conducted under severest conditions on normal, dry and oily skin types . . . Cashmere Bouquet Soap was *proved* amazingly mild! So use Cashmere

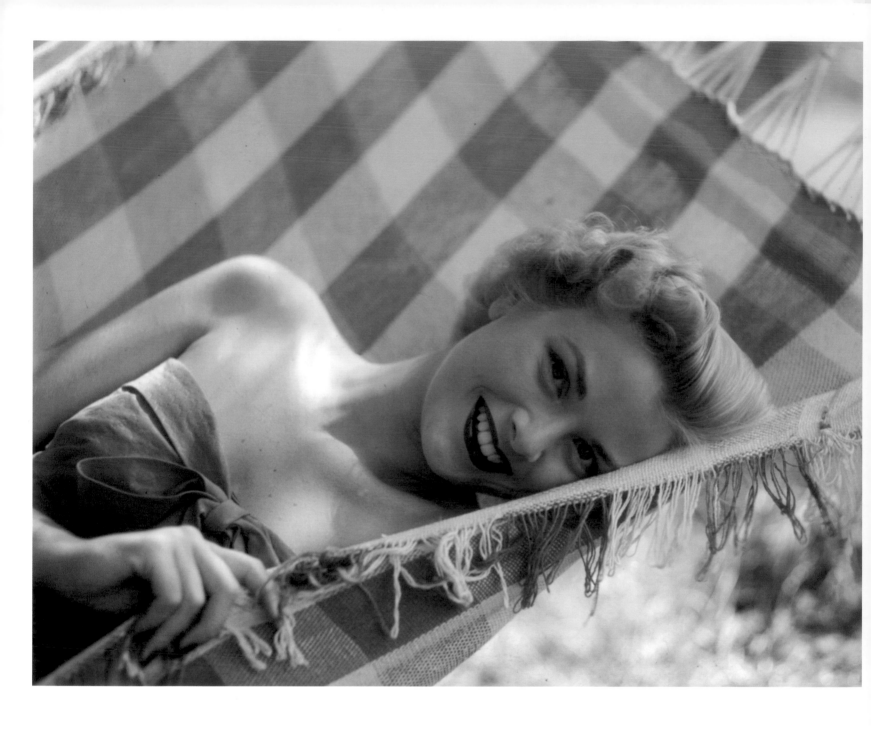

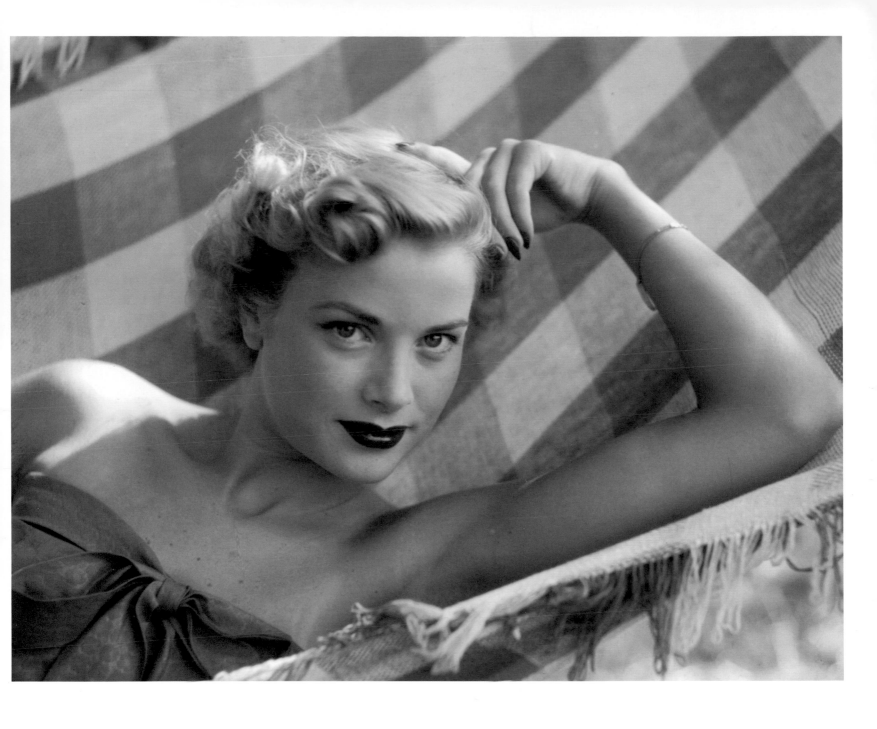

Grace Kelly modelling in New York, c. 1950. *(Prince's Palace Archives. Monaco)*

"My parents, despite their serious attitude toward life in general, and that of their children in particular, were very broadminded people. There was no such thing as a bad profession for them. As I was their daughter, they knew that, whatever profession I chose, I would do it well. That was enough for them. There was always trust among the Kellys."

Markus Blechman, Grace Kelly, studio, New York, c. 1952. *(Prince's Palace Archives. Monaco)*
Following pages: **Françoise Huguier**, Christian Dior silk muslin dress with pearls and sequins. *(Loan: Prince's Palace. Monaco)*
Grace Kelly, studio, contact sheet, New York, c. 1952. *(Prince's Palace Archives. Monaco)*

⋘ 52 ⋙

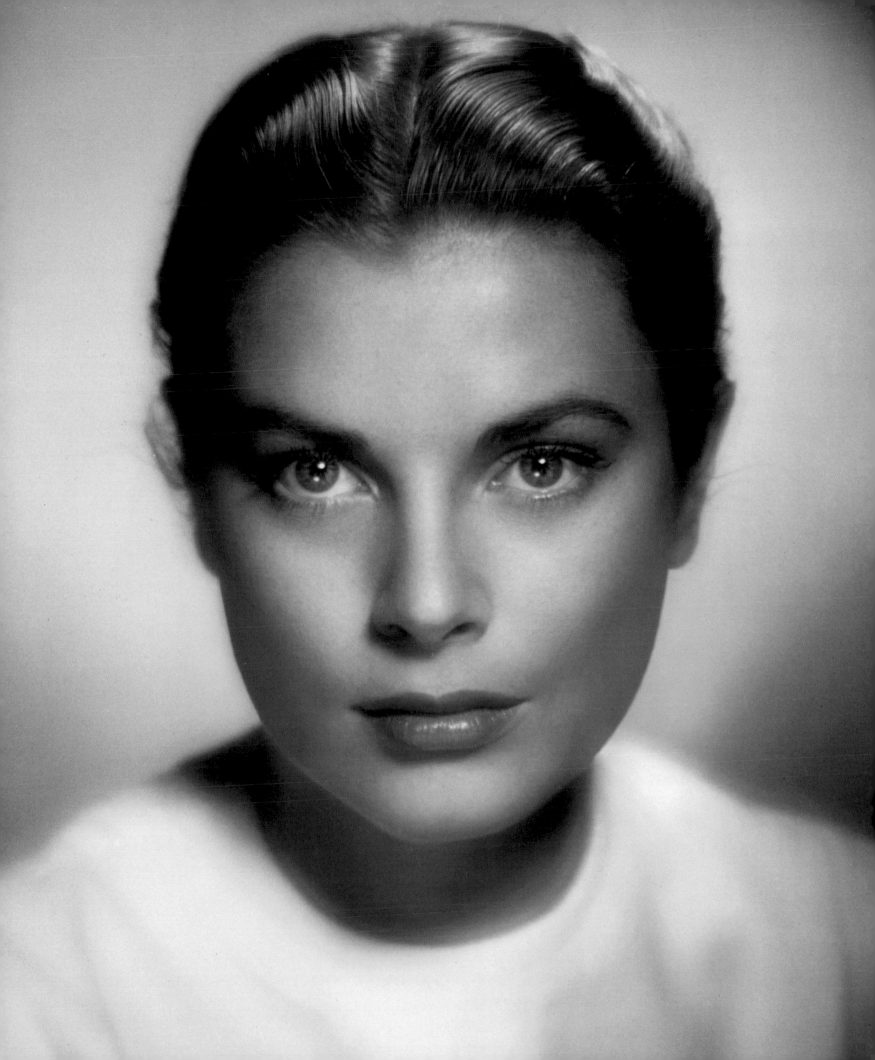

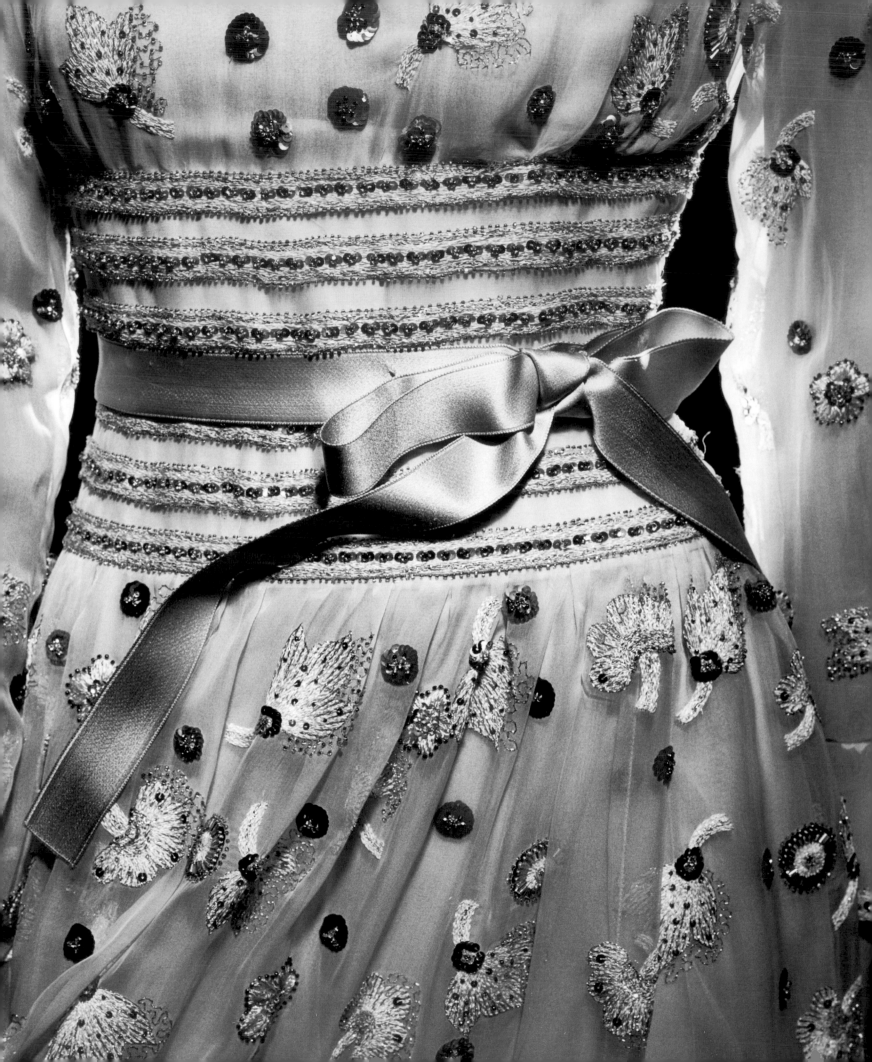

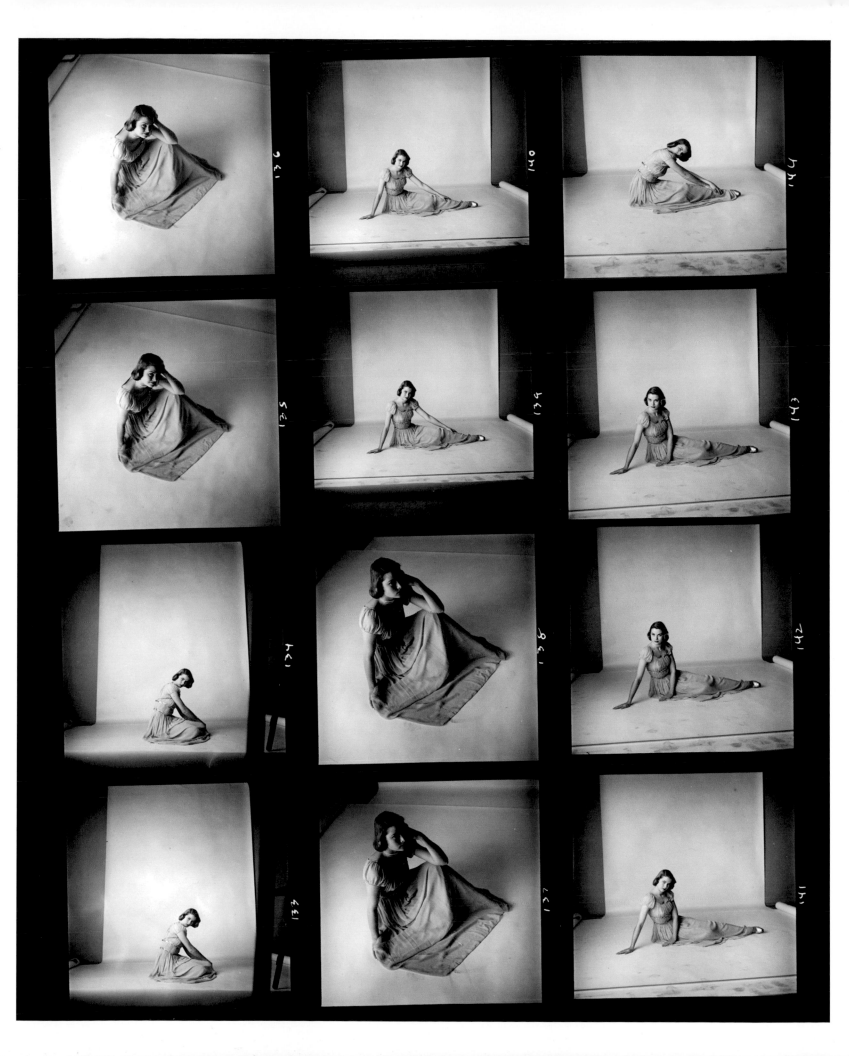

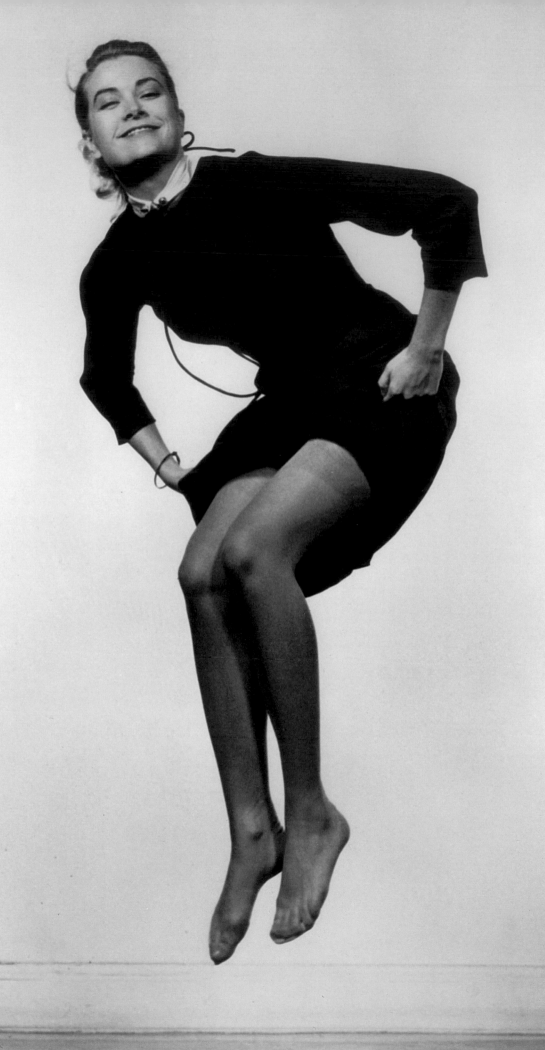

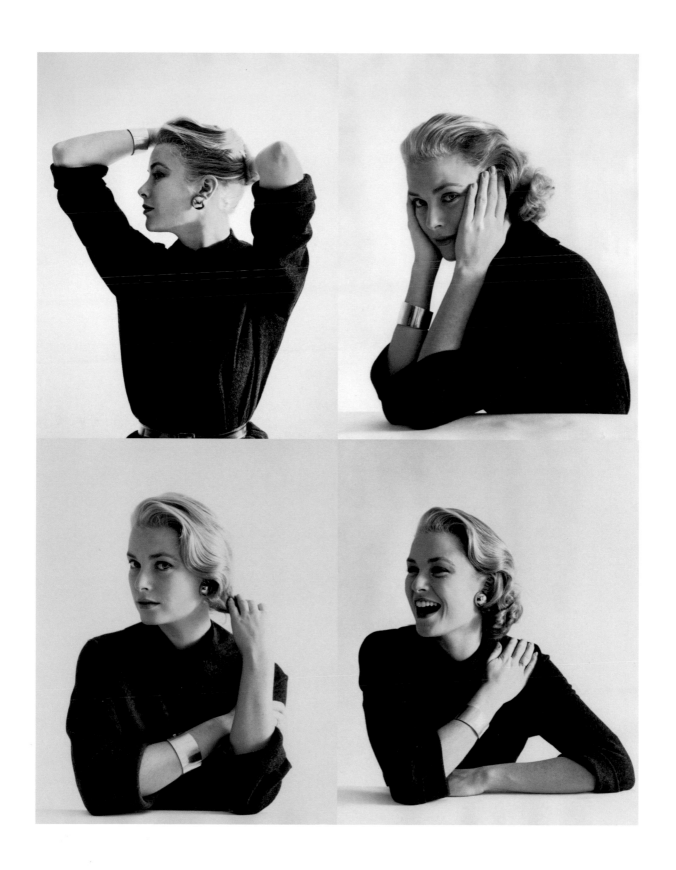

Mark Shaw, Grace Kelly, c. 1955.
Facing page: **Philippe Halsman**, Grace Kelly, 1955. From the famous "Jump" series in which many celebrities were asked to jump for the camera.

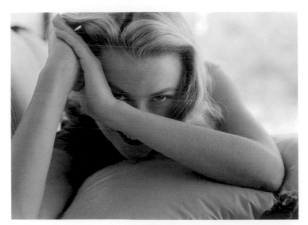

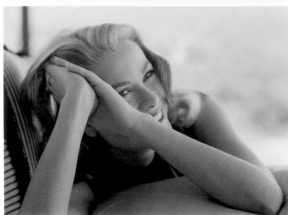

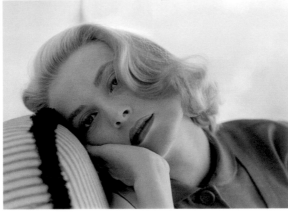

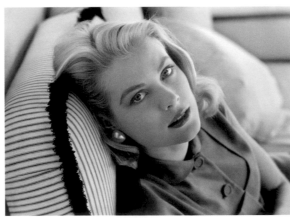

Howell Conant, Grace Kelly, Jamaica, 1955. Exhausted after making six films in one year, Grace Kelly went on holiday with her sister Peggy and Howell Conant who became her official photographer. Reportage for *Collier's*.

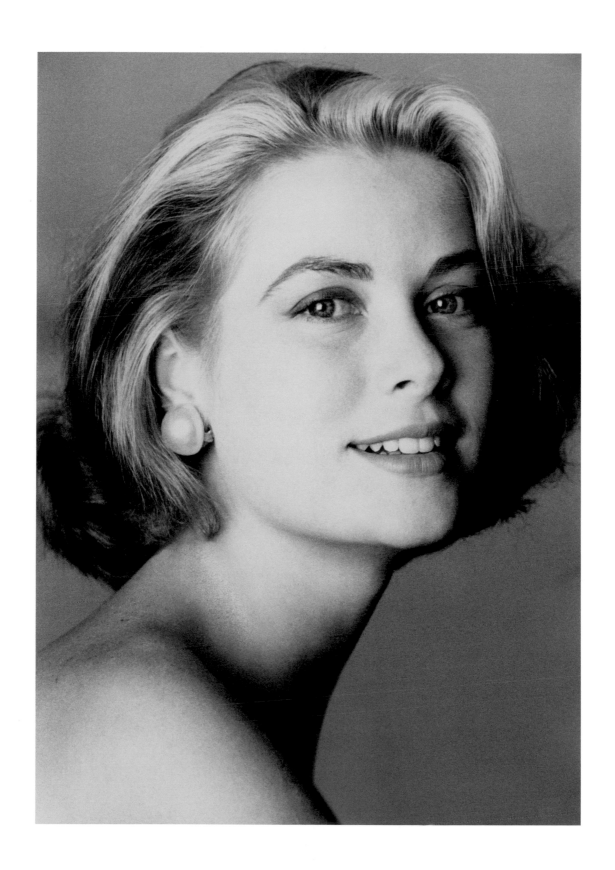

Irving Penn, Grace Kelly, New York, 1954.

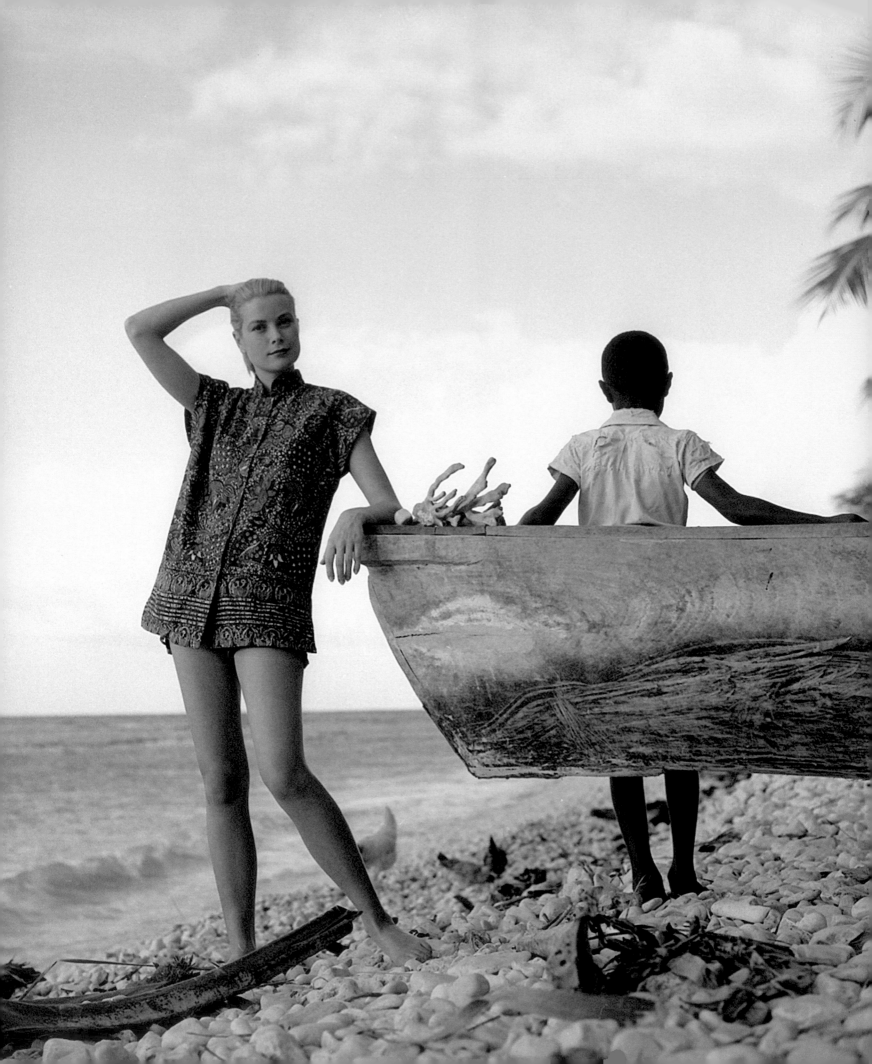

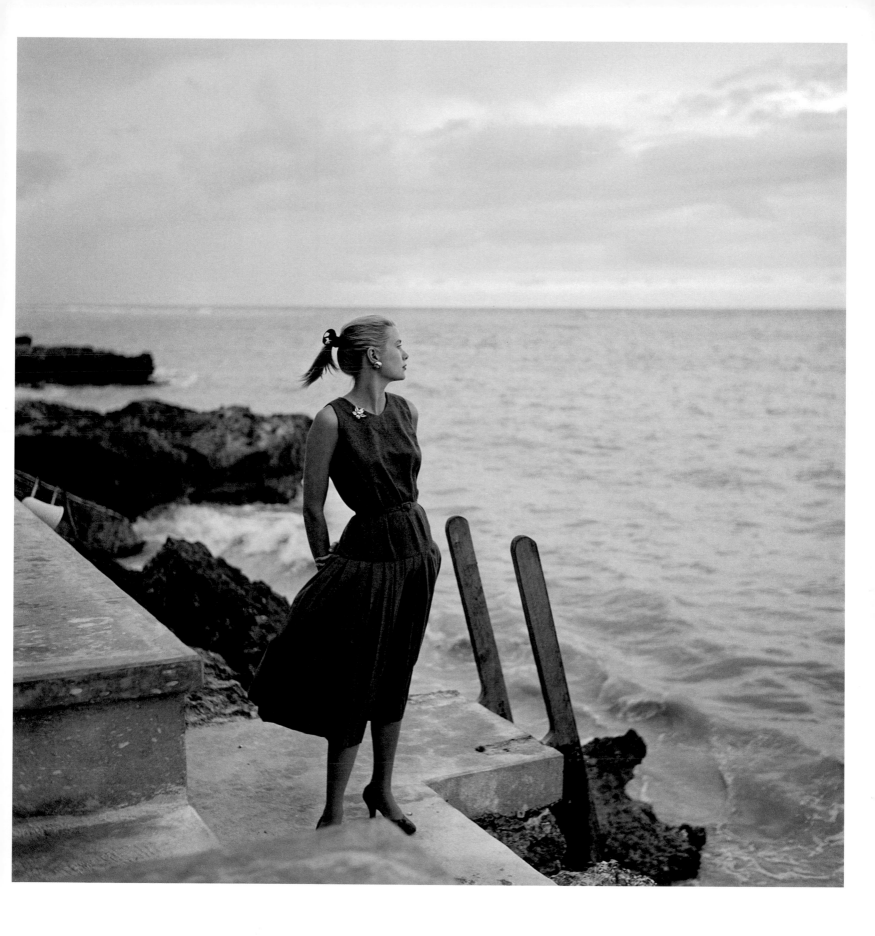

Howell Conant, Grace Kelly, Jamaica, 1955.
Following pages: **Howell Conant**, Grace Kelly, Jamaica, contact sheet, 1955.

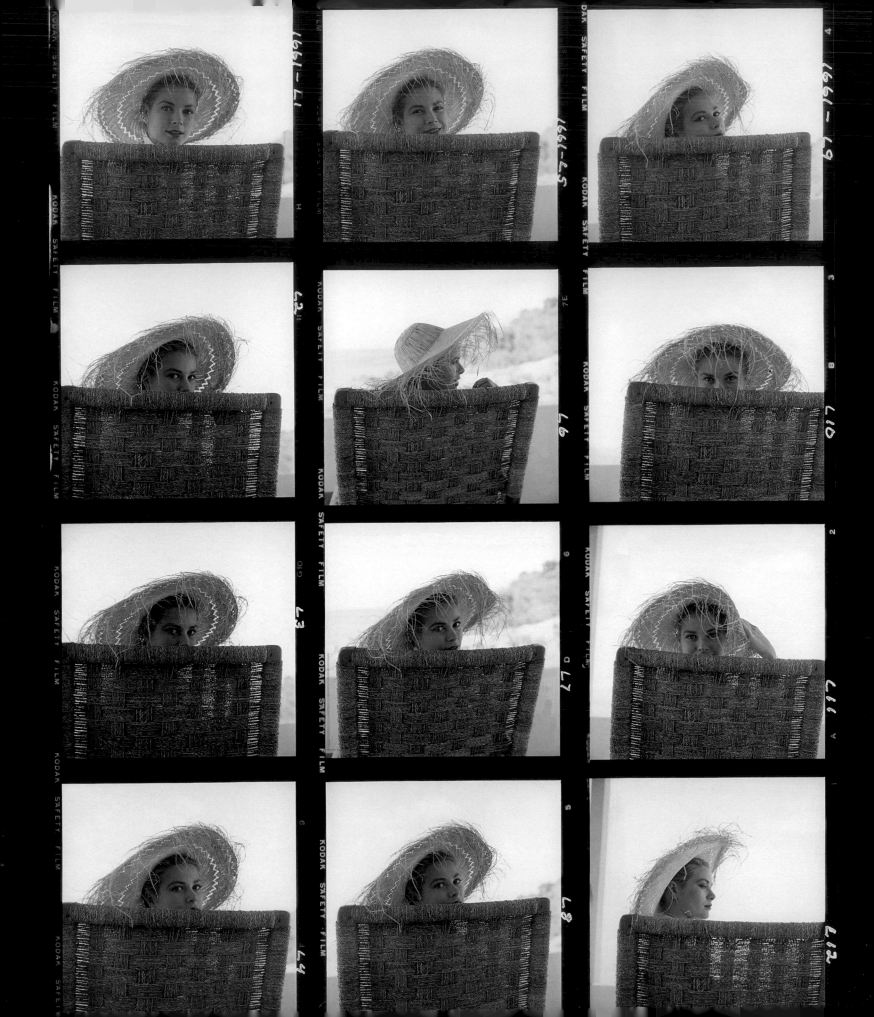

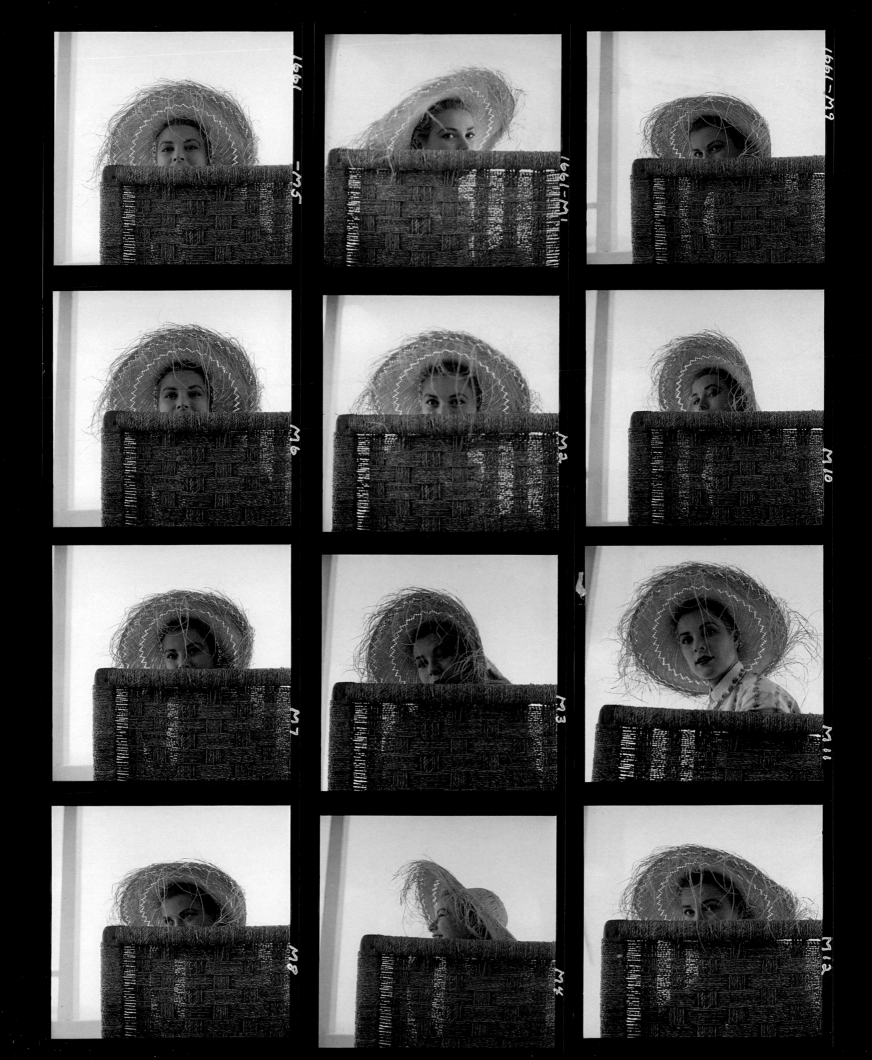

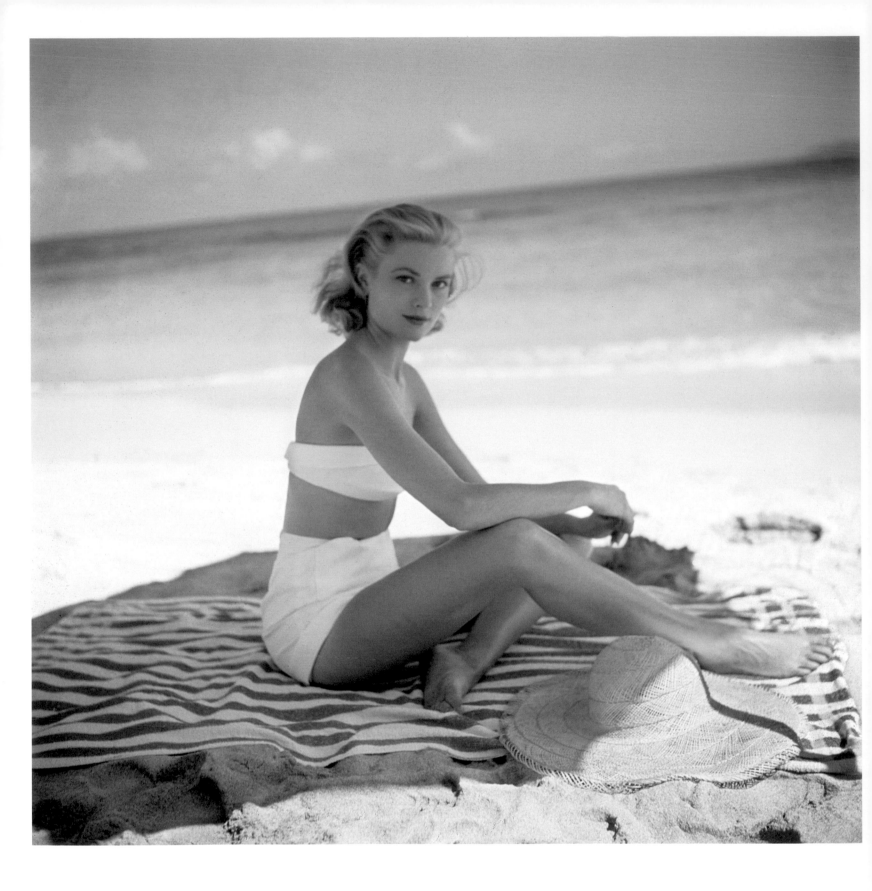

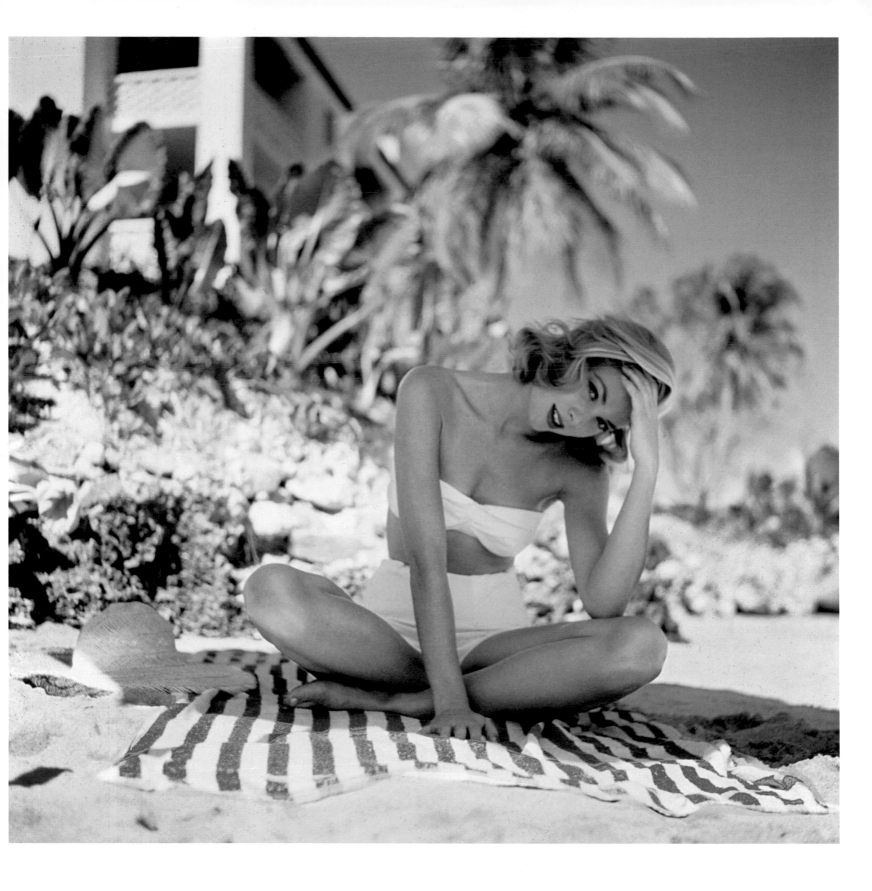

Howell Conant, Grace Kelly, Jamaica, 1955.

Howell Conant, Grace Kelly, Jamaica, 1955.

"As an unmarried woman, I was thought to be a danger. Other women looked at me as a rival. And it pained me a great deal. But I avoided confiding in anyone and talking about my plans. One shouldn't talk about the future, it's the best way to mess it up."

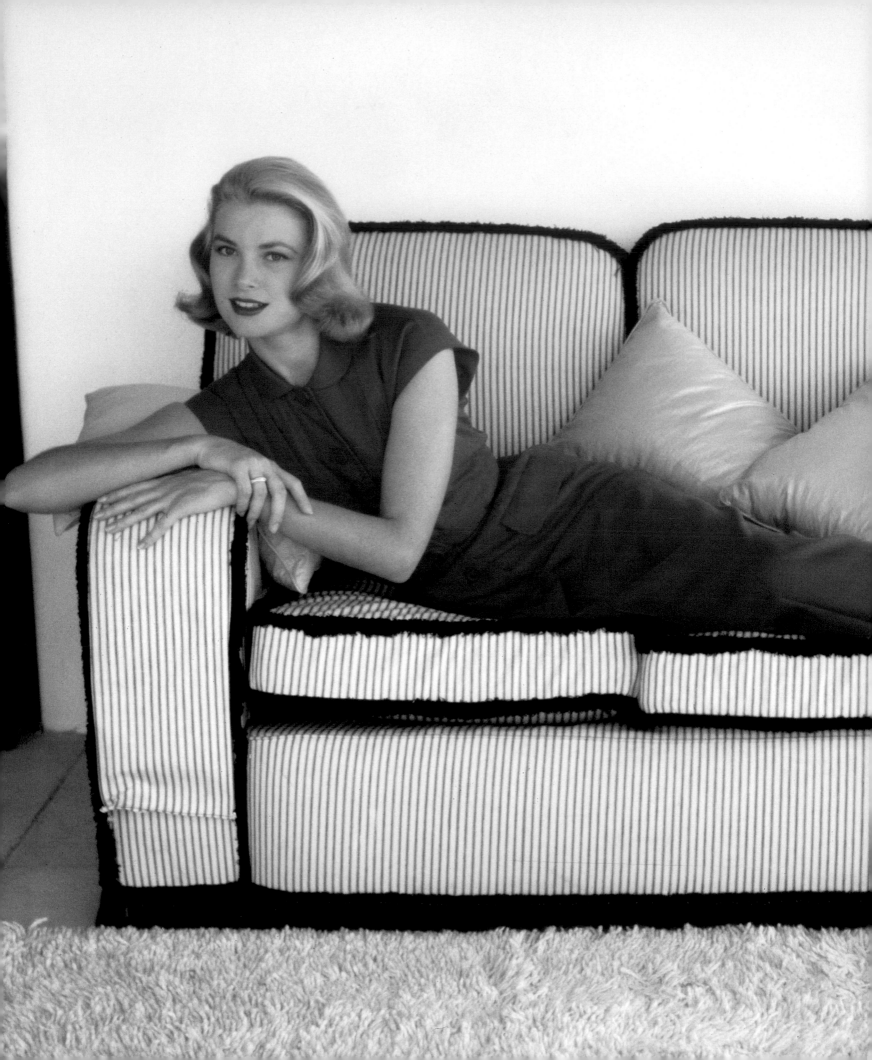

Howell Conant, Grace Kelly, Jamaica, 1955.

Howell Conant, Grace Kelly, Jamaica, 1955.

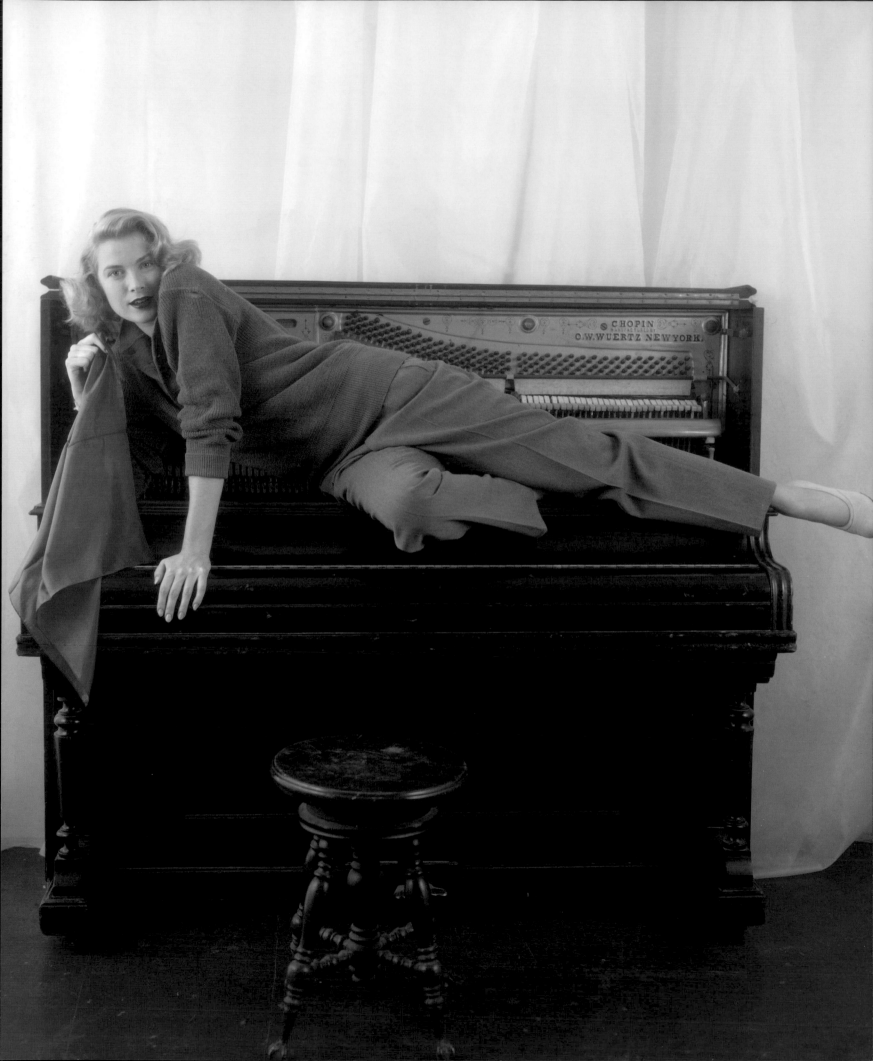

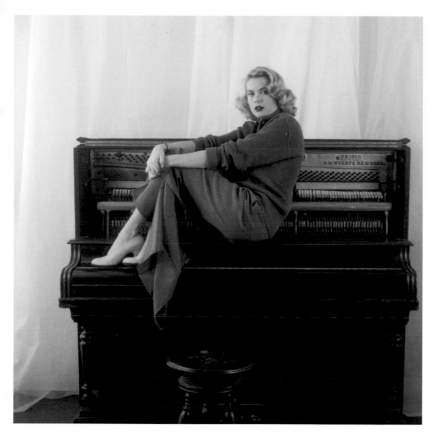

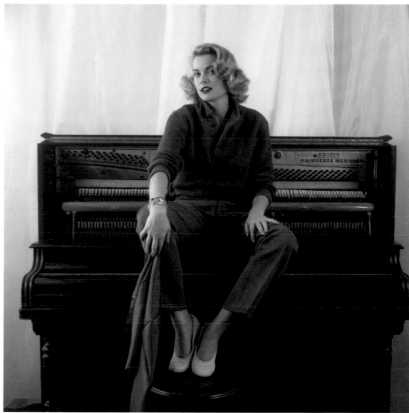

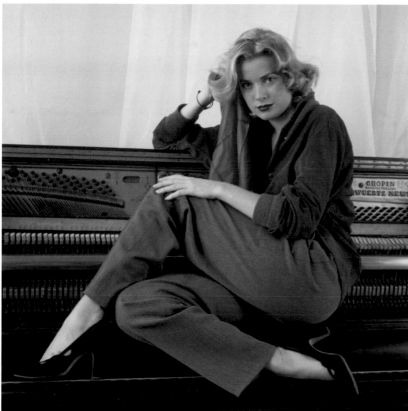

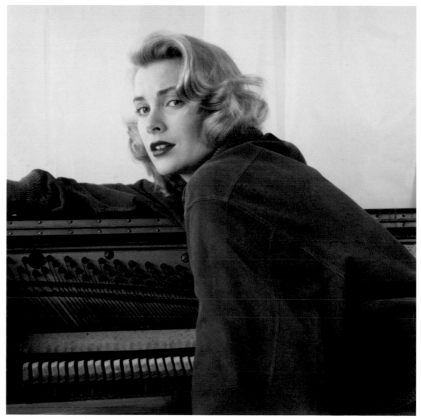

Milton H. Greene, Grace Kelly, New York, 1955.
Milton H. Greene was also the author of a series of famous shots of Marilyn Monroe; he was her friend and, briefly, her companion as she moved
to New York in what was to become a turning-point in her career.

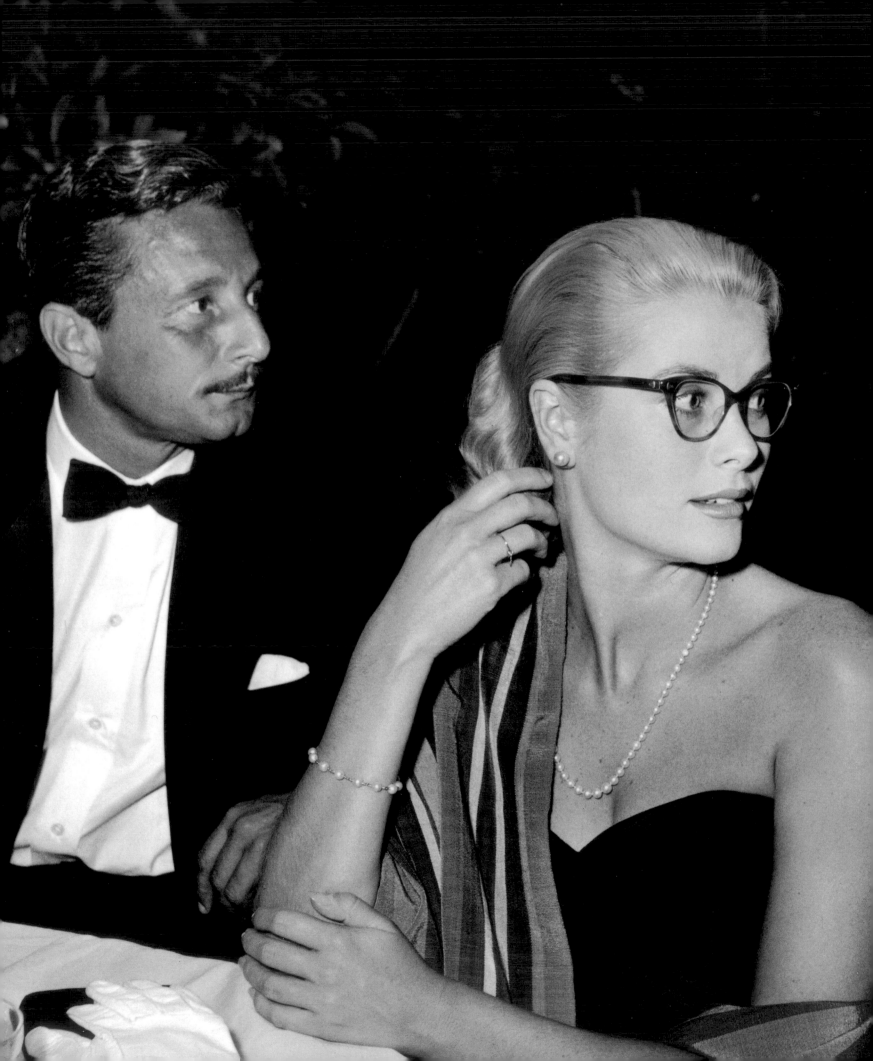

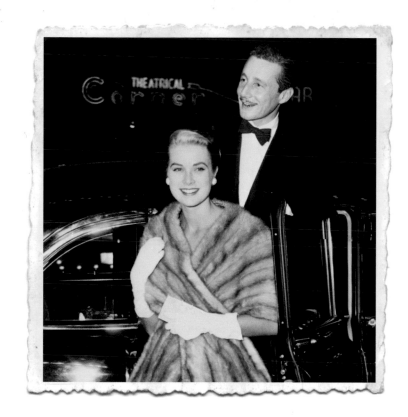

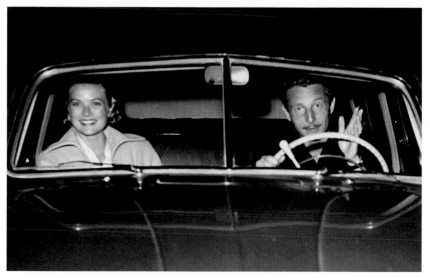

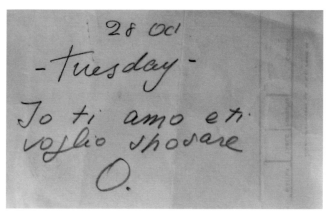

28 Oct
- Tuesday -
Io ti amo eti
voglio sposare
O.

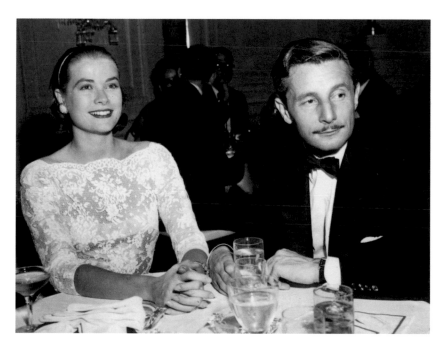

From left to right, top to bottom: Grace Kelly and Oleg Cassini arrive at the screening of *Desirée*, Roxy Cinema, New York, November 18, 1954.
The talented fashion designer Oleg Cassini, ex-husband of Gene Tierney and responsible for Jacqueline Kennedy's wardrobe, was Grace Kelly's first serious romantic attachment.
— Grace Kelly and Oleg Cassini in Cannes during the shooting of *To Catch a Thief* (Alfred Hitchcock), 1954.
Billet-doux signed by Oleg Cassini. *(Prince's Palace Archives. Monaco)* — Grace Kelly and Oleg Cassini at a soirée held by Tallulah Bankhead, April 11, 1954.
Tallulah Bankhead was a star actress, famous both for her talent and strong personality.
Facing page: Grace Kelly and Oleg Cassini at a party given by Louella Parsons, Hollywood, 1955.
Louella Parsons was a famous Hollywood gossip and rival of the poisonous columnist Hedda Hopper.

LIFE

THE REMARKABLE GEORGE EASTMAN
HIS STORY AS REVEALED IN HIS PRIVATE PAPERS

PHOTOGRAPHY'S EARLIEST DAYS

GRACE KELLY
HOLLYWOOD'S BRIGHTEST
AND BUSIEST NEW STAR

20 CENTS

APRIL 26, 1954

REG. U. S. PAT. OFF.

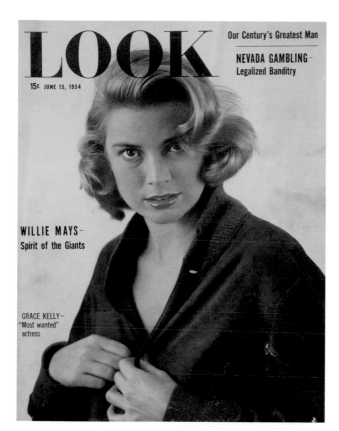

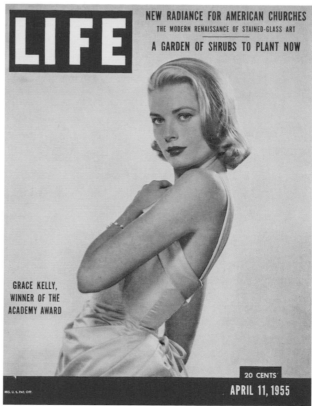

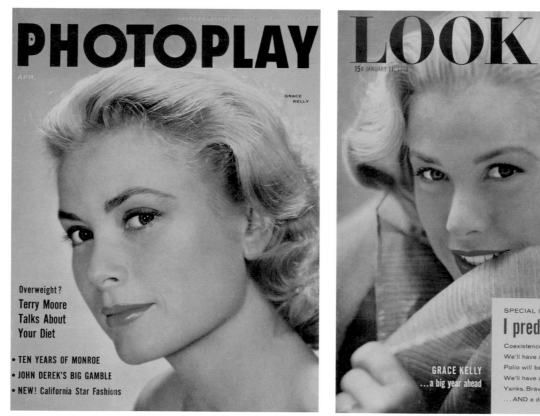

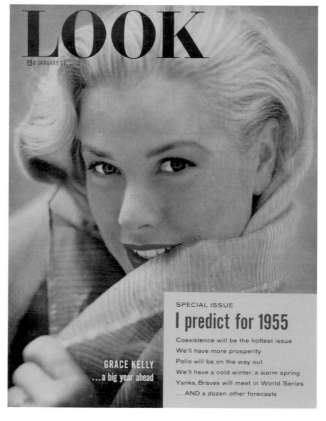

From left to right, top to bottom: **Milton Greene,** *Look* magazine cover, June 15, 1954. — **Philippe Halsman,** *Life* magazine cover, April 11, 1955.
Howell Conant, *Photoplay* magazine cover, April 1955. — *Look* magazine cover, January 11, 1955. *(Loan: Prince's Palace, Monaco)*
Facing page: **Philippe Halsman,** *Life* magazine cover, April 26, 1954. *(Loan: Prince's Palace, Monaco)*

"Of course, I think about marriage, but my career is still the most important thing for me. If I interrupt it now to get married, because I don't believe in a part-time family life, I would risk passing the rest of my existence wondering whether or not I would have been able to become a great actress."

Erwin Blumenfeld, Grace Kelly, 1955.
Erwin Blumenfeld, a naturalised American originally from Berlin, played a significant role in the history of twentieth-century photography, and wrote a remarkable book of memoirs. Here Grace Kelly is wearing an Oleg Cassini dress.

78

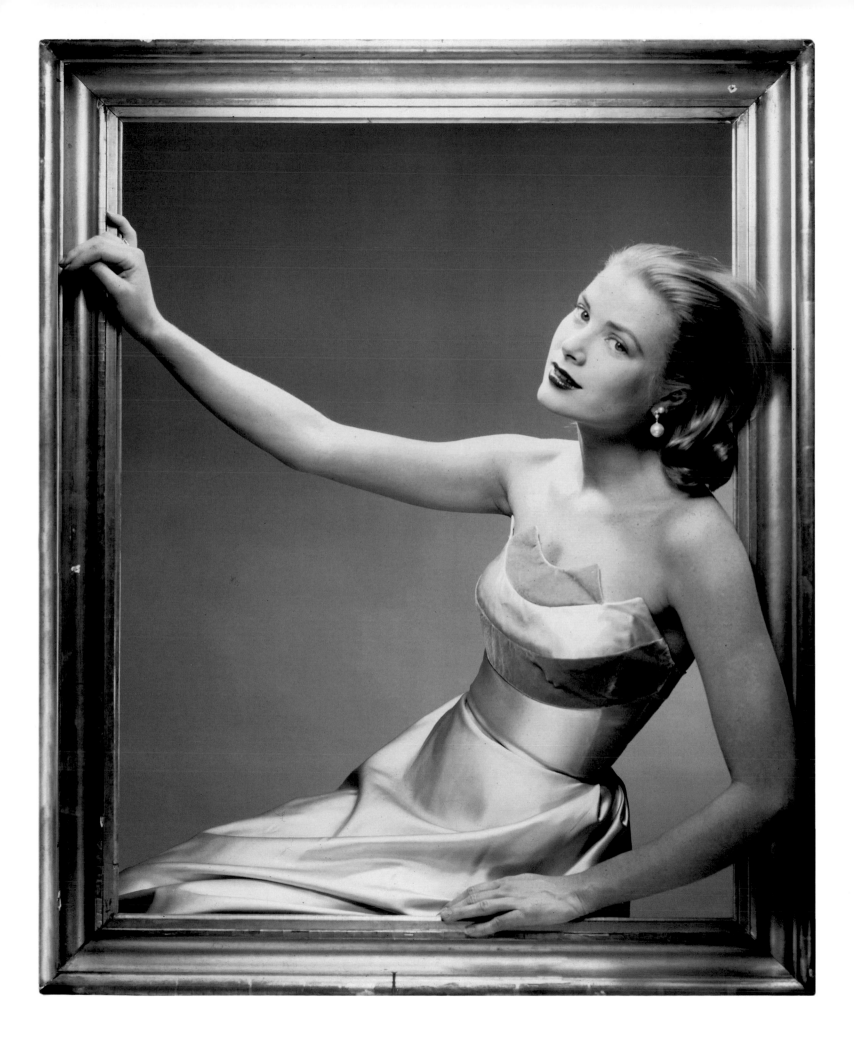

"The studios are tenacious. When they want someone or something, they always get it in the end. I ended up signing a contract with MGM. I signed because they offered me the chance of shooting in Africa, but I signed it at the desk of the airport, when the engines of the plane were already turning."

Jean Howard, Grace Kelly, c. 1954.
Jean Howard, the former actress, celebrity Hollywood hostess and wife of a major impresario, was fond of photographing her film and show-business friends.
She left a considerable body of work whose true importance was only acknowledged in the late eighties.

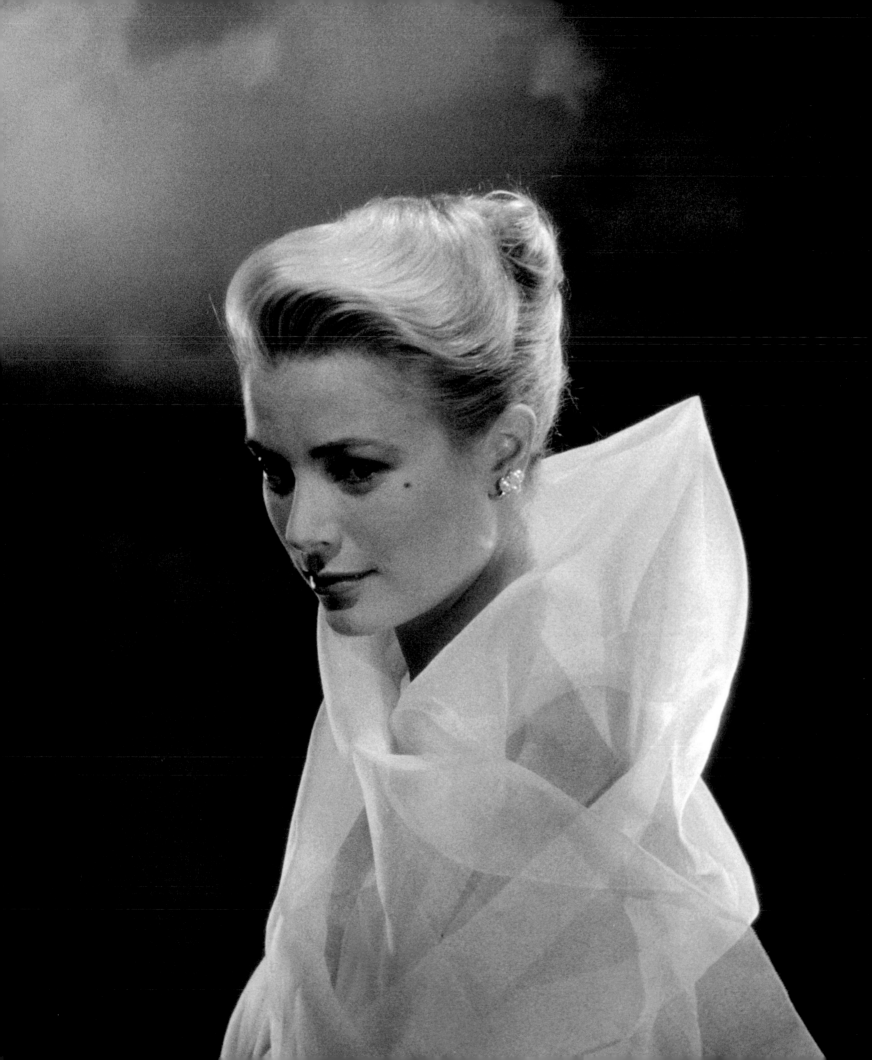

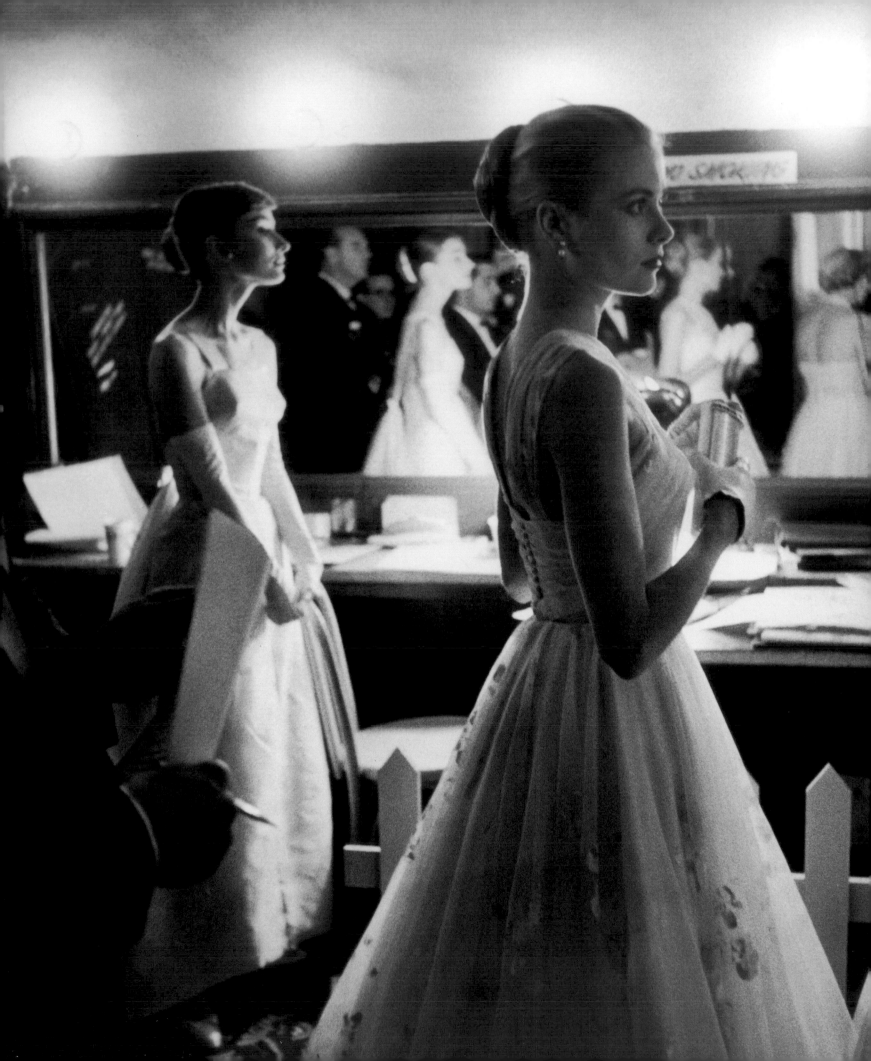

"I get up at seven for the make-up, Rita Hayworth at six, Joan Crawford and Bette Davis at five. I don't want to know the time when I'll have to come to the studio even earlier."

Audrey Hepburn and Grace Kelly, presenters of the 28th Academy Awards, waiting in the backstage of the RKO Theatre, March 21, 1956. This was Grace Kelly's last "official" appearance in the movie world.

"When Ava Gardner gets in a taxi, the driver knows at once she's Ava Gardner. It's the same for Lana Turner or Elizabeth Taylor, but not for me. I'm never Grace Kelly, I'm always someone who looks like Grace Kelly."

Stanley Kramer, Grace Kelly and Gary Cooper, *High Noon* (Fred Zinnemann), 1952.

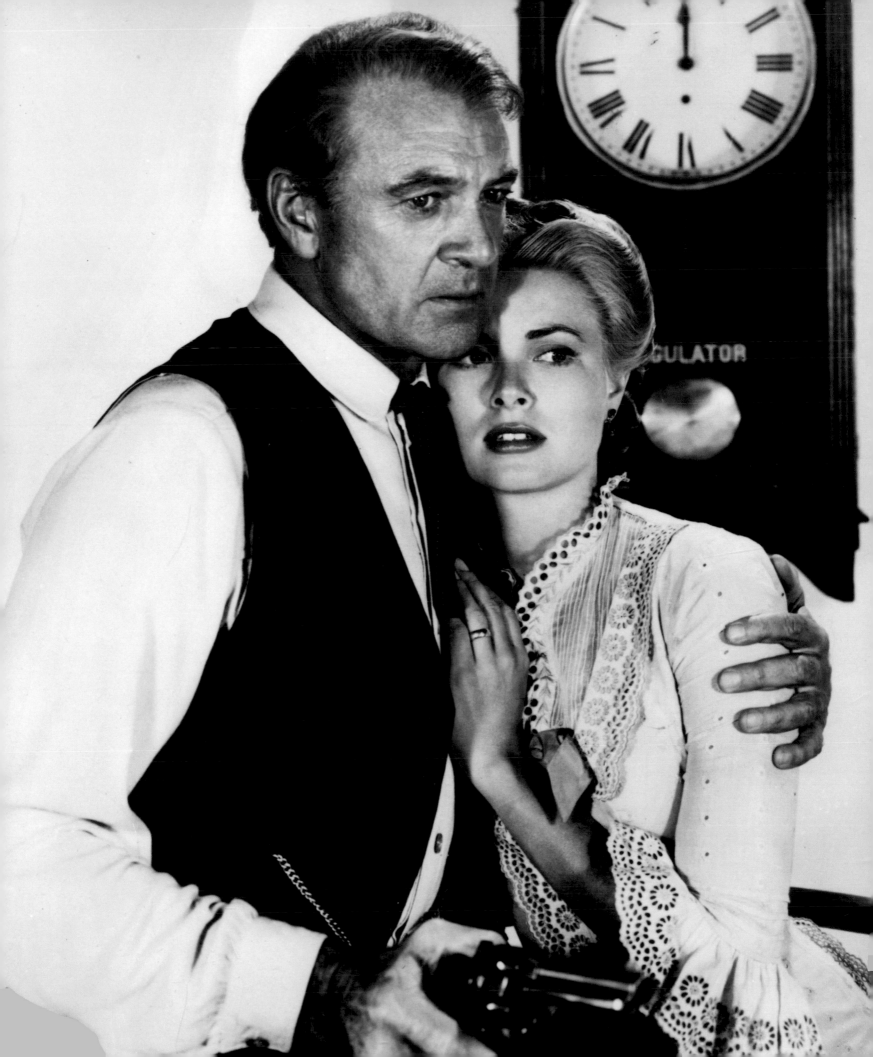

Grace Kelly, William Holden and Bing Crosby, *The Country Girl* (George Seaton), 1954.
Following pages: Grace Kelly and Ava Gardner, *Mogambo* (John Ford), 1953.
Bud Fraker, Grace Kelly and William Holden, *The Bridges at Toko-Ri* (Mark Robson), 1955.

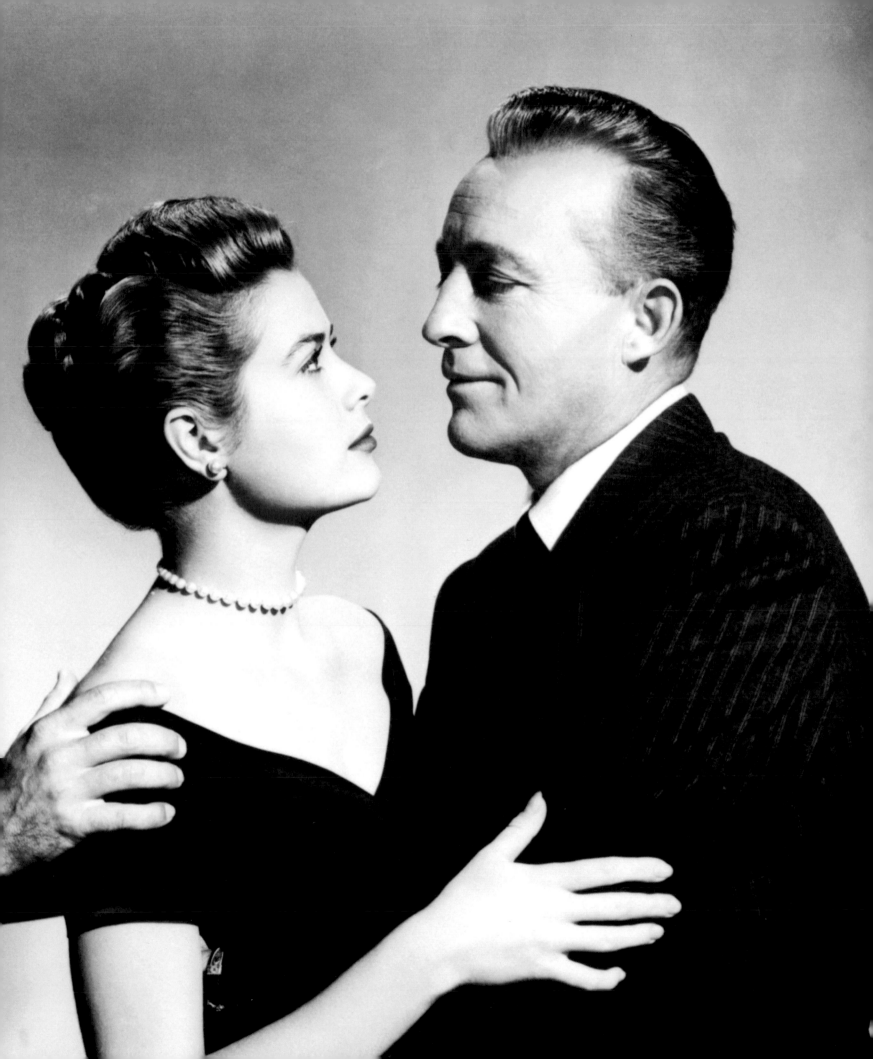

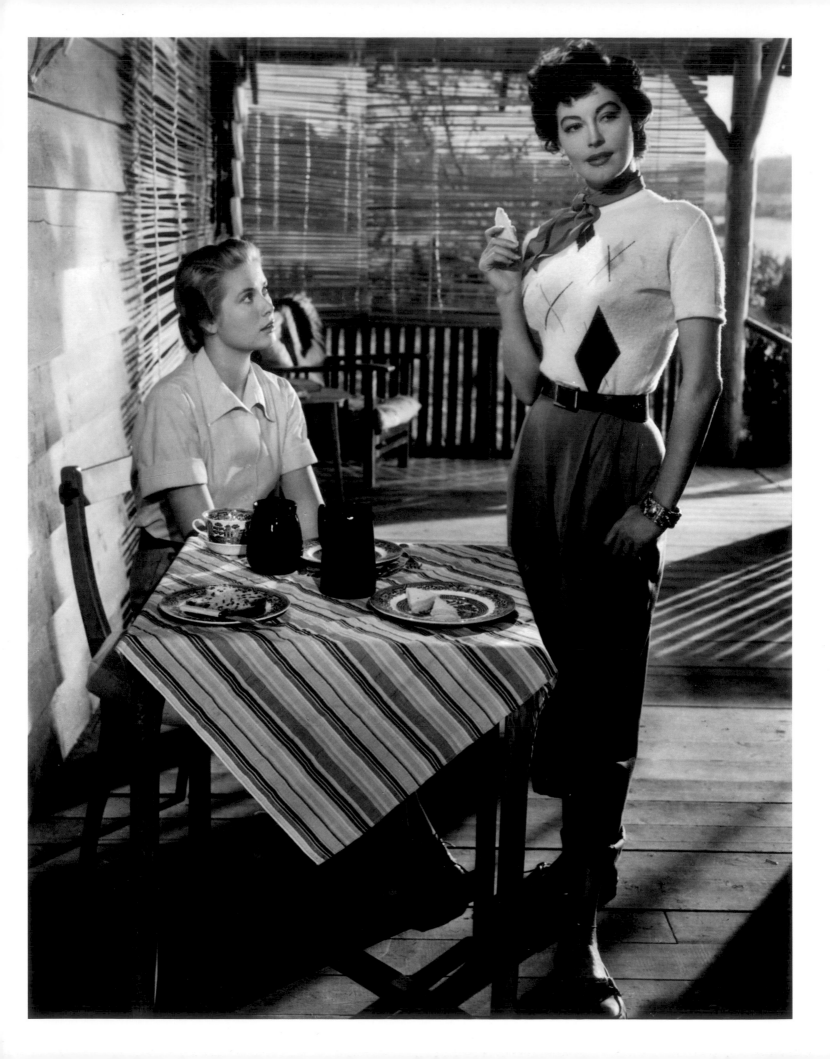

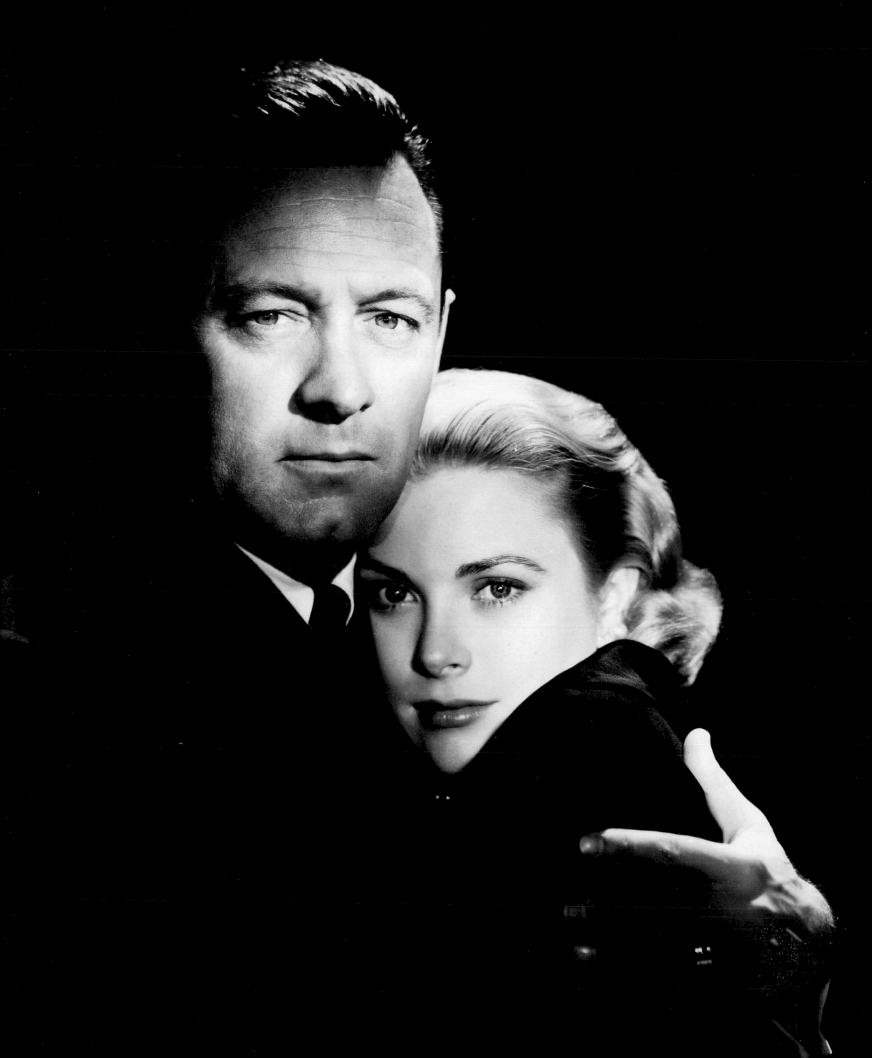

MAKEUP DEPT.
PROD. NO. 1684 DATE 9-15-55
TITLE
NAME GRACE KELLY
CHARACTER ALEXANDRIA
HDRS NO #1

MKP NO
BASE
LIPS

MAKEUP DEPT.

PROD. NO. 1684 DATE 9-16-55
TITLE

NAME GRACE KELLY

CHARACTER ALEXAND R 39

HDRS NO #7

MKP NO
BASE
LIPS

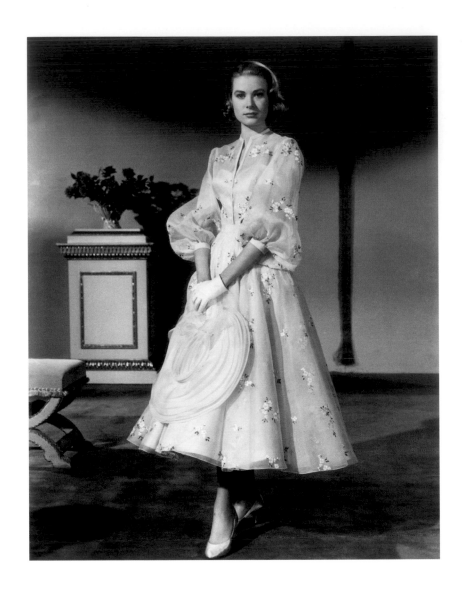

Eric Carpenter, Grace Kelly, *High Society* (Charles Walters), 1956.
Previous pages: In make-up for *The Swan* (Charles Vidor), September 15–16, 1955. *(Prince's Palace Archives. Monaco)*
Facing page: **Françoise Huguier**, Wedding dress worn by Grace Kelly, *High Society* (Charles Walters), 1956. *(Loan: Prince's Palace. Monaco)*
Following pages: **Eric Carpenter**, Frank Sinatra and Grace Kelly, *High Society* (Charles Walters), 1956.
Françoise Huguier, Engagement outfit, *High Society* (Charles Walters), 1956. *(Loan: Prince's Palace. Monaco)*
High Society was Grace Kelly's last film for MGM. Breaking with its usual custom, the studio gave the dress to the future Princess of Monaco as part of the deal that
included the right to film the wedding ceremonies.

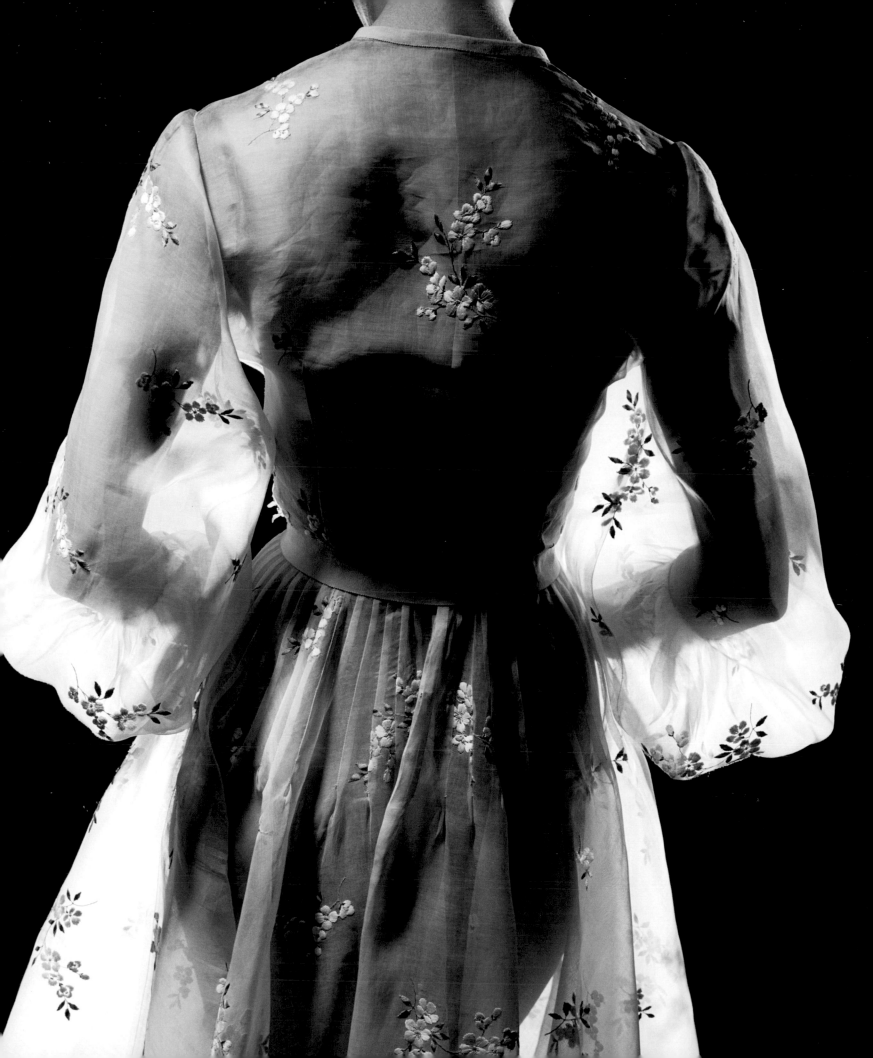

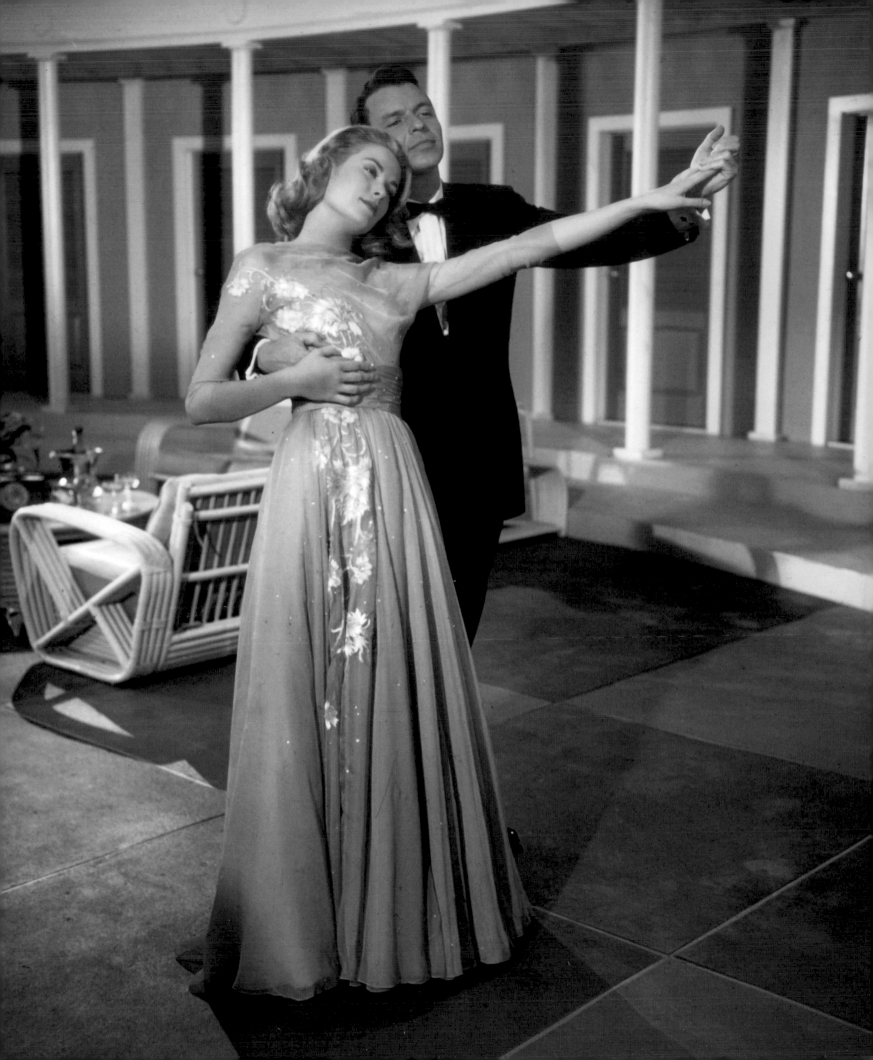

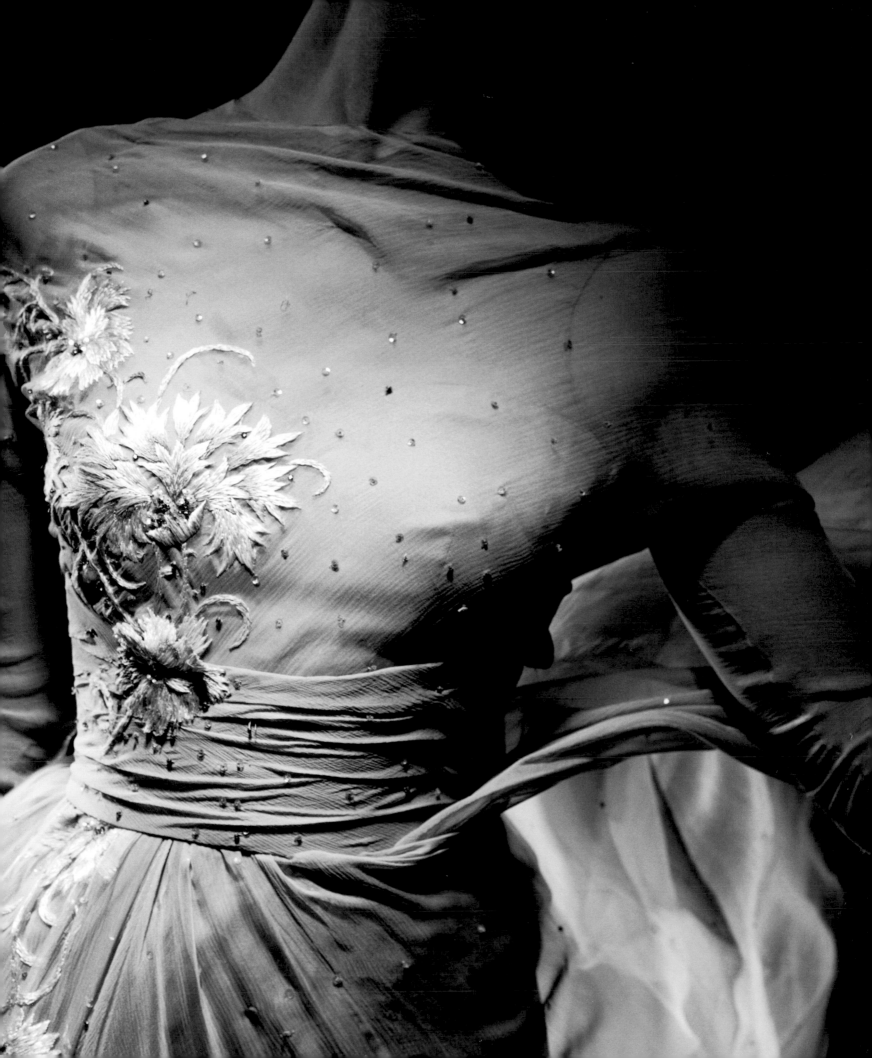

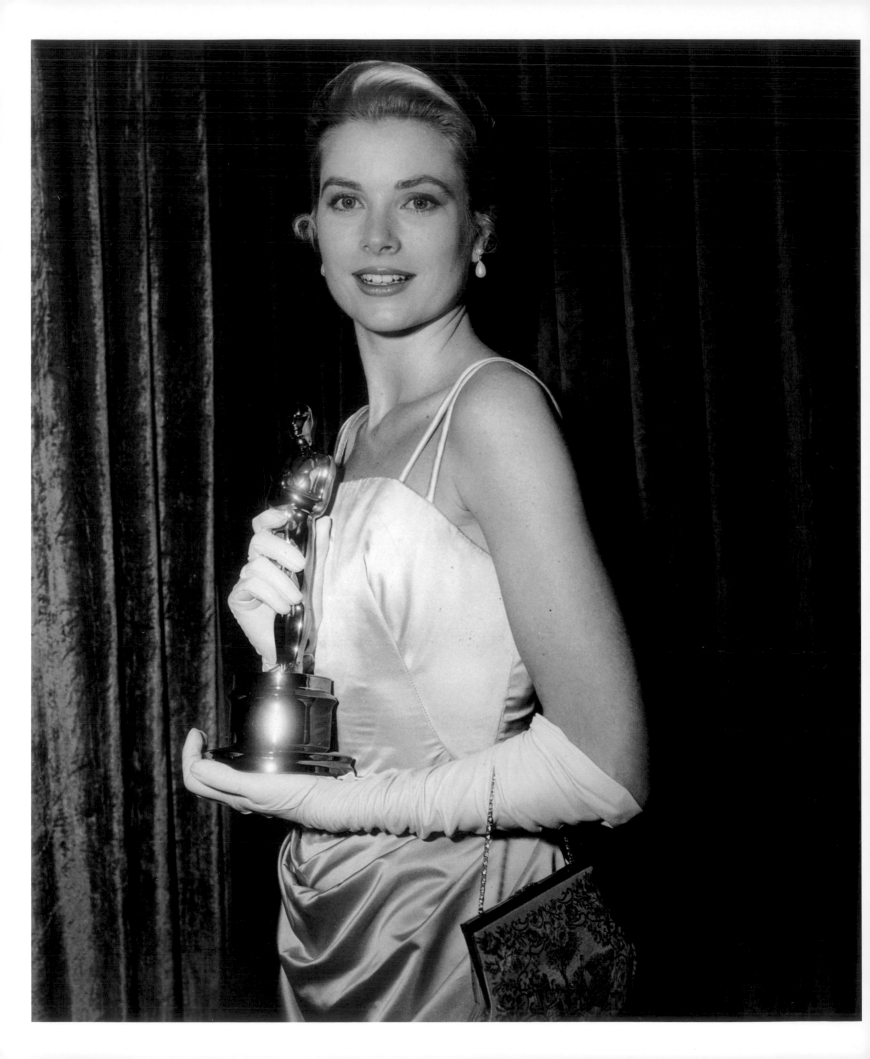

"Although I've played a wide variety of roles, I've never had the chance to act in a story written specially for me. It's a pity as they are the only stories that really let you reveal your personality."

Grace Kelly at the Oscars in the year she won the Best Actress Award for her role in *The Country Girl* (George Seaton), March 25, 1955.

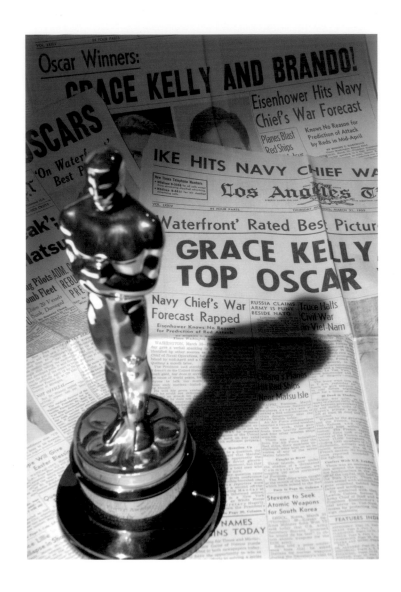

Sebastian Rosenberg, Press cuttings for March 31, 1955, and Oscar. *(Loan: Prince's Palace and Prince's Palace Archives. Monaco)*
Facing page: **Françoise Huguier**, Dress worn by Grace Kelly at the Oscars ceremony, March 25, 1955. *(Loan: Prince's Palace. Monaco)*

"I hated Hollywood. It's a town without pity. Only success counts. I know of no other place in the world where so many people suffer from nervous breakdowns, where there are so many alcoholics, neurotics and so much unhappiness."

Apger Virgil, Portrait of Grace Kelly, c. 1954.

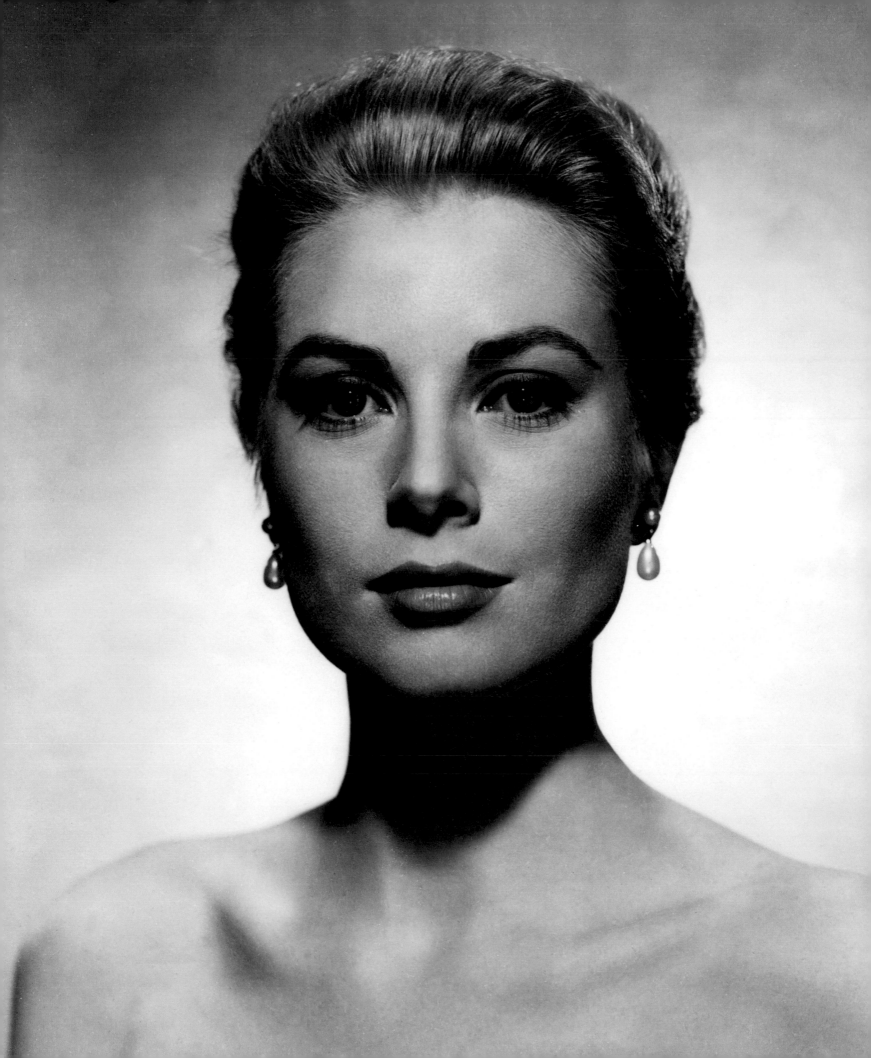

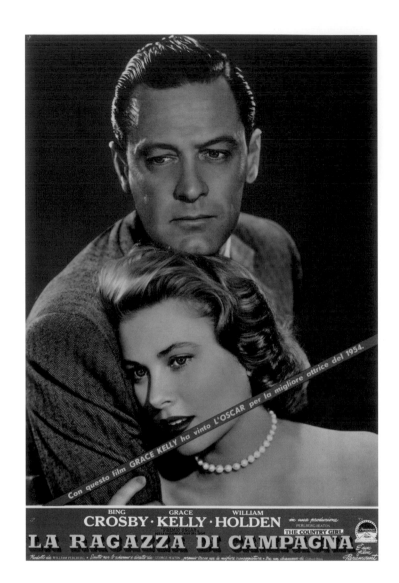

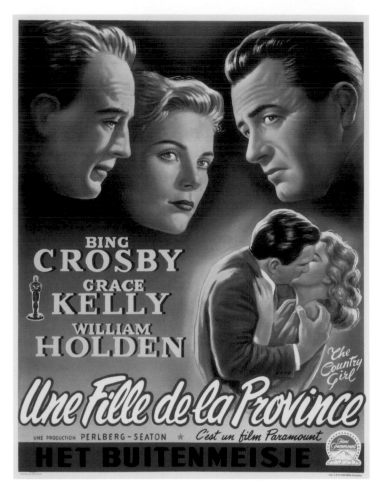

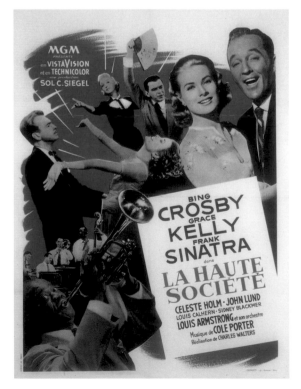

From left to right, top to bottom: **Anonymous**, Italian poster for *The Country Girl* (George Seaton), 1954.
Anonymous, Belgian poster for *The Country Girl* (George Seaton), 1954. — **Anonymous**, French poster for *High Society* (Charles Walters), 1956.
Facing page: **Anonymous**, Belgian poster for *High Noon* (Fred Zinnemann), 1952. — **Roger Soubier**, French poster for *The Swan* (Charles Vidor), 1956.
Roger Soubier, French poster for *Green Fire* (Andrew Marton), 1954. — **Anonymous**, Italian poster for *The Bridges at Toko-Ri* (Mark Robson), 1954.

(Audiovisual Archives of the Principality of Monaco – AAPM)

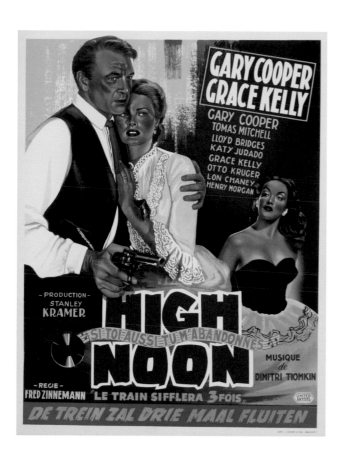

"Mr. Hitchcock taught me everything about cinema. It was thanks to him that I understood that murder scenes should be shot like love scenes and love scenes like murder scenes."

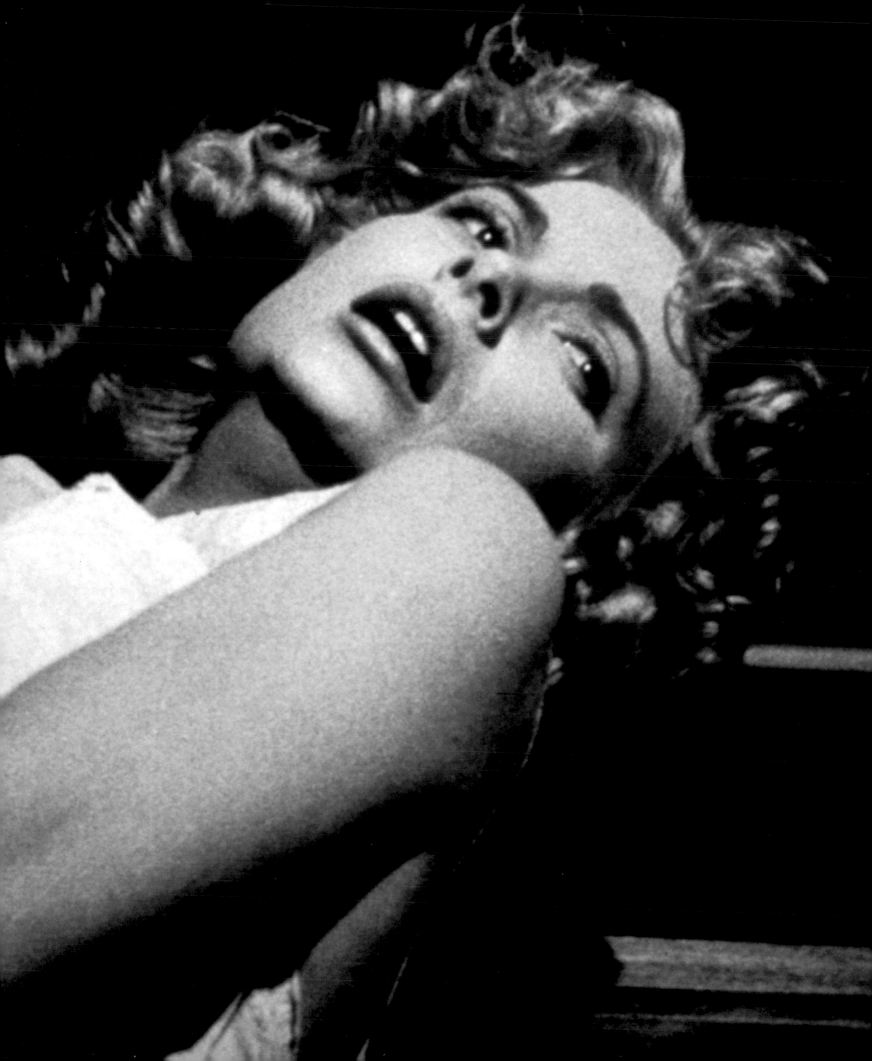

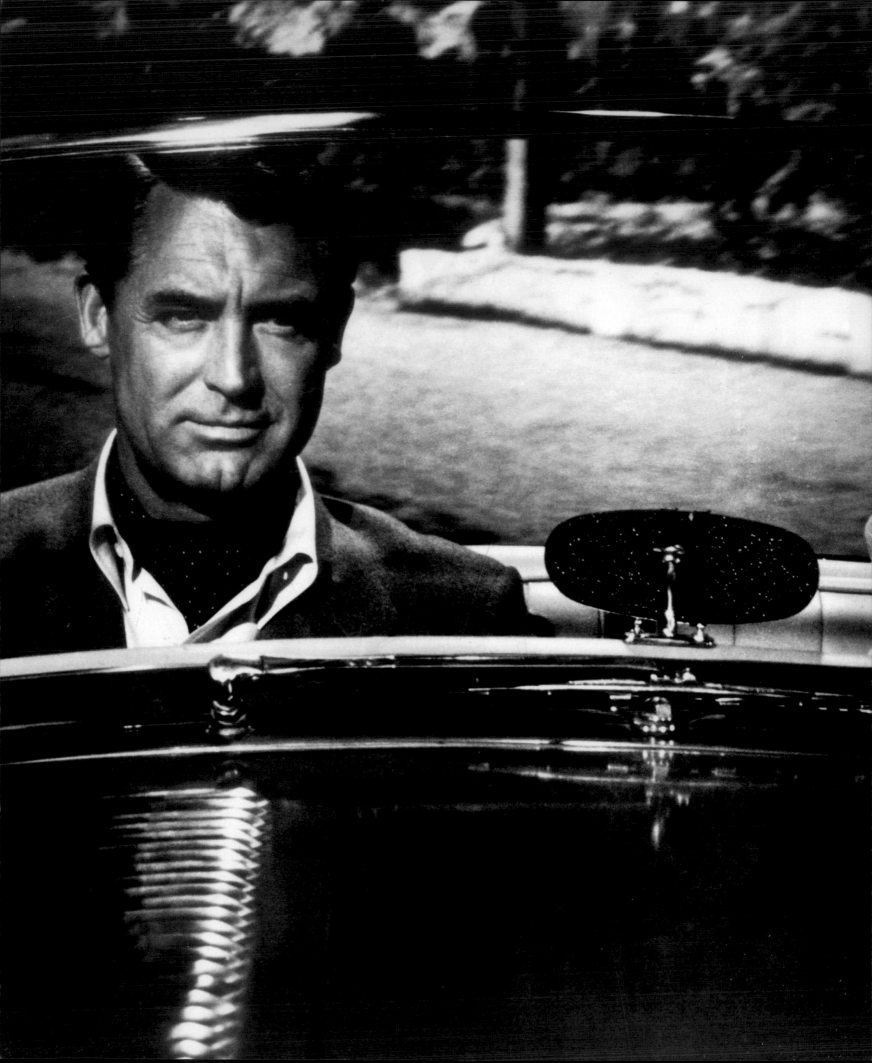

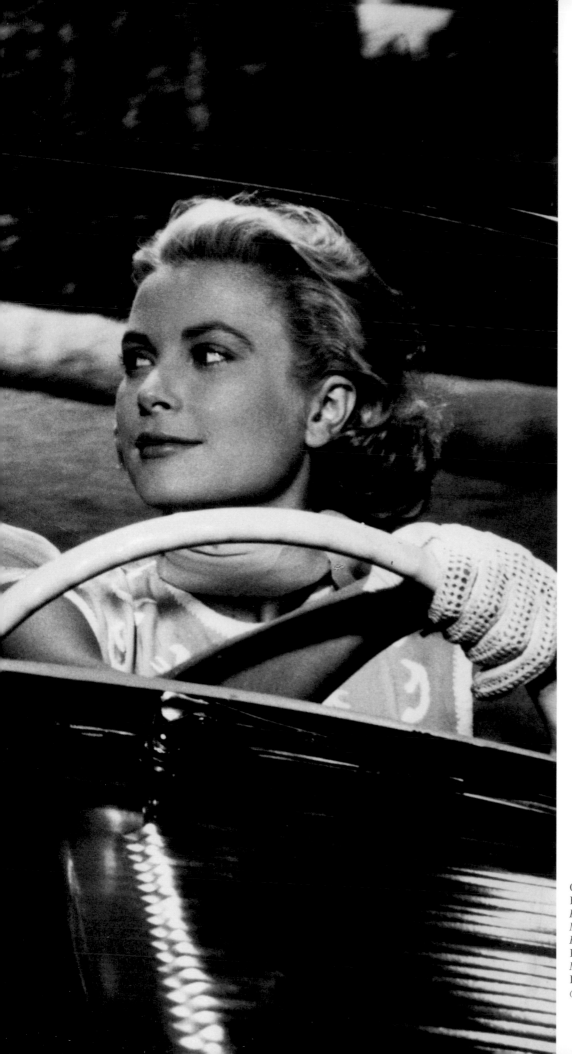

Grace Kelly and Cary Grant, *To Catch a Thief* (Alfred Hitchcock), 1955.
Previous pages: **Sanford Roth**, Grace Kelly, *Dial M for Murder* (Alfred Hitchcock), 1954.
Following pages: **Jean-Jacques L'Héritier**, Letter from Alfred Hitchcock to Grace Kelly about the *Marnie* project. — Letter from Grace Kelly to Alfred Hitchcock about the film project *Marnie*, June 18, 1962.
(Prince's Palace Archives. Monaco)

ALFRED HITCHCOCK

Dear Grace,

Yes it was sad, wasn't it. I was looking forward so much to the fun and pleasure of our doing a picture again.

Without a doubt, I think you made, not only the best decision, but the only one.

After all, it was 'only a movie!'

Alma joins me in sending our most fond and affectionate thoughts for you.

Hitch

P.S Enclosed is a recording I have made for R. To be played privately. H.

June 18th 1962

Dear Hitch,

It was heartbreaking for me to have to leave the picture.. I was so excited about doing it and particularly about working with you again...

When we meet I would like to explain to you myself all of the reasons which is difficult to do by letter or through a third party... It is unfortunate that it had to happen this way and I am deeply sorry. Thank you dear Hitch for being so understanding and helpful I hate disappointing youI also hate the fact that there are probably many other "cattle " who could play the part equally as well Despute that I hope to remain one of your "sacred cows"

with deep affection

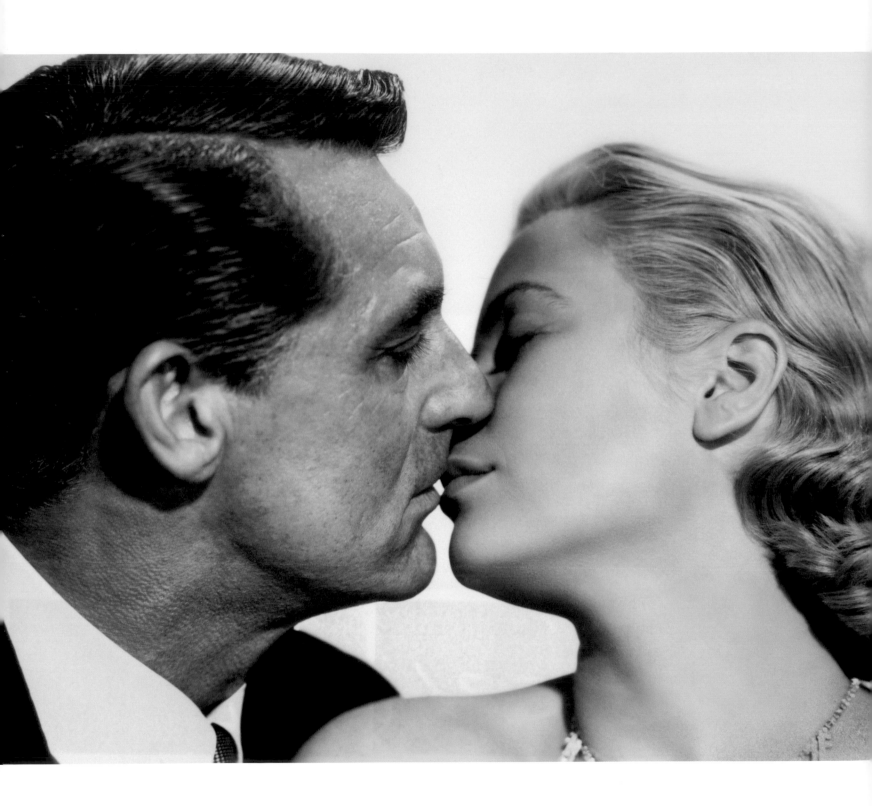

Grace Kelly and Cary Grant, *To Catch a Thief* (Alfred Hitchcock), 1955.

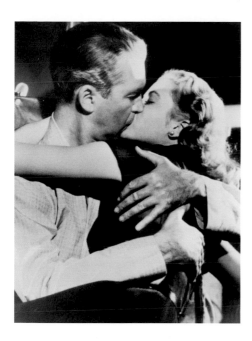

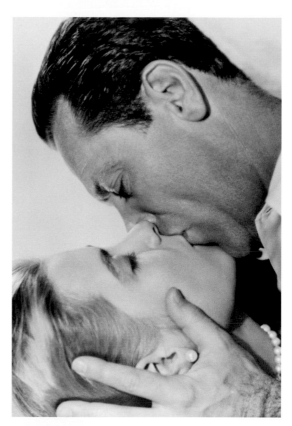

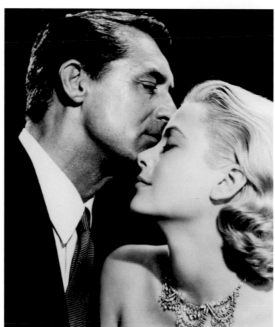

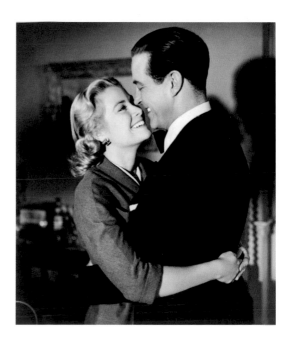

From left to right, top to bottom: Grace Kelly and James Stewart, *Rear Window* (Alfred Hitchcock), 1954.
Grace Kelly and William Holden, *The Bridges at Toko-Ri* (Mark Robson), 1954.
Bud Fraker, Grace Kelly and Cary Grant, *To Catch a Thief* (Alfred Hitchcock), 1955.
Grace Kelly and Ray Milland, *Dial M for Murder* (Alfred Hitchcock), 1954.

Grace Kelly and Cary Grant, *To Catch a Thief* (Alfred Hitchcock), 1955.
It was during the shooting of *To Catch a Thief* on the Côte d'Azur in spring 1954 that Grace Kelly first discovered the Principality of Monaco.

"He came back to me after using some fairly crude words to direct my colleague and he was curious to know whether I had heard them. 'Are you shocked at what I just said Miss Kelly?' I answered him: 'Not at all, I went to boarding school Mr. Hitchcock. I had already heard that sort of thing at the age of thirteen.' I felt that he appreciated my response. He was a man who turned slightly red when he was upset."

Robert Hunt, Alfred Hitchcock welcoming Grace Kelly to Cannes for the shooting of *To Catch a Thief* (Alfred Hitchcock), 1954.

114

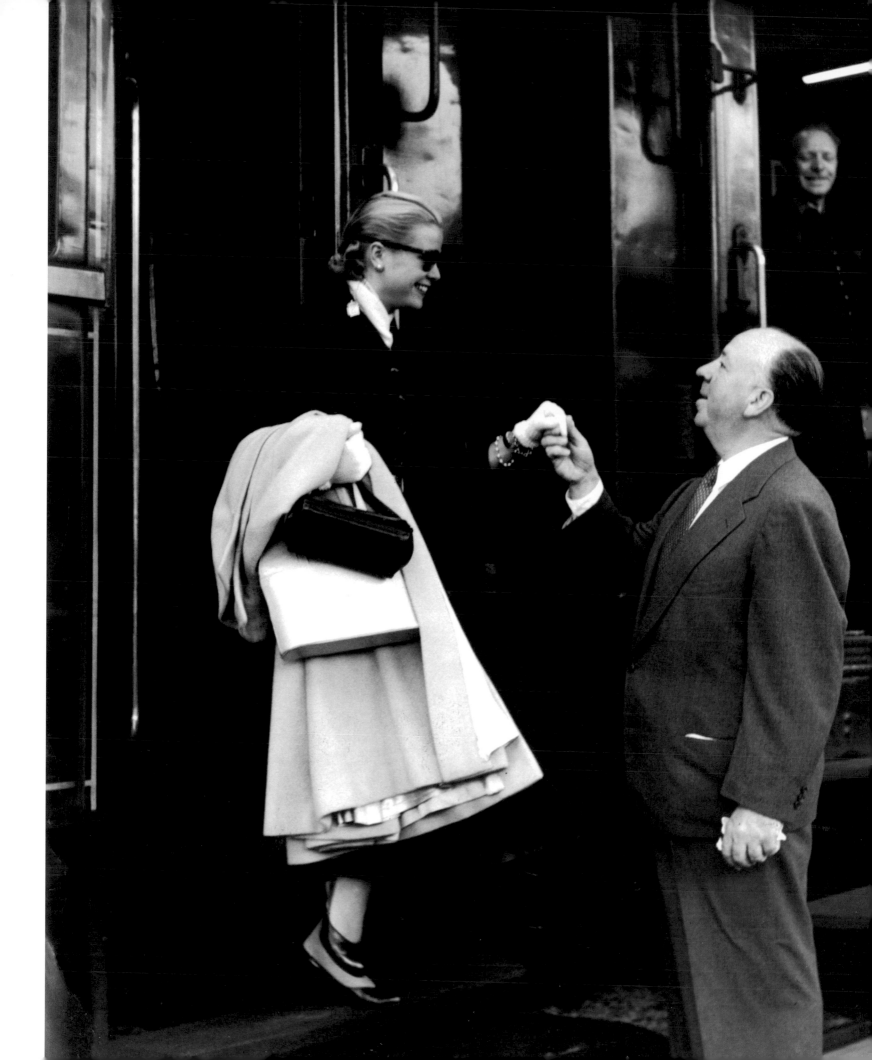

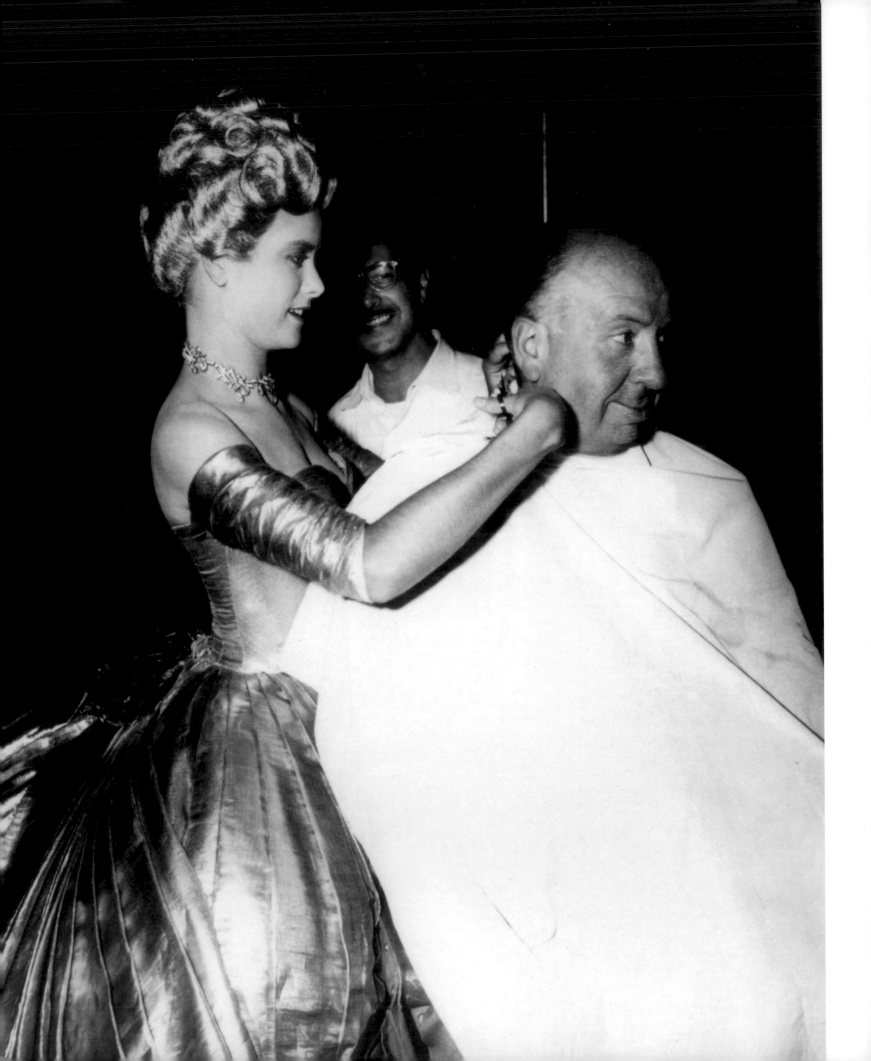

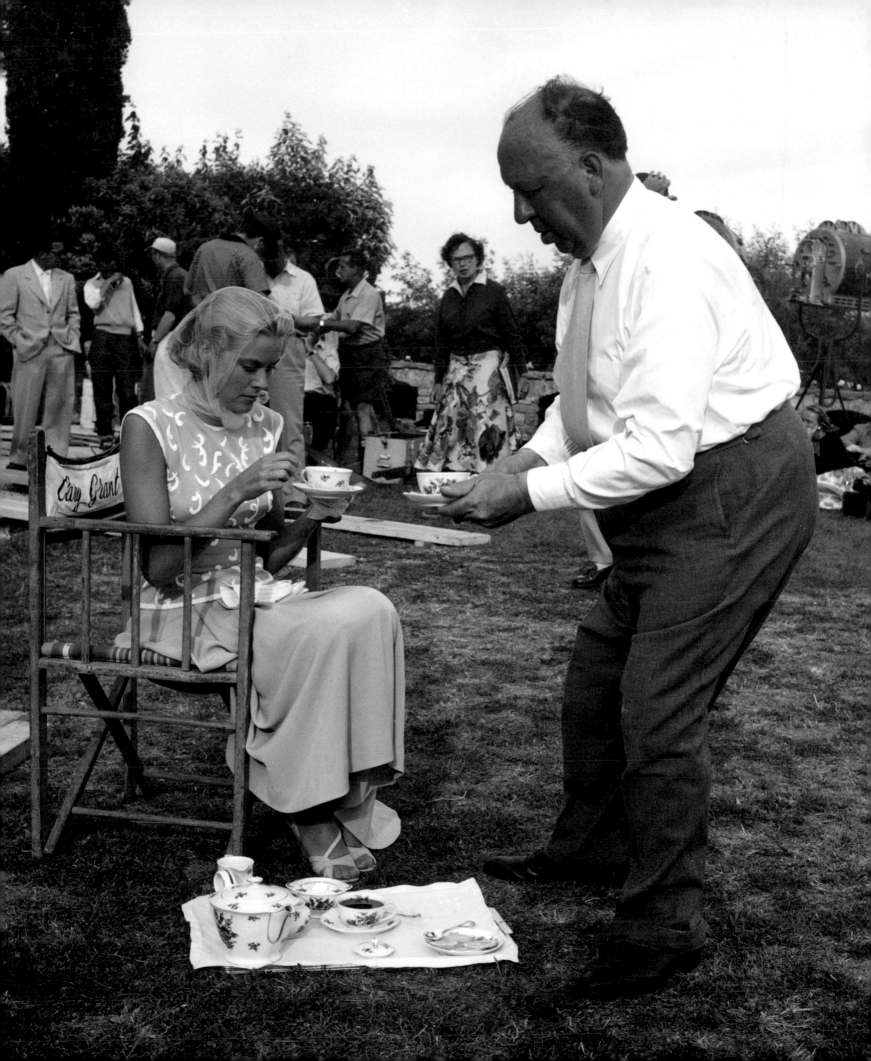

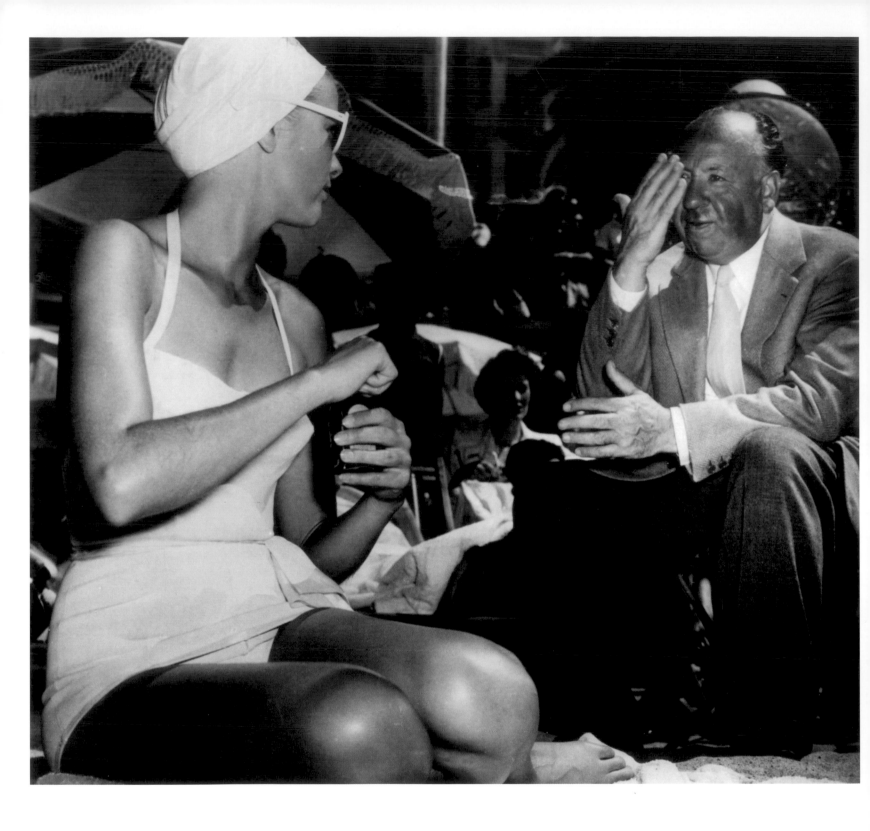

Grace Kelly and Alfred Hitchcock on the set of *To Catch a Thief* (Alfred Hitchcock), Cannes, 1954.
Previous pages: Grace Kelly and Alfred Hitchcock on the set of *To Catch a Thief* (Alfred Hitchcock), Cannes, 1954. — **Edward Quinn**, Grace Kelly and Alfred Hitchcock on the set of *To Catch a Thief* (Alfred Hitchcock), Cannes, 1954.

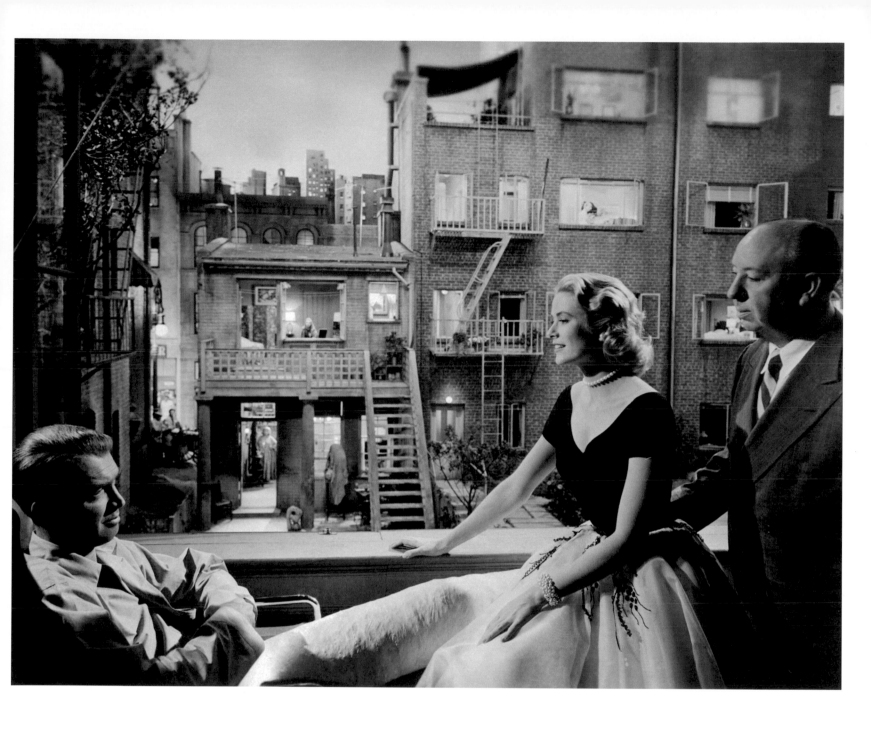

James Stewart, Grace Kelly and Alfred Hitchcock pose for a commercial poster *Rear Window* (Alfred Hitchcock), 1954.
Following pages: **Sebastian Rosenberg**, Advertising material: the set of *Rear Window* (Alfred Hitchcock). *(Prince's Palace Archives. Monaco)*

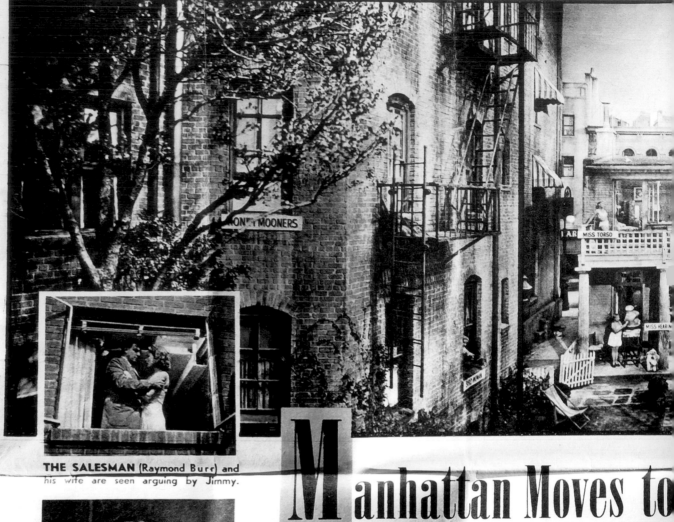

THE SALESMAN (Raymond Burr) and his wife are seen arguing by Jimmy.

MISS LONELY HEARTS, played by Judith Evelyn, looks sadly from her room.

Manhattan Moves to

Remarkably realistic set, one of the largest ever

constructed, provides Hitchcock with a genuine Greenwich

Village locale for his latest thriller, "Rear Window"

IF YOU were to take a New Yorker, blindfold him and place him on Paramount Studio's largest sound stage, he'd find it hard to believe that he wasn't really in Greenwich Village.

Months were spent in the erection of full scale buildings, using real brick and mortar, in order to capture the Village atmosphere. And why not? Alfred Hitchcock, famed for his realism and attention to detail, sent cameramen to New York for the express purpose of photographing hundreds of Greenwich Village apartments. His aim for authenticity has been

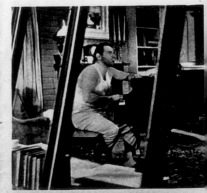

MISS HEARING AID, so dubbed by the convalescent, is a sculptress of note.

MISS TORSO flexes her muscles. She's a dancer played by Georgine Darcy.

THE COMPOSER runs through a tune on piano. Ross Bagdasarian has the role.

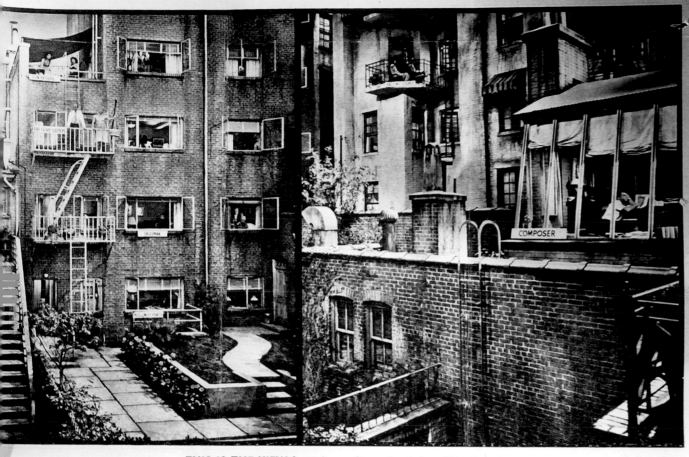

THIS IS THE VIEW from Jimmy Stewart's window. Titles have been given tenants by Jimmy from what he's able to observe of their manner and conversation. His imagination fills in the rest.

ollywood

t the expense of the largest in-
Hollywood history.

Stewart plays a magazine pho-
confined to his room because of
leg. Jimmy whiles away the
urs of convalescence by trying
e the lives his neighbors lead.
committed across the court-
Jimmy, despite his immobility,
with the solution.

cture is scheduled for release
ork in the Fall. According to
otices, "Rear Window" is Hitch-
very best. Need more be said?

UNBATHER exposes her body
of the sun atop apartment roof.

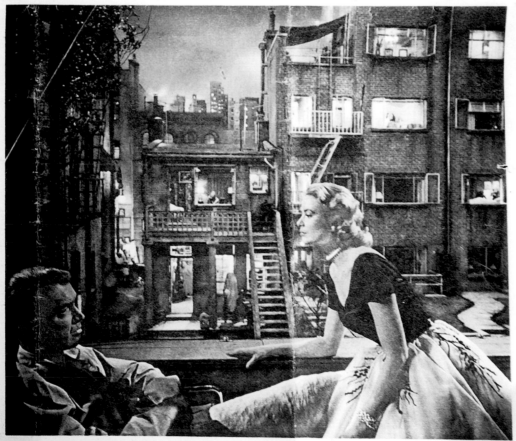

HIS LEG IN A CAST. Jimmy is visited by a Park Ave. beauty (Grace Kelly) in love with him.
Jimmy has trouble convincing her and detective (Wendell Corey) his murder solution is sound.

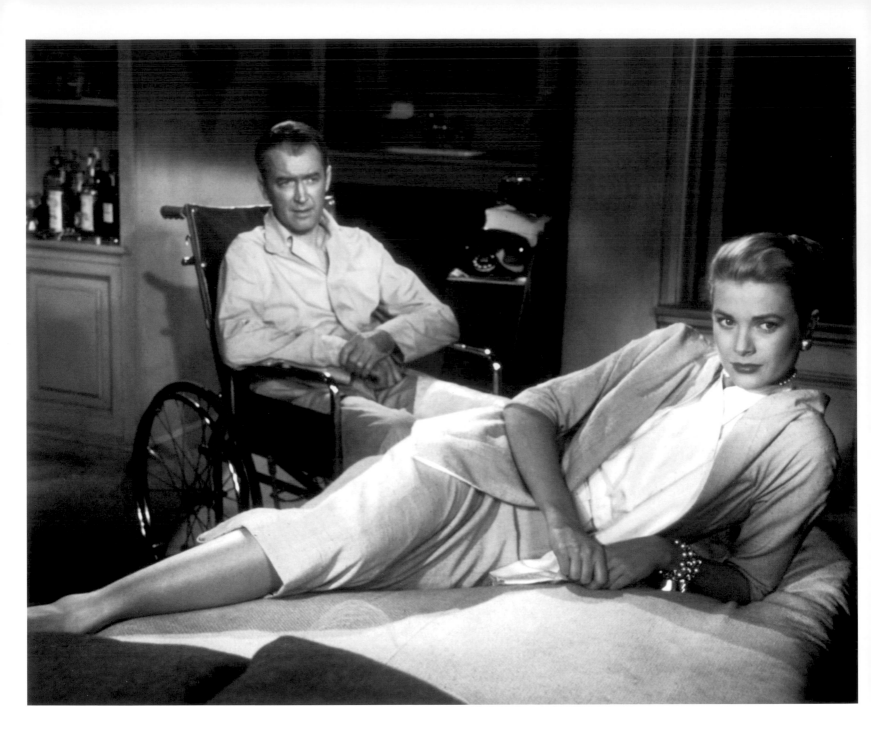

Grace Kelly and James Stewart, *Rear Window* (Alfred Hitchcock), 1954.

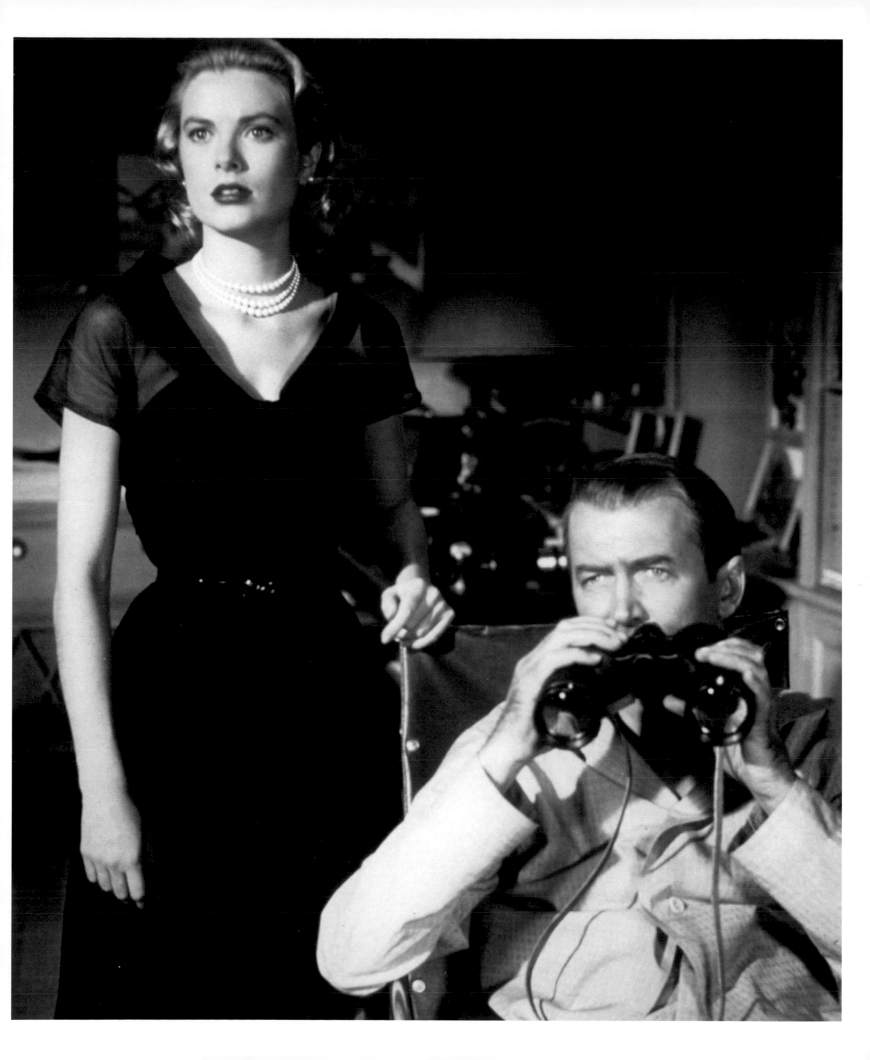

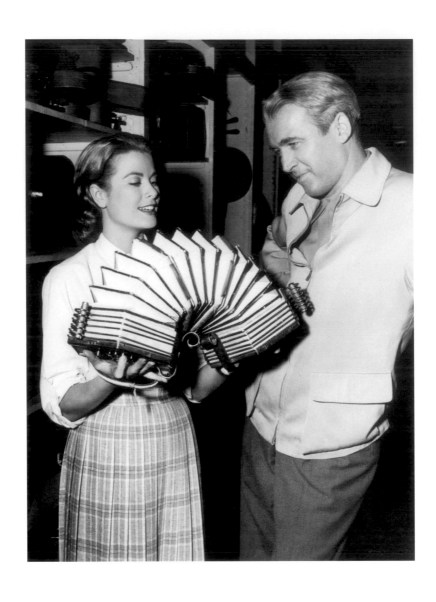

Grace Kelly and James Stewart on the set of *Rear Window* (Alfred Hitchcock), 1954.
Facing page: Grace Kelly, c. 1954.
Following pages: Studio publicity shot: *To Catch a Thief* (Alfred Hitchcock), 1954. – Studio, c. 1954

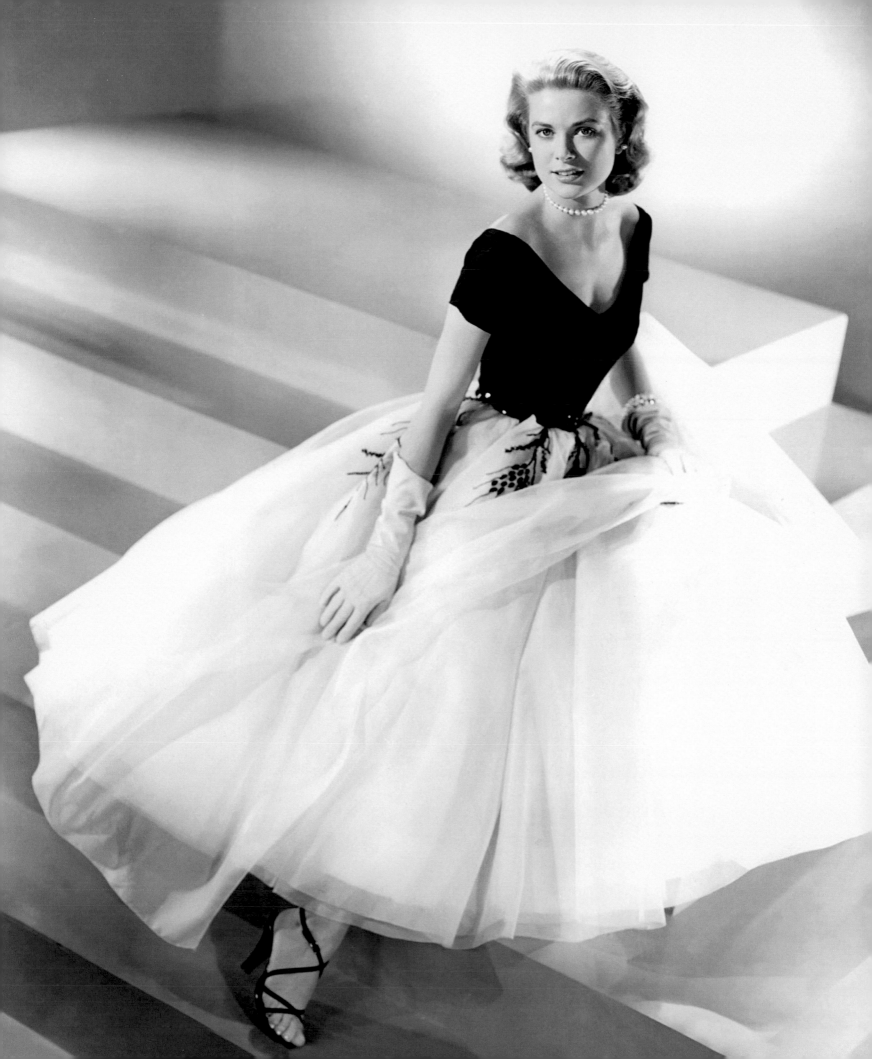

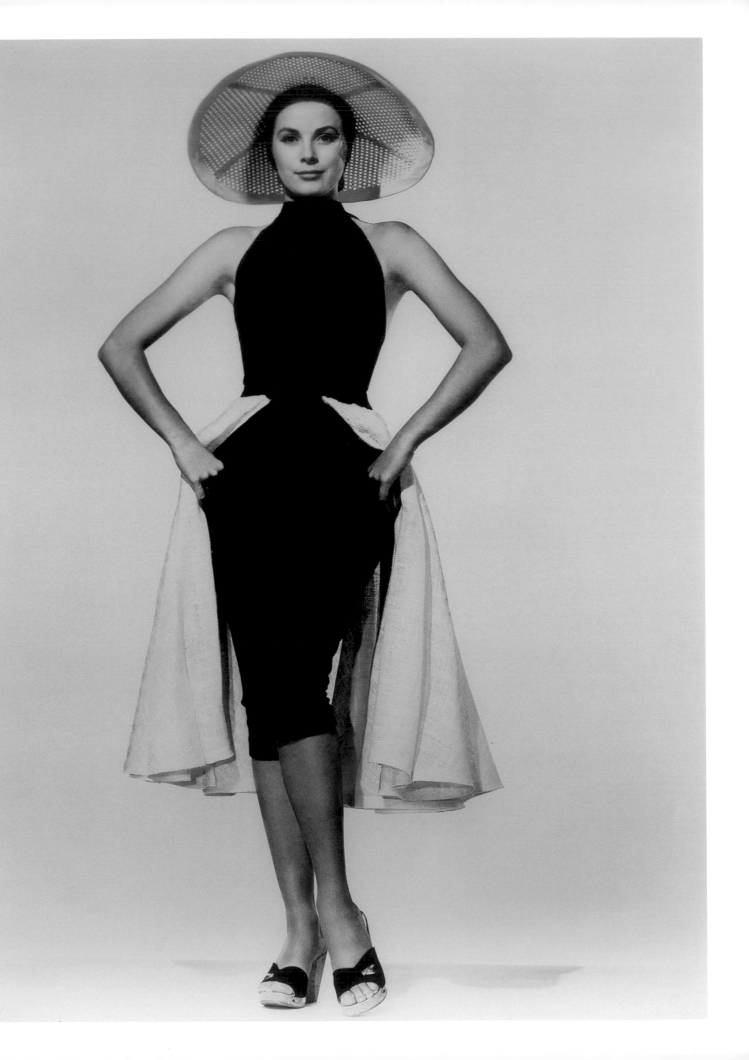

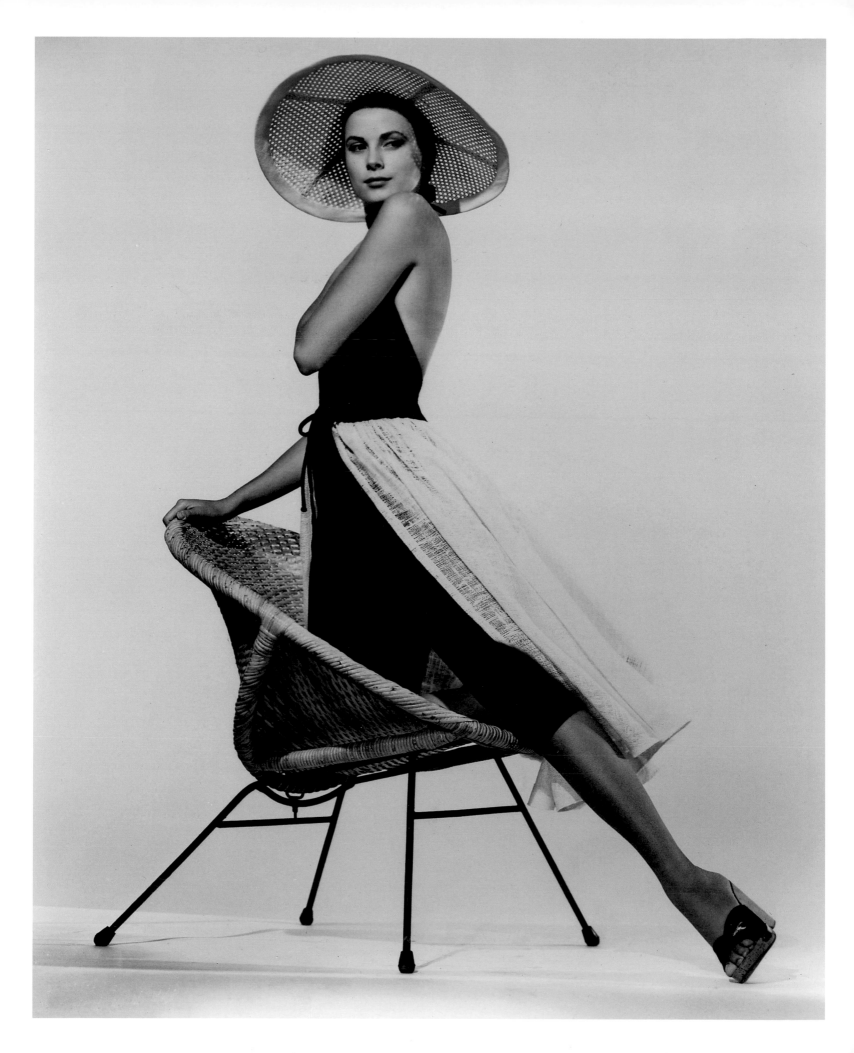

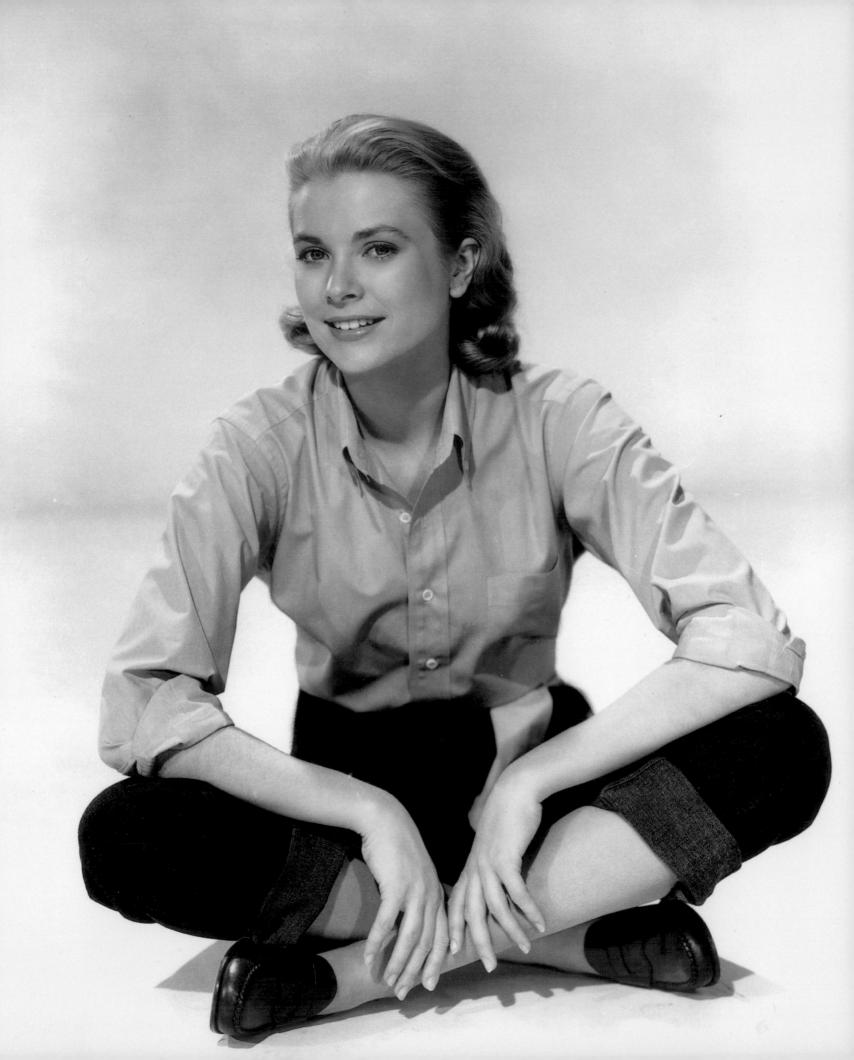

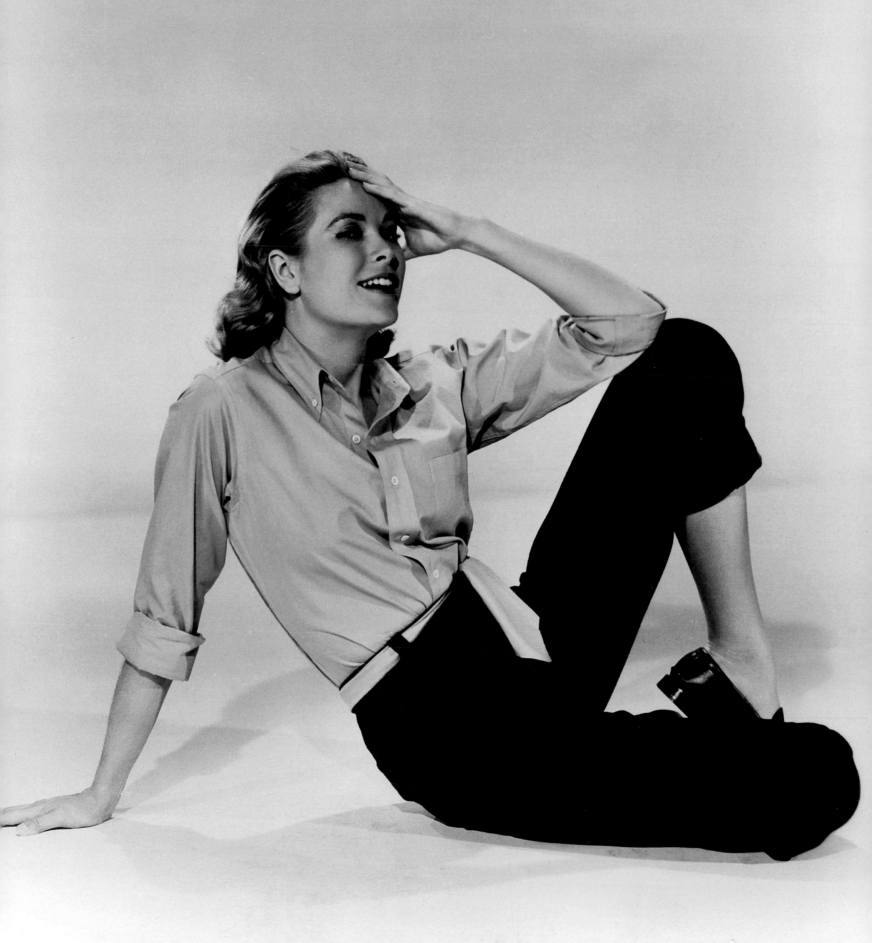

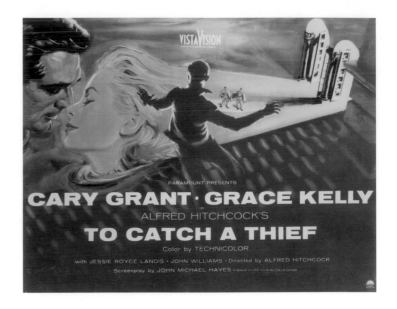

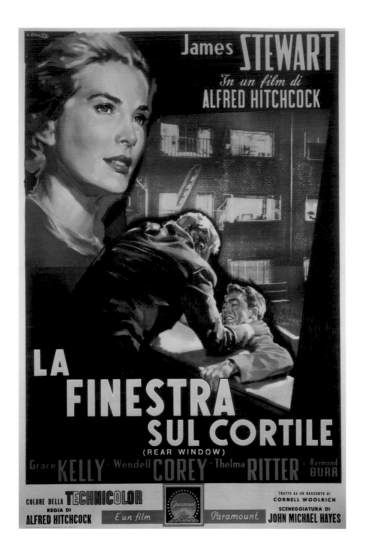

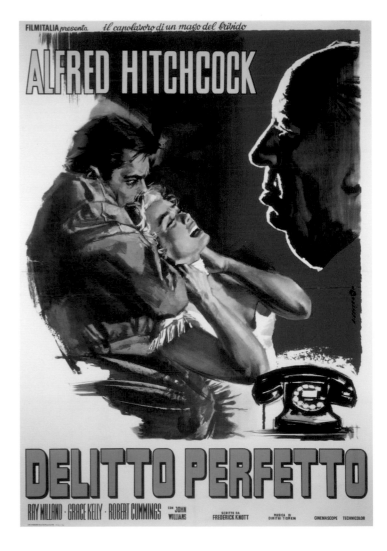

From left to right, top to bottom: **Averardo Ciriello**, Italian poster for *Rear Window* (Alfred Hitchcock), 1954.
Anonymous, American poster for *To Catch a Thief* (Alfred Hitchcock), 1955. — **Angelo Cesselon**, Italian poster for *Dial M for Murder* (Alfred Hitchcock), 1954.
Facing page: **Anonymous**, Japanese poster for *To Catch a Thief* (Alfred Hitchcock), 1955. — **Anonymous**, Belgian poster for *To Catch a Thief* (Alfred Hitchcock), 1955.
Anonymous, American poster for *To Catch a Thief* (Alfred Hitchcock), 1955.
(Audiovisual Archives of the Principality of Monaco — AAPM)

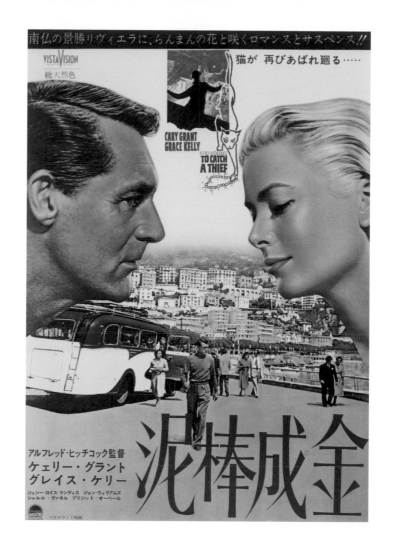

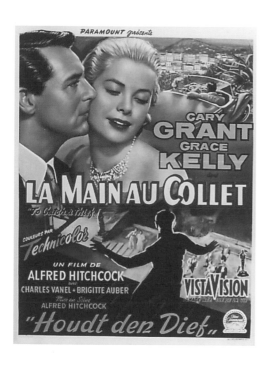

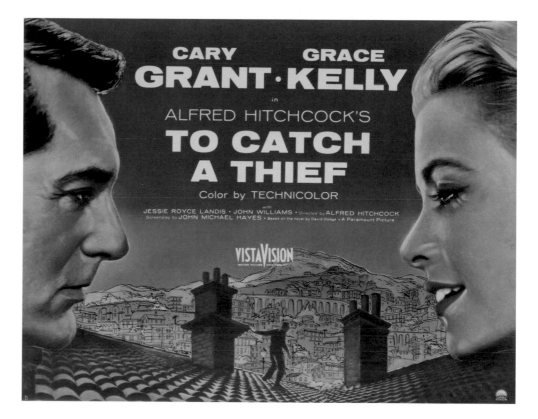

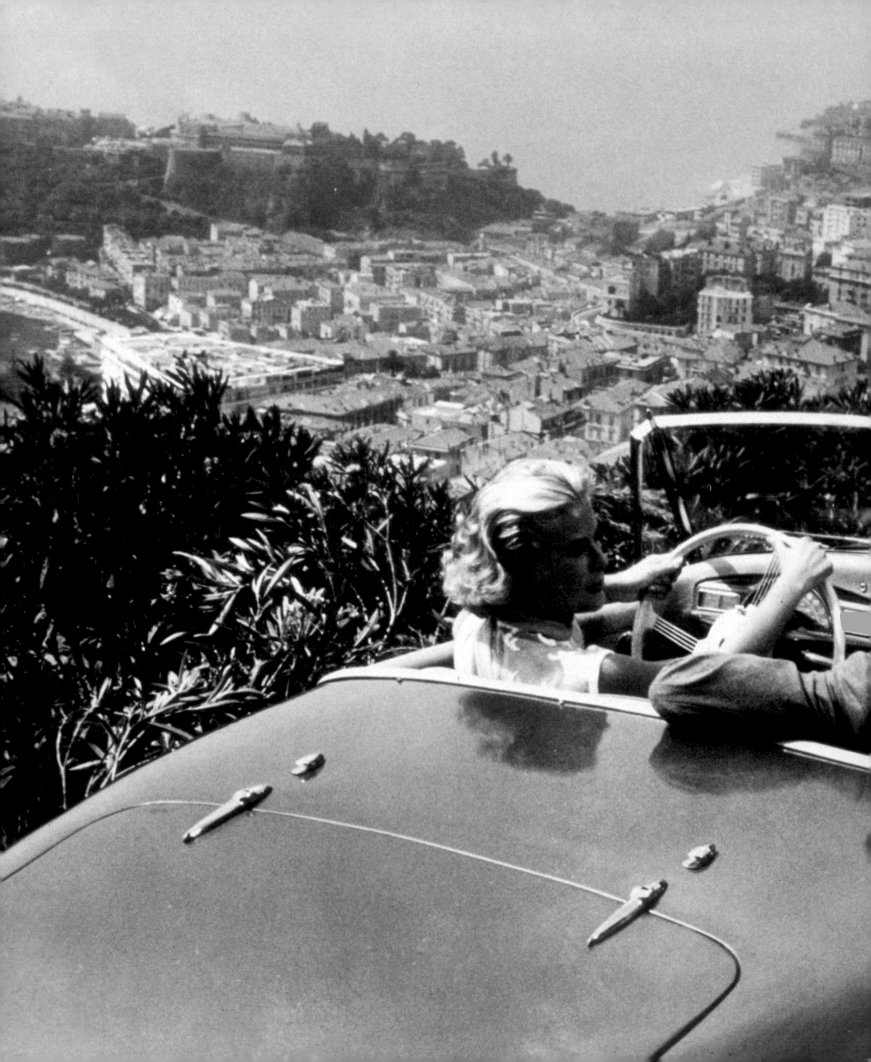

Jerry Ohlinger, Grace Kelly and Cary Grant in a scene from *To Catch a Thief* (Alfred Hitchcock), 1954.

Edward Quinn, Grace Kelly in the lobby of the Carlton Hotel, during the Cannes Film Festival, 1955.

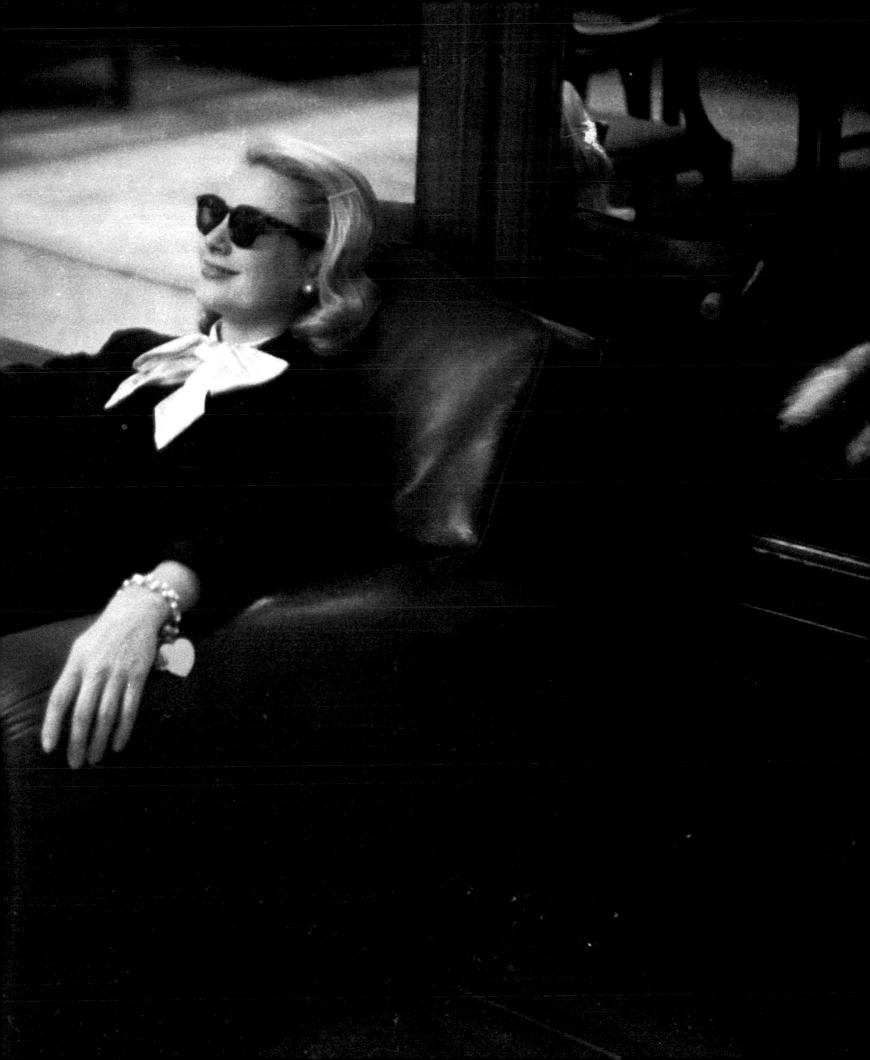

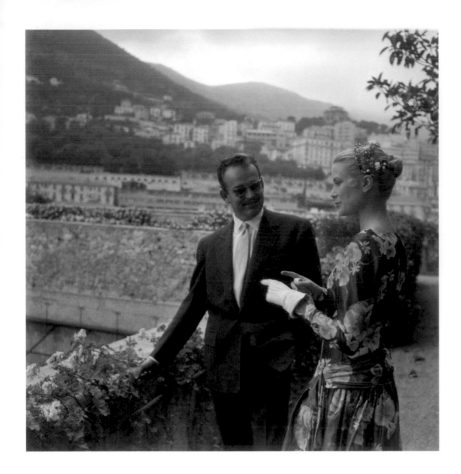

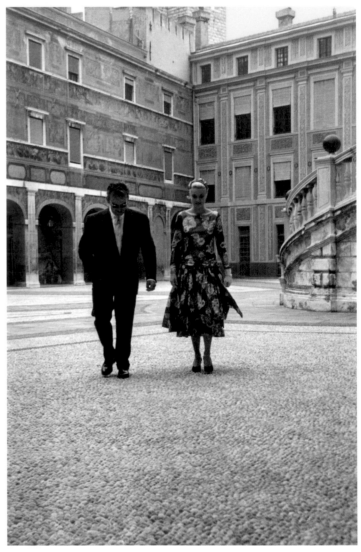

Michou Simon, Grace Kelly and Prince Rainier at their first meeting at the Palace of Monaco, May 1955.
Grace Kelly's visit to the Palace of Monaco was arranged by the great *Paris Match* reporter Pierre Galante (husband of Olivia de Havilland), with two of the magazine's
photographers on hand. Up to the last minute Grace Kelly, extremely busy with the Cannes Festival in full swing, was
in two minds whether to go or cancel; and Prince Rainier himself arrived late . . .

"I've been accused of being cold, snobbish, distant. Those who know me well know that I'm nothing of the sort. If anything, the opposite is true. But is it too much to ask to want to protect your private life, your inner feelings? Lots of things touch me and I don't want to be indiscreet."

"He is charming, a very charming man, indeed."

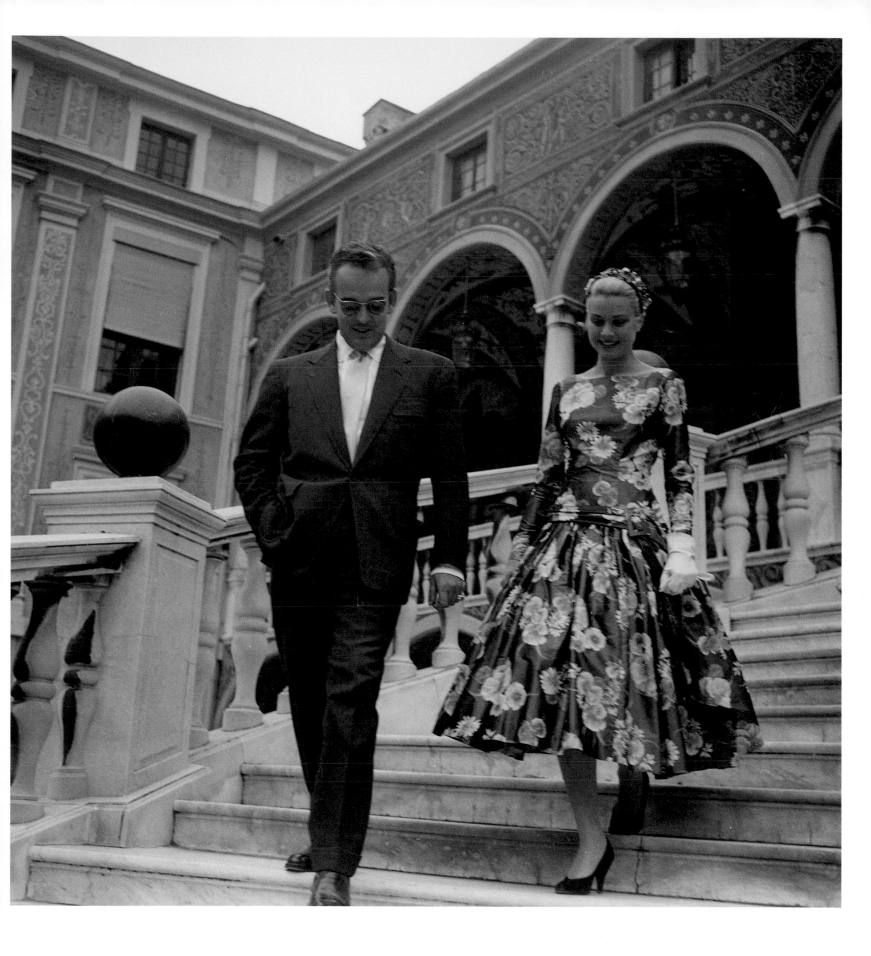

Edward Quinn, First visit to the Palace and first meeting with Prince Rainier, Monaco, May 1955.

My darling

This to tell in a very mild way how terribly much I love you. miss you need you, and want you near me always Safe trip my love. Rest relax and think of me turning myself out with this terrible longing of you, for you! I love you so.

Prince Rainier's billet-doux to Grace Kelly, April 1956. *(Prince's Palace Archives. Monaco)*
Facing page: **Françoise Huguier**, US-designed taffeta dress worn at the first meeting, May 1955. *(Loan: Prince's Palace. Monaco)*

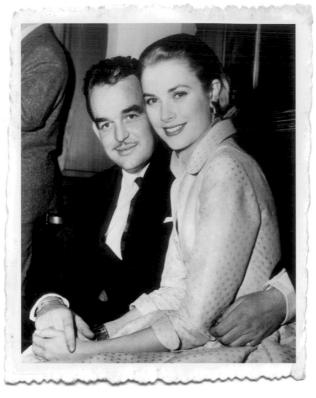

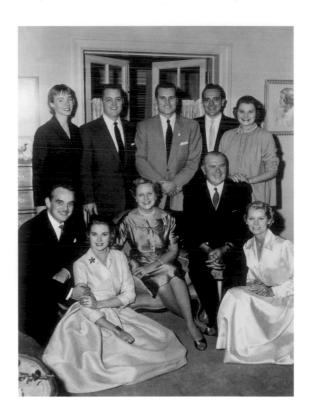

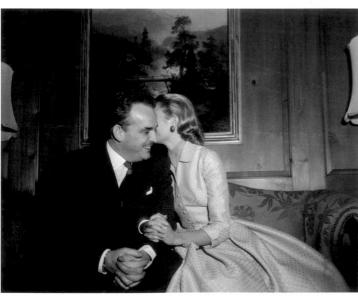

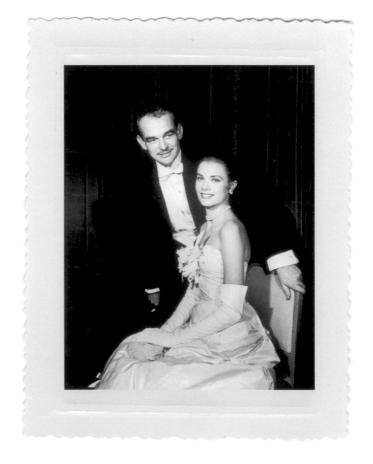

From left to right, top to bottom: Prince Rainier and Grace Kelly officially announce their engagement, New York, January 5, 1956.
Grace Kelly and Prince Rainier with the Kelly family, Philadelphia, January 7, 1956.
Grace Kelly and her future husband Prince Rainier in Philadelphia, January 5, 1956.
Elliott Erwitt, The couple celebrate their engagement at the Waldorf-Astoria Hotel, New York, January 6, 1956.
Facing page: Prince Rainier and Grace Kelly dancing after the announcement of their engagement, New York, January 6, 1956.

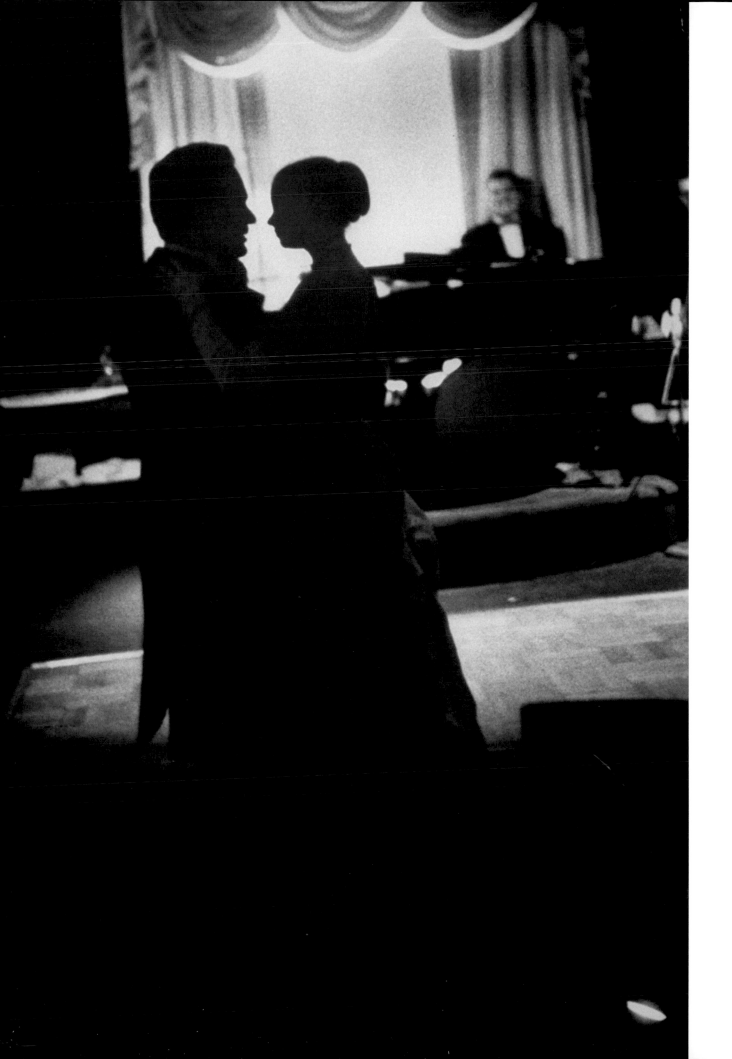

Howell Conant, An intimate moment for the engaged couple, New York, 1956.
Facing page: **Jean-Jacques L'Héritier**, Manuscript letter from "Mamou", Prince Rainier's mother, the Princess Charlotte, 1956. *(Prince's Palace Archives. Monaco)*

My-dear Grace —

Rainier made me feel very
happy by announcing me
his engagement to you.
Ever since you came to Monaco
I was hoping he would
marry you!

I am just longing to meet
you.

Please accept this small
gift in souvenir of this
very happy event.

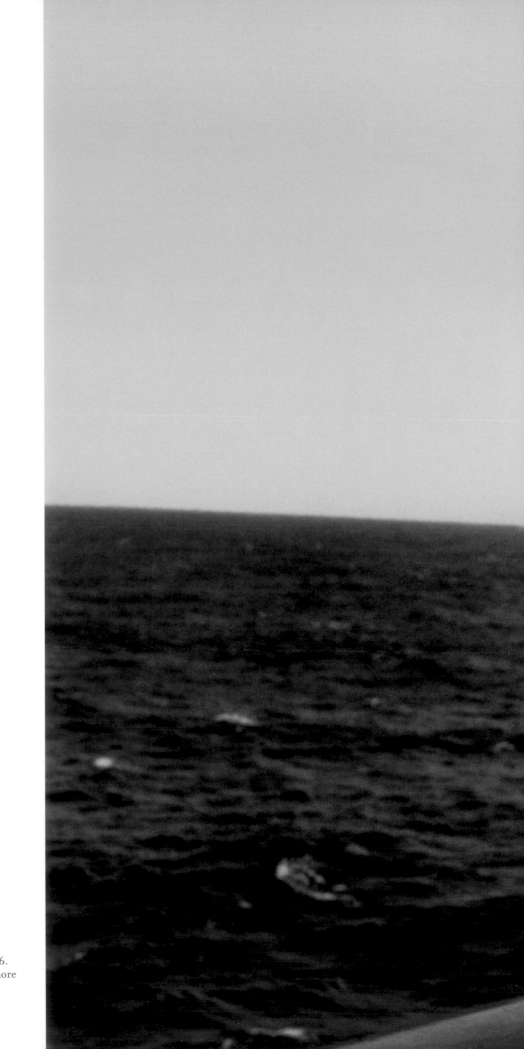

Grace Kelly watches the sea from the *SS Constitution*, April 12, 1956.
Grace Kelly was accompanied on the crossing by her family and more
than sixty friends – and followed by some thirty photographers.

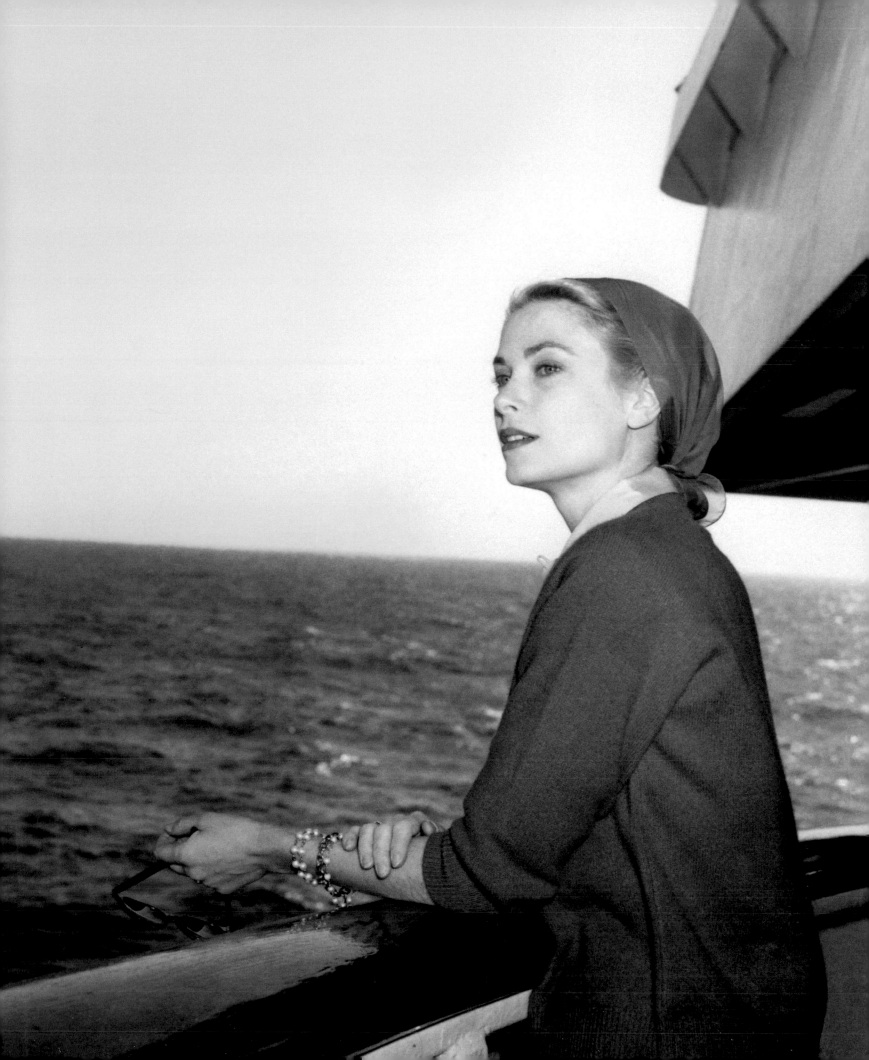

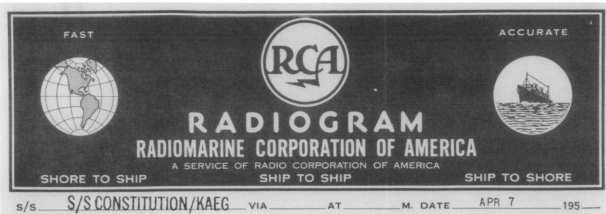

RADIOGRAM

RADIOMARINE CORPORATION OF AMERICA

A SERVICE OF RADIO CORPORATION OF AMERICA

FAST ACCURATE

SHORE TO SHIP SHIP TO SHIP SHIP TO SHORE

s/s S/S CONSTITUTION/KAEG VIA_____ AT_____ M. DATE___ APR 7 ___195__

MONTE CARLO 4 43 6 1929 OP

MISS GRACE KELLY

 SS CONSTITUTION FFL PARTD NEWYORK POUR CANNES

WHAT A LOVELY AND SWEET MESSAGE HEARD OVER RADIO STOP IT COULD NOT

HAVE BEEN BETTER AND NICER STOP WONDERFULLY RECEIVED HERE STOP I THINK

OF YOU SO MUCH STOP LOVE STOP RAINIER

0210

NOTE: THIS FORM MUST ACCOMPANY ANY INQUIRY RESPECTING THIS RADIOGRAM
ADDRESS: 75 VARICK STREET, NEW YORK 13, N. Y

Form No. ST-2 1-50-500M

Jean-Jacques L'Héritier, Telegram from Prince Rainier to Grace Kelly on the *SS Constitution* taking her to Monaco, April 1956. *(Prince's Palace Archives. Monaco)*
Facing page: **Howell Conant**, Grace Kelly and Prince Rainier just after being reunited on the *SS Constitution*, Monaco, April 12, 1956.

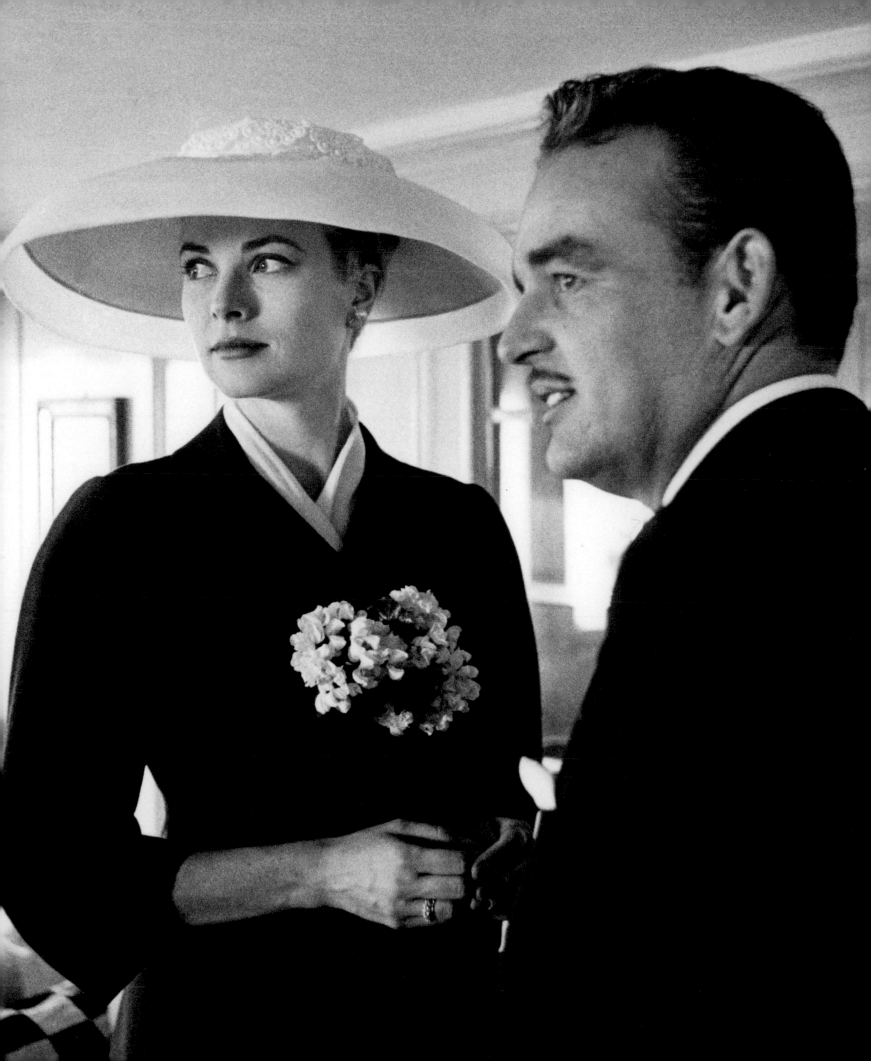

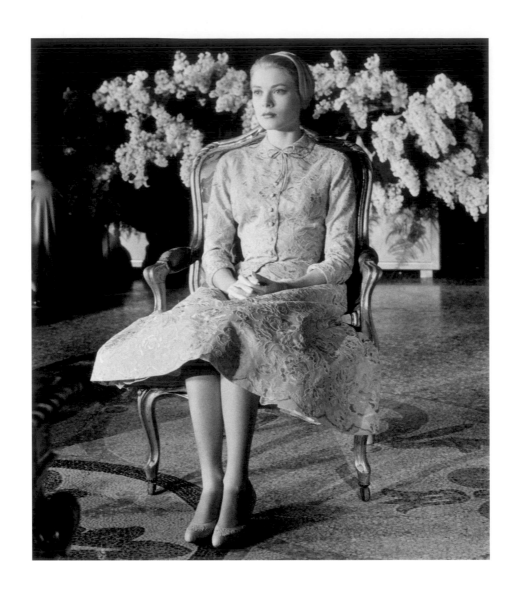

Howell Conant, The civil ceremony, Palace of Monaco, April 18, 1956.
Facing page: **Françoise Huguier**, Lace-trimmed suit by Helen Rose, worn for the civil ceremony, April 18, 1956. *(Loan: Prince's Palace. Monaco)*

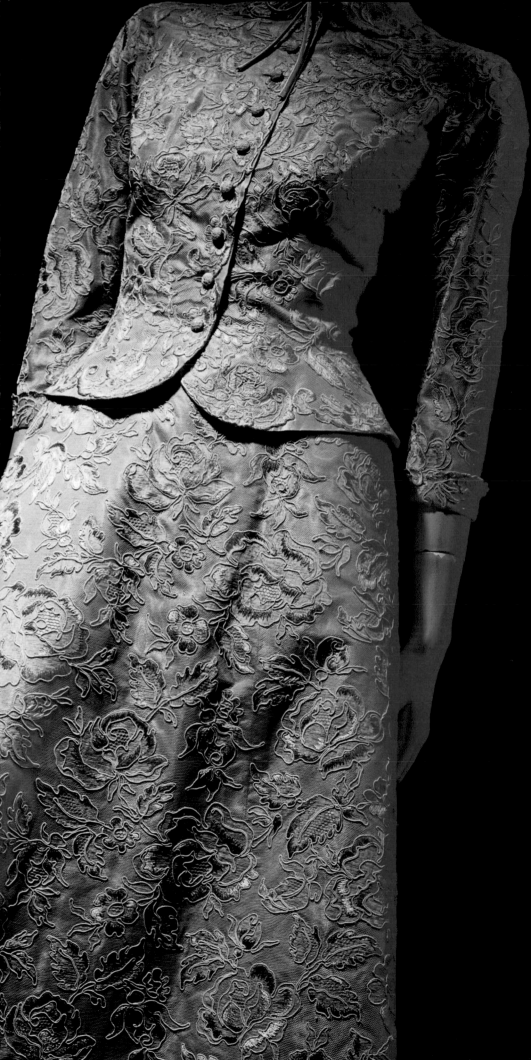

"I would like to say to my future fellow citizens that the Prince, my fiancé, has taught me to love them. I already know a lot about them from the way he has described them to me, and my dearest desire today is to find a little place in their hearts."

Jacques-Henri Lartigue, "The little dog", from the wedding reportage, April 19, 1956.
As usual, Lartigue preferred to get the mood of Monaco during the wedding festivities by mingling with the crowd, where his camera caught Jean Cocteau.
Gloria Swanson chose to get accredited as a reporter for a major American magazine – one of 1,500 journalists from all over the world. History does not
record whether Lartigue's little dog managed an interview with the black poodle belonging to the Princess . . .
Following pages: **Jacques-Henri Lartigue**, Wedding reportage, April 19, 1956.

11 AVRIL: MONACO

PREPARATIFS POUR LE MARIAGE

DU PRINCE

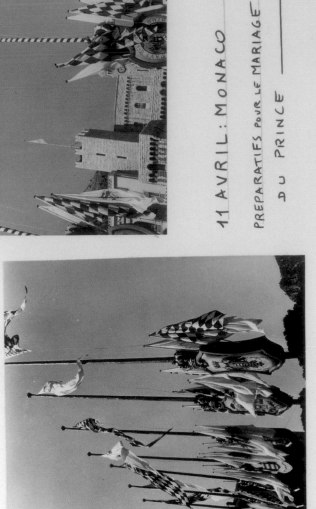

DANS LE PALAIS

158

AVRIL: MONACO PENDANT LE MARIAGE DU PRINCE.

TÉLÉVISION DANS LE PALAIS

AVRIL : MONACO : MARIAGE du PRINCE →

DEVANT LE PALAIS

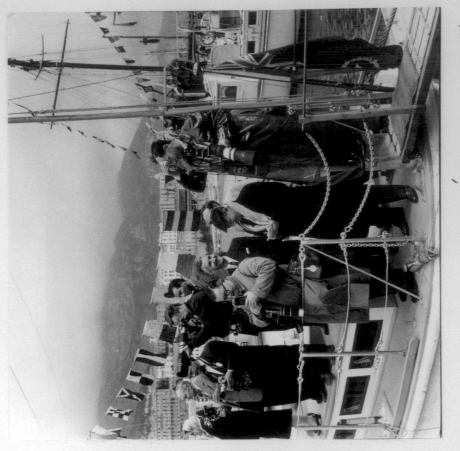

HELLENE D'ESTAINVILLE

WALTER CARONE

12 AVRIL : MONACO . ARRIVÉE DE GRACE KELLY →

LE PRINCE

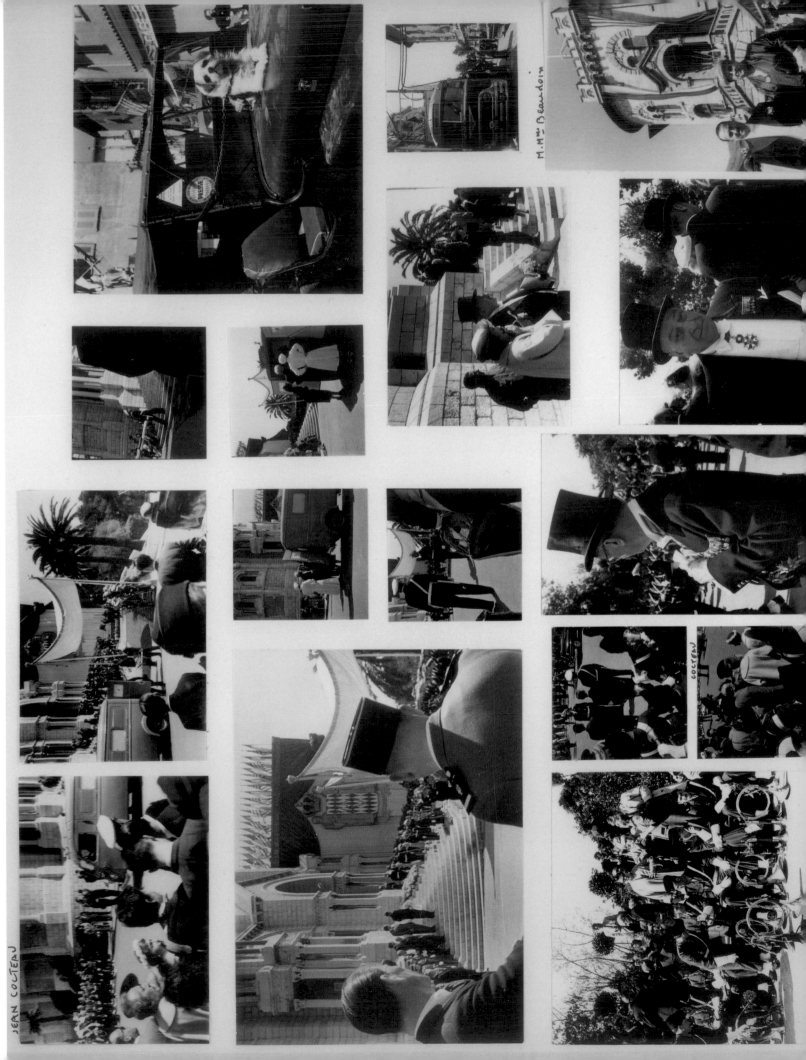

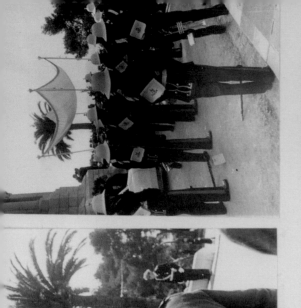

SERGE LIFAR

JEAN COCTEAU

JEAN COCTEAU - FRANCINE WEISWELLER

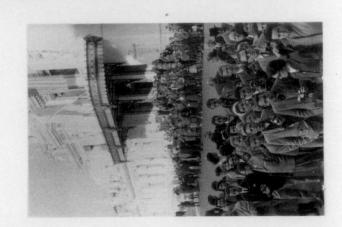

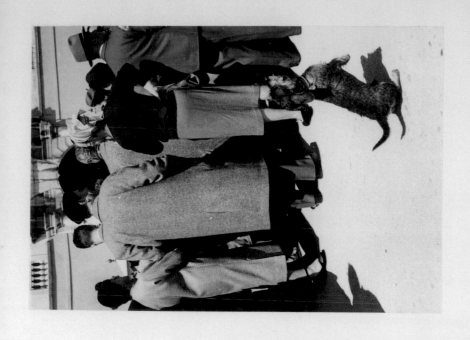

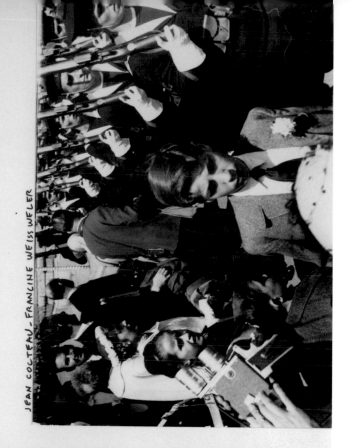

JEAN COCTEAU - FRANCINE WEISS WELER

FLORETTE

MARIAGE DU PRINCE : PORT ILLUMINÉ

19 AVRIL : MONACO

"Yes, I do."

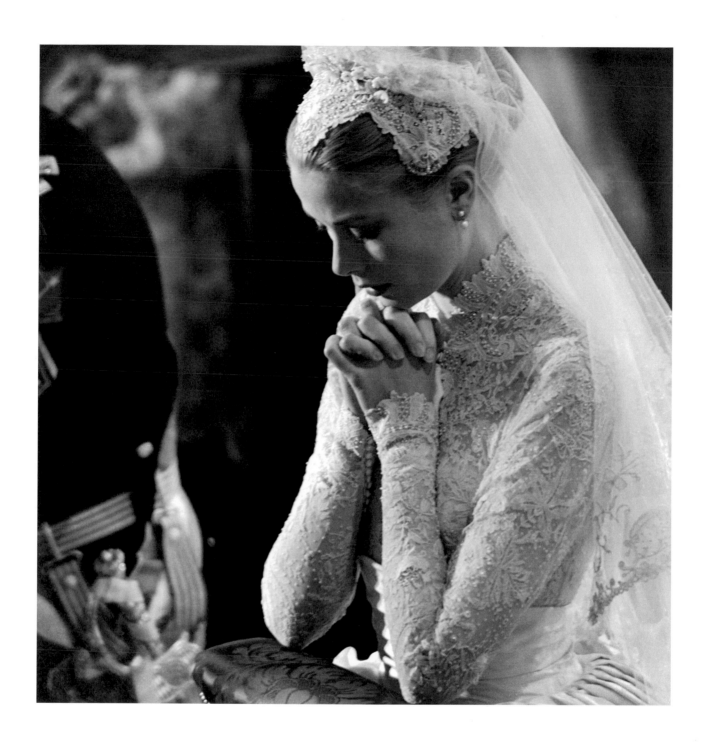

Princess Grace in prayer during the wedding in the Saint-Nicolas Cathedral, Monaco, April 19, 1956. The dress is a Helen Rose creation.

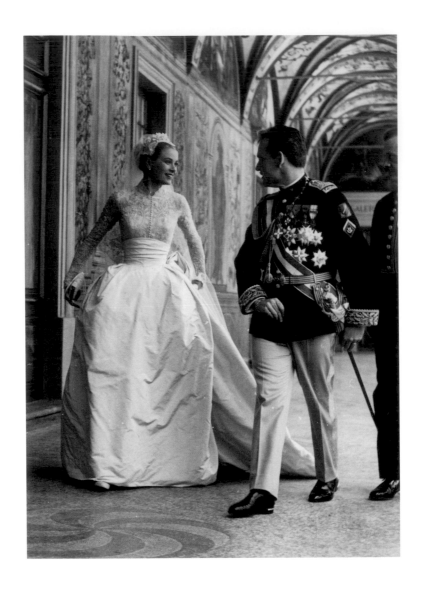

Detaille Archives, Grace Kelly and Prince Rainier before the church ceremony, April 19, 1956. *(Prince's Palace Archives. Monaco)*
Facing page: **Detaille Archives**, Princess Grace on the balcony, April 19, 1956. *(Prince's Palace Archives. Monaco)*

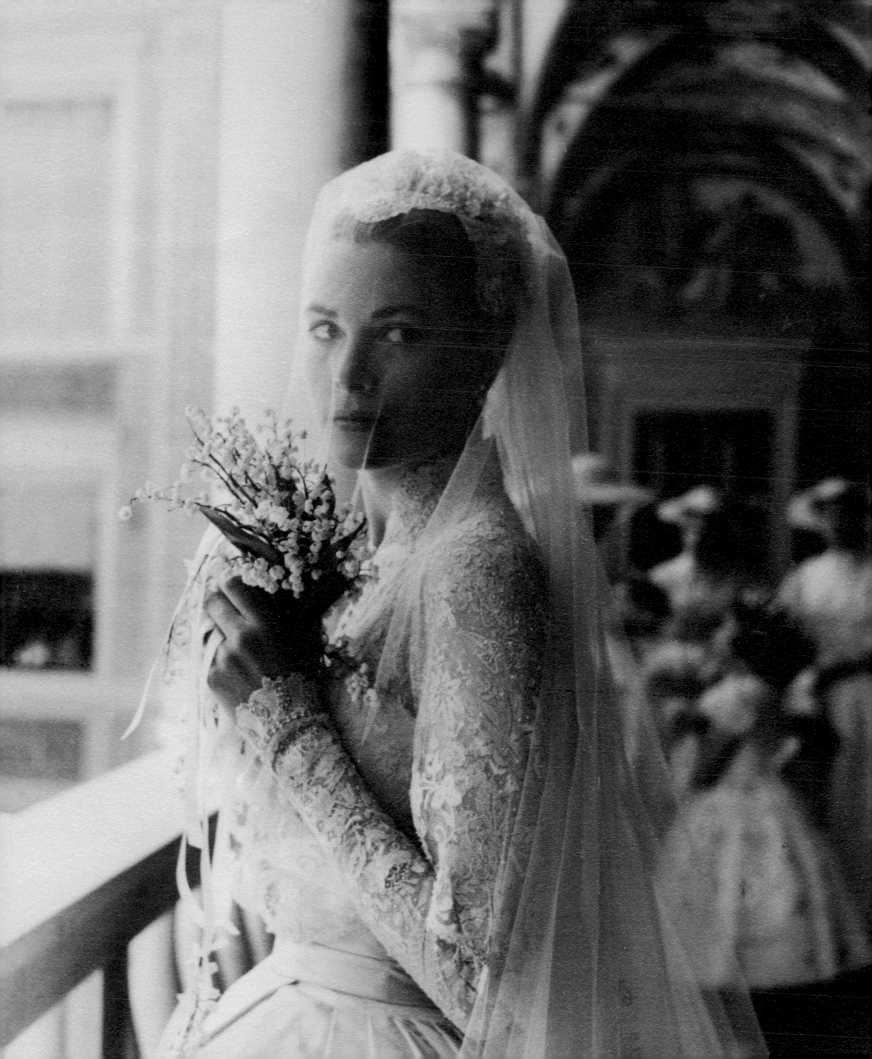

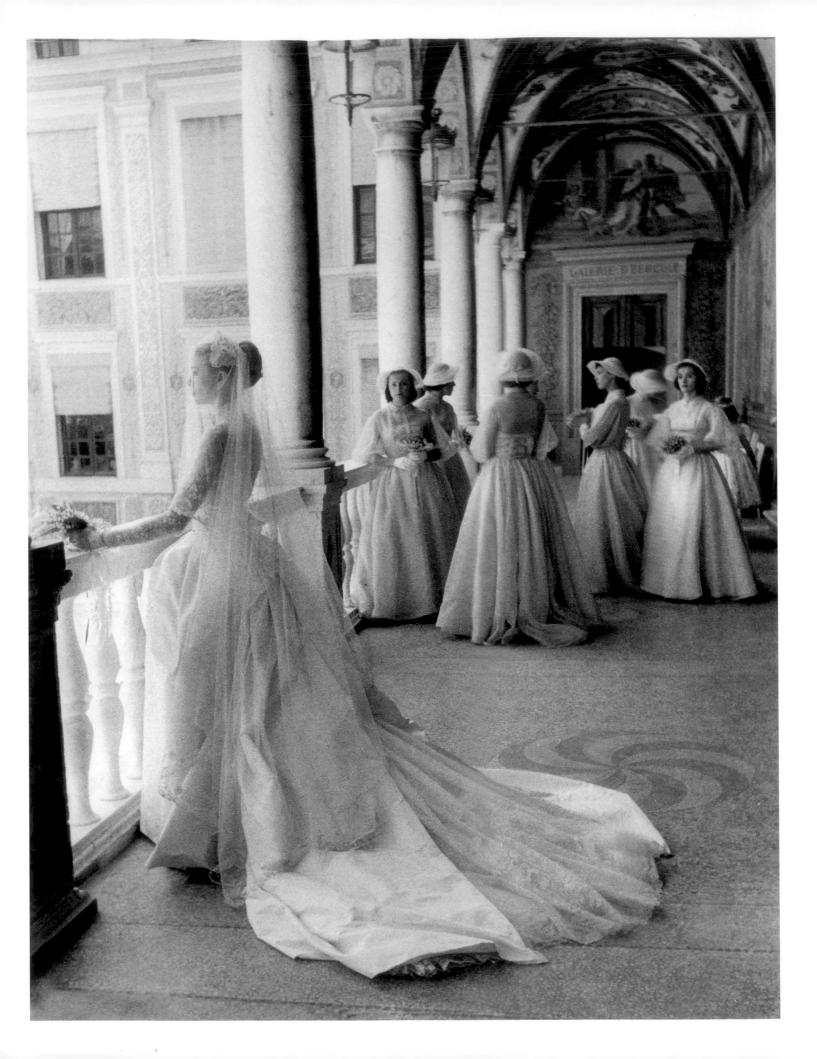

Paris: the crowd watches the wedding on television, April 19, 1956. *(Prince's Palace Archives. Monaco)*
Facing page: **Howell Conant**, Princess Grace and her bridesmaids, creation by Joseph Hong.

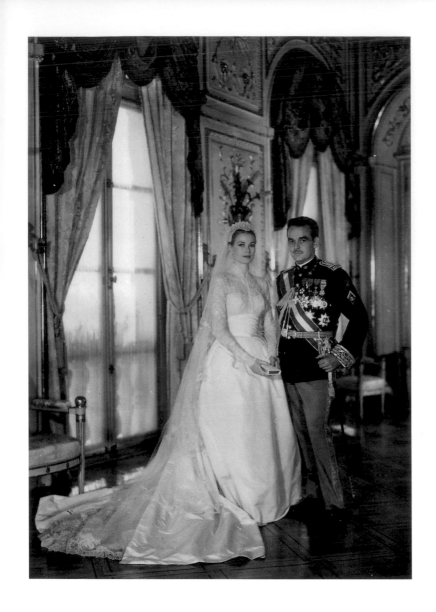

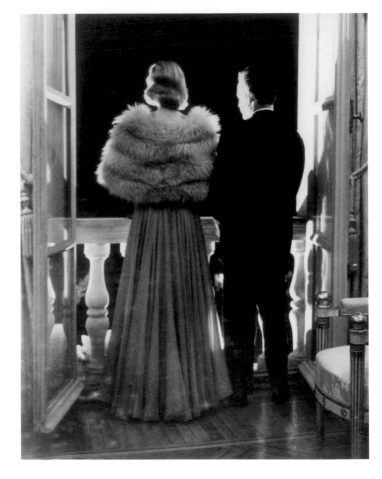

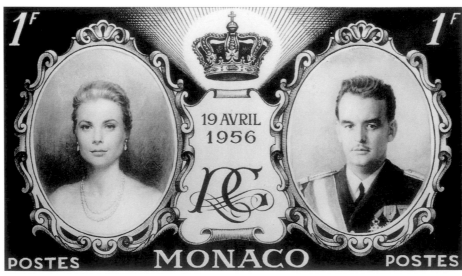

From left to right, top to bottom: **Howell Conant**, Official portrait of Prince Rainier III and Princess Grace of Monaco, Palace of Monaco, April 19, 1956.
Princess Grace and Prince Rainier III on the balcony after the civil ceremony, April 18, 1956.
Detaille Archives, Stamp issued by the Principality in honour of the wedding of Rainier and Grace. *(Philatelic Collection of H.S.H. the Prince)*
Facing page: **Robert de Hoé**, Princess Grace and Prince Rainier III of Monaco, April 9, 1958. *(Prince's Palace Archives. Monaco)*

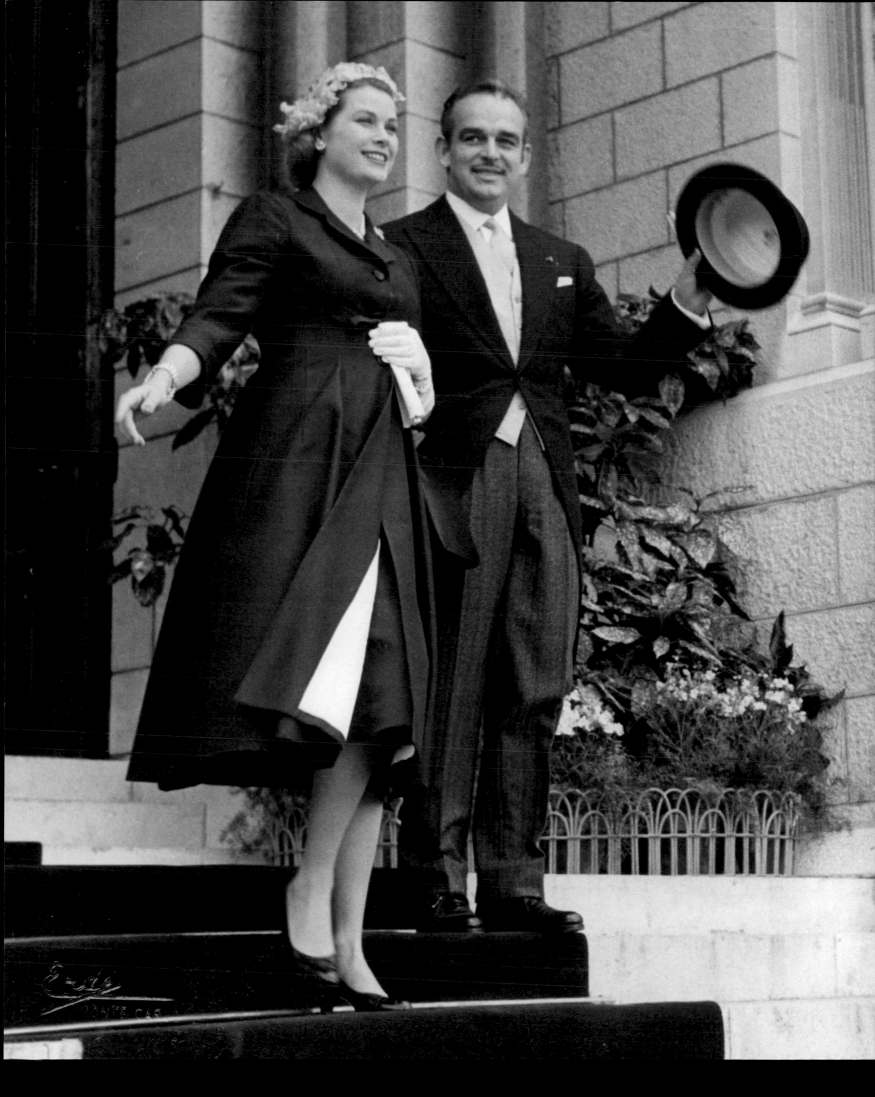

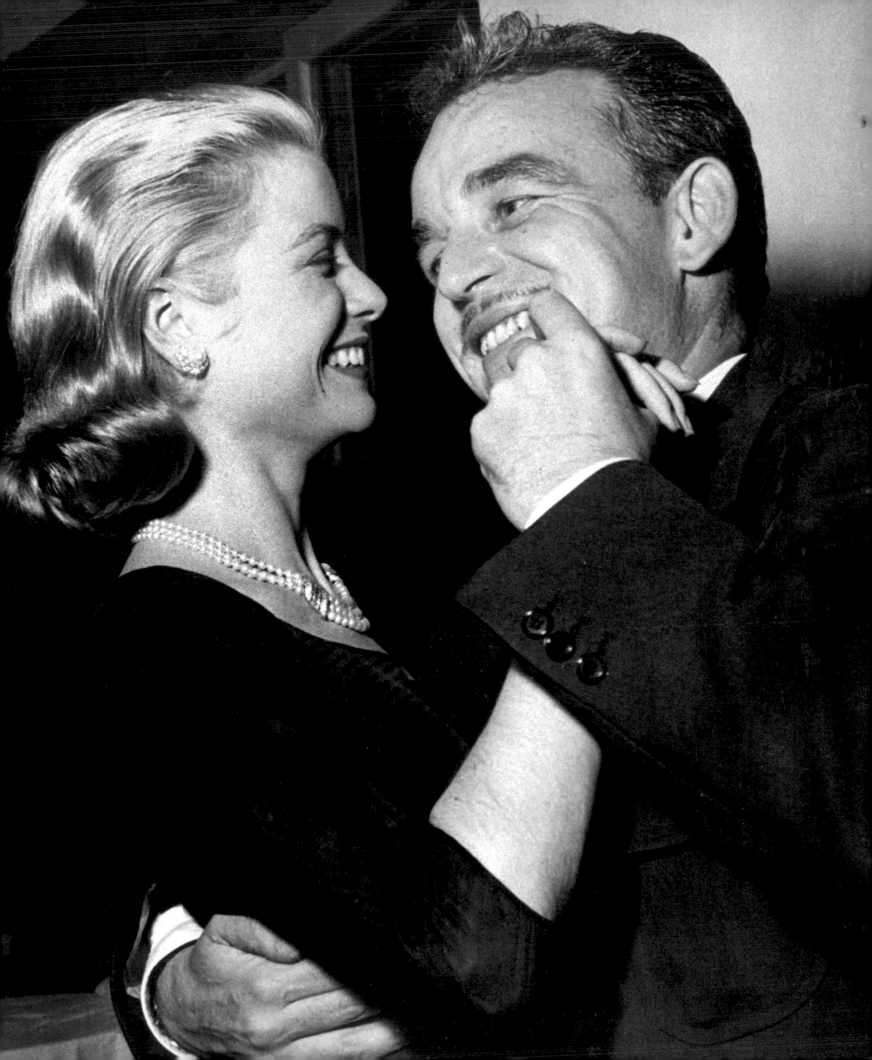

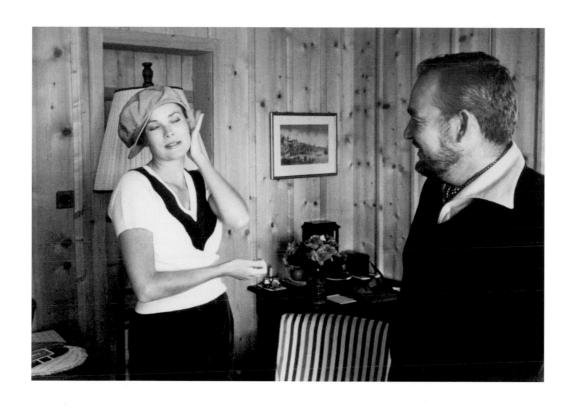

Howell Conant, Princess Grace and Prince Rainier in their chalet at Gstaad, Switzerland, 1957.
Facing page: Princess Grace and Prince Rainier III of Monaco dancing on their honeymoon, Formentor Yacht Club, Majorca, April 23, 1956.

Frank Sinatra

December 17, 1971

Dear Gracie:

Thank you so much for your birthday
wire. I had a marvelous time.

Unfortunately, the holidays are very
large with my family and close friends,
so I won't be able to get away to join
you for the benefit.

Hope you have a wonderful Christmas
and wish you the best in the New Year.

All my love to Rainier and the children.

Love,

Hank

Her Serene Highness
Princess Grace
The Palace
Monaco

CARY GRANT 27th April, 1982.

My dear Grace,

What an absolutely dear friend you are. I've just received
a note from Steve Ross to say that arrangements have been
made for him, together with his business associates, to
visit the Palace. Knowing all you have to do, without people
such as myself, who should know better, initiating still more
requests, I'm touched by your willingness and kindness.

You should, I warmly hope, find Steve Ross quite interesting;
especially if you get him on the subject of his latest, and
yet another incredibly successful aquisition, a company
named "Atari".

Please tell Prince Rainier, too, of my appreciation for
making Steve's visit possible.

 Gratefully and affectionately, and with love from
Barbara,

Jean-Jacques L'Héritier, Letter from Cary Grant to Grace Kelly, April 27, 1982. *(Prince's Palace Archives. Monaco)*
Facing page: **Jean-Jacques L'Héritier**, Letter from Frank Sinatra to Princess Grace, December 17, 1971. *(Prince's Palace Archives. Monaco)*

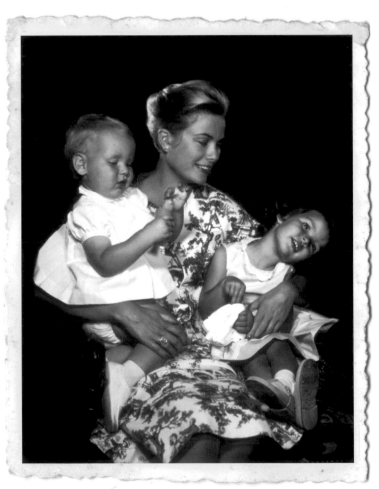

From left to right, top to bottom: **Howell Conant**, Princess Grace with Caroline, winter 1957.
Philippe Halsman, Princess Grace with her son Albert, 1960. — **Philippe Halsman**, Princess Grace with her children, Albert and Caroline, 1959.
Facing page: **Cecil Beaton**, Princess Grace of Monaco and Stéphanie, September 30, 1965.

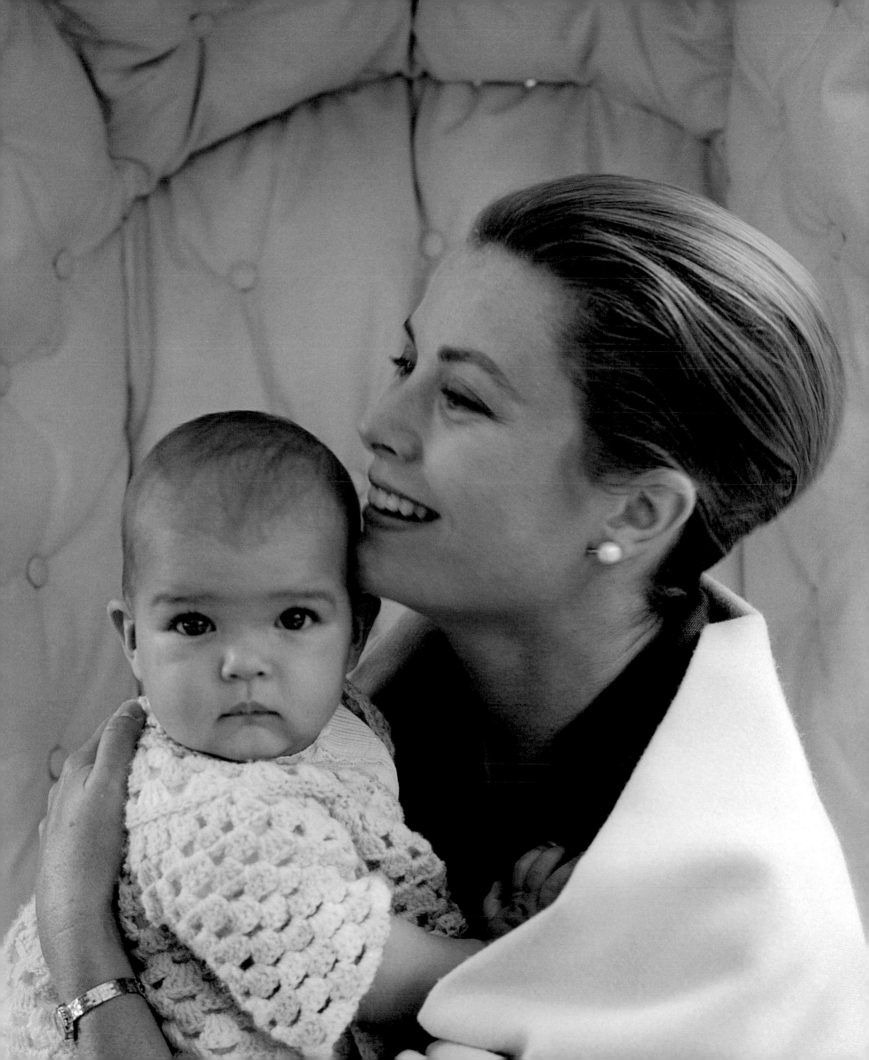

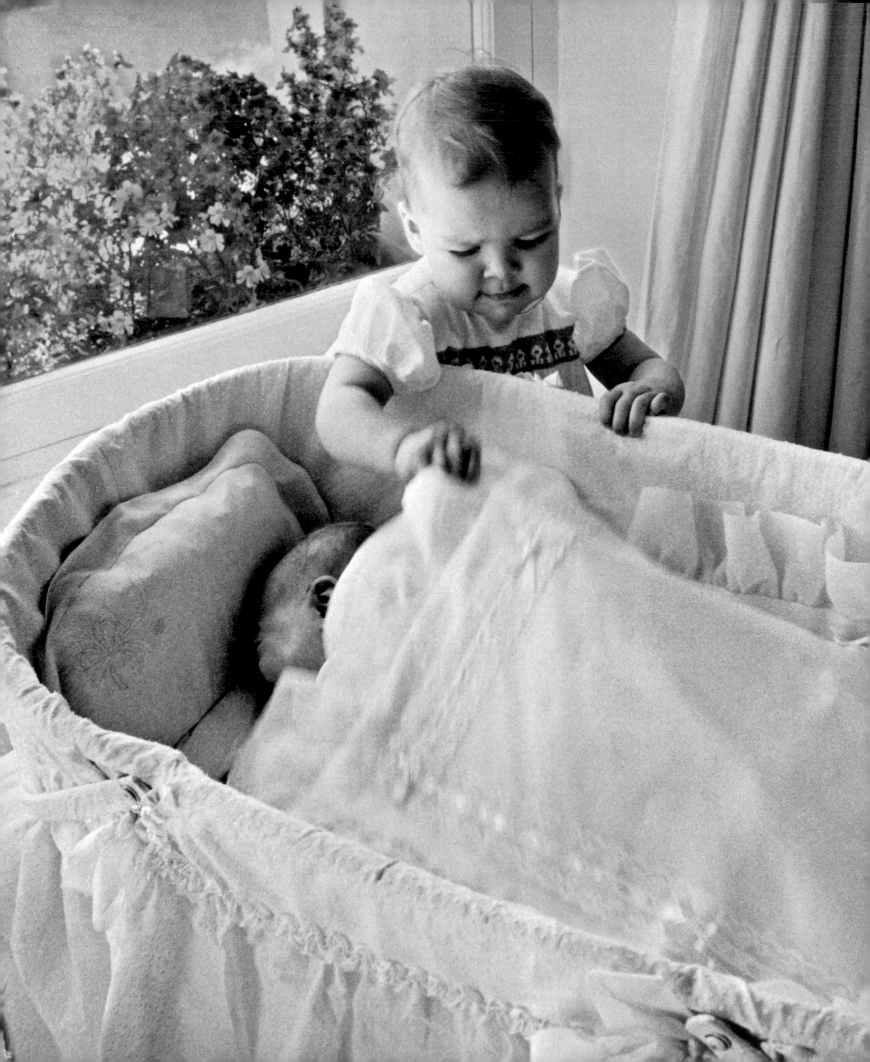

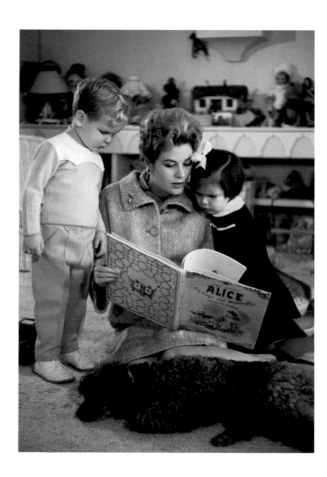

From left to right, top to bottom: **Georges Lukomski**, The children, Caroline and Albert, on board, August–September 1960.
Albert and Caroline as children, c. 1963. *(Prince's Palace Archives. Monaco)*
Howell Conant, Princess Grace getting Christmas presents ready. — **Howell Conant**, Reading to the children.
Facing page: **Howell Conant**, Princess Caroline by the one-year-old Prince Albert's cradle, 1958.

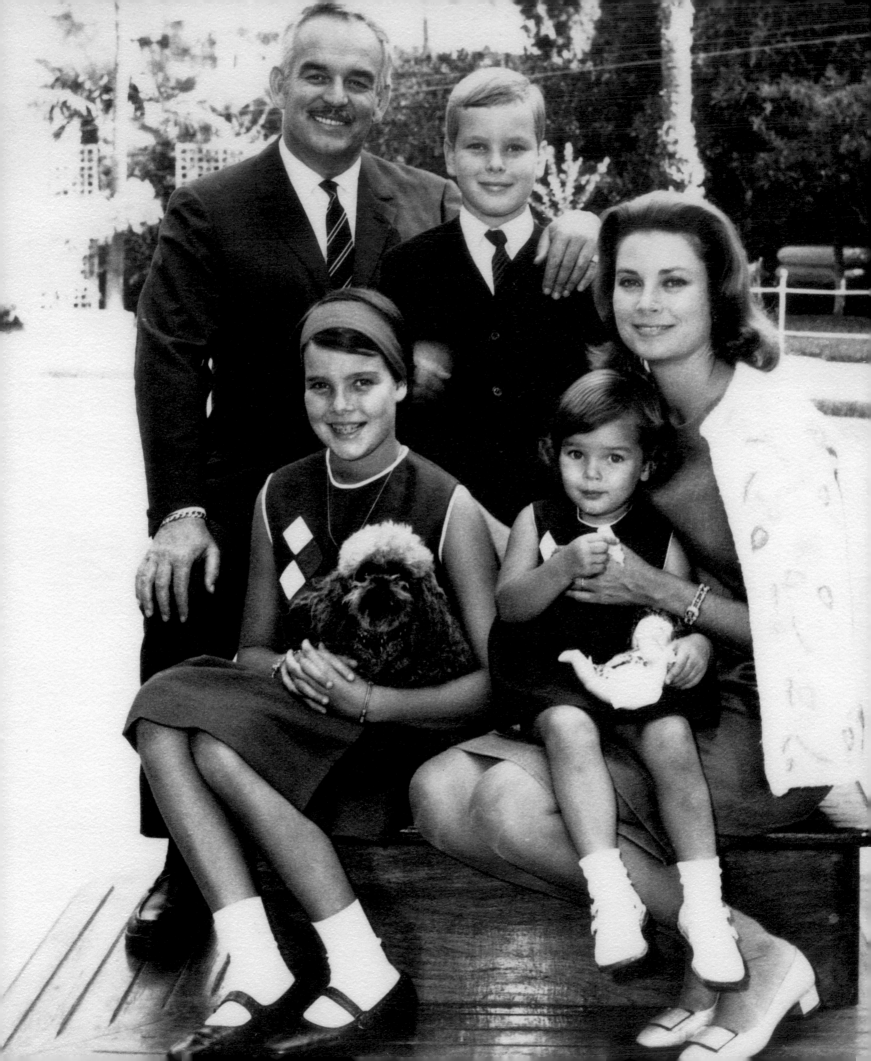

"My real difficulty was to become a normal person again, after having been a movie actress for so long. For me, at the time I was living in New York and Hollywood, a normal person was someone who made movies."

The royal family, c. 1968. (Prince's Palace Archives. Monaco)

"It would be very sad if children had no memories before those of school. What they need most is the love and attention of their mother."

Princess Grace filming Caroline, June 17, 1962. *(Prince's Palace Archives. Monaco)*

≪ 184 ≫

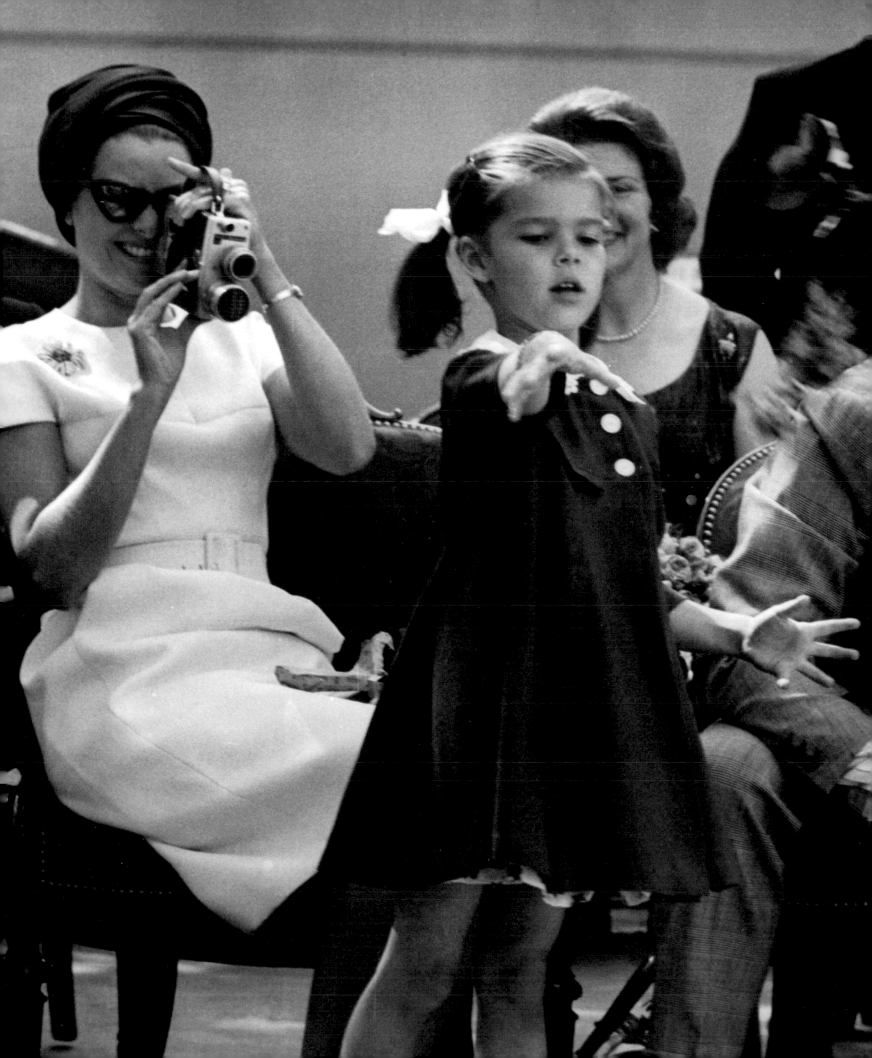

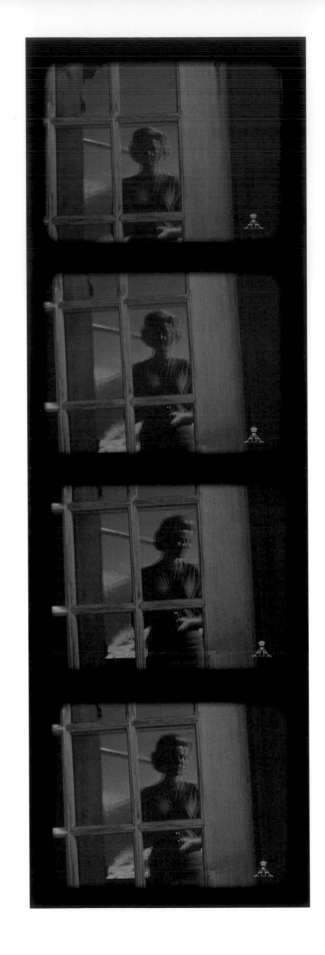

H.S.H. Princess Grace reflected in a window of the chalet at Gstaad, Switzerland, 1962.
Princess Grace began to film the family life of her children with a small amateur cine camera in the early sixties. The composition is carefully arranged, and sometimes the scenario as well, and "signed" by Princess Grace herself who fleetingly appears in a mirror or reflected in a window-pane. (© Source: Prince's Palace. Monaco)

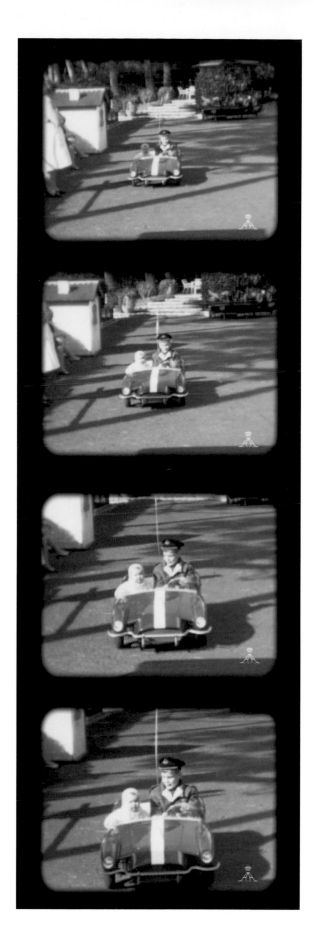
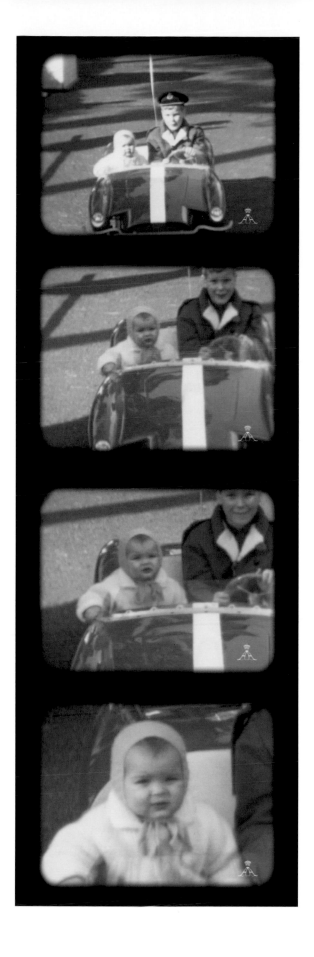

Albert and Stéphanie in a children's racing car, 1965–1966. (© Source: Prince's Palace. Monaco)

Caroline and Albert as children playing in the Palace gardens. *(© Source: Prince's Palace. Monaco)*

"I've always treated my children as beings in their own right. I respect their feelings and aspirations entirely."

Princess Grace and Prince Albert on holiday in Montego Bay, Jamaica, March 17, 1967.
Following page: **Françoise Huguier**, Yves Saint-Laurent "Mondrian" dress, autumn–winter 1965. *(Loan: Prince's Palace. Monaco)*

≪ 190 ≫

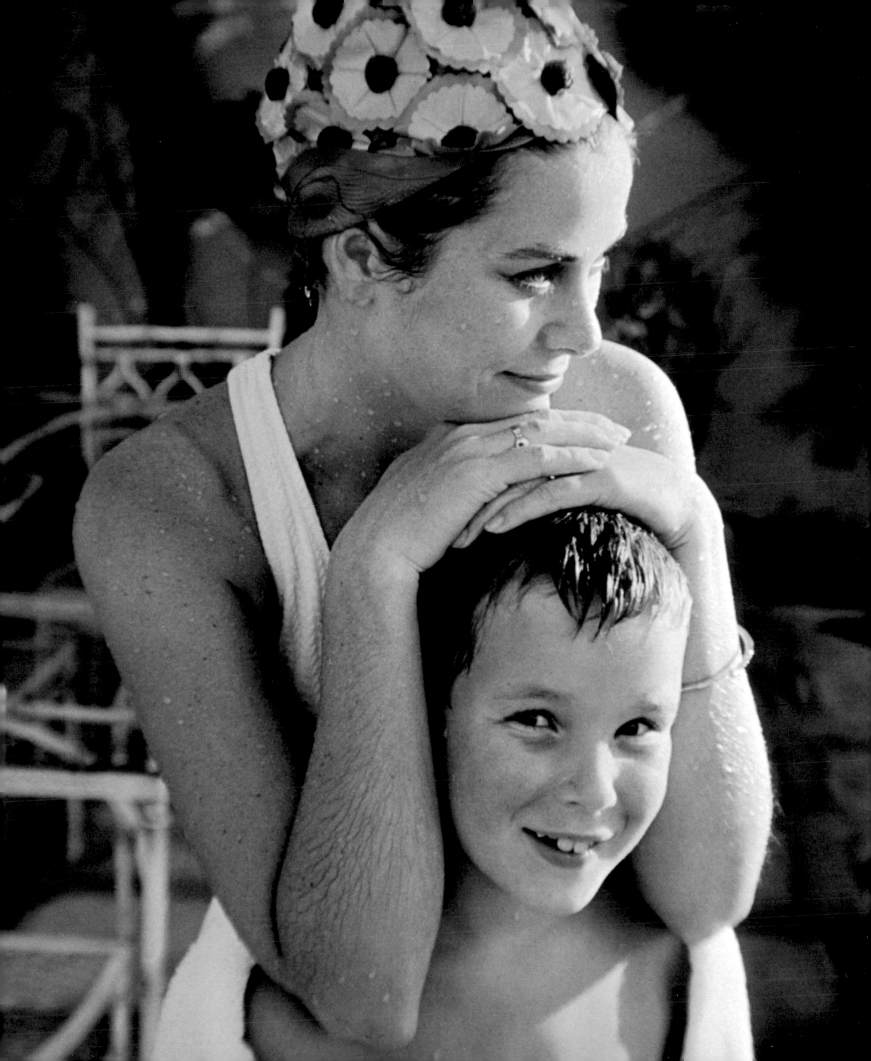

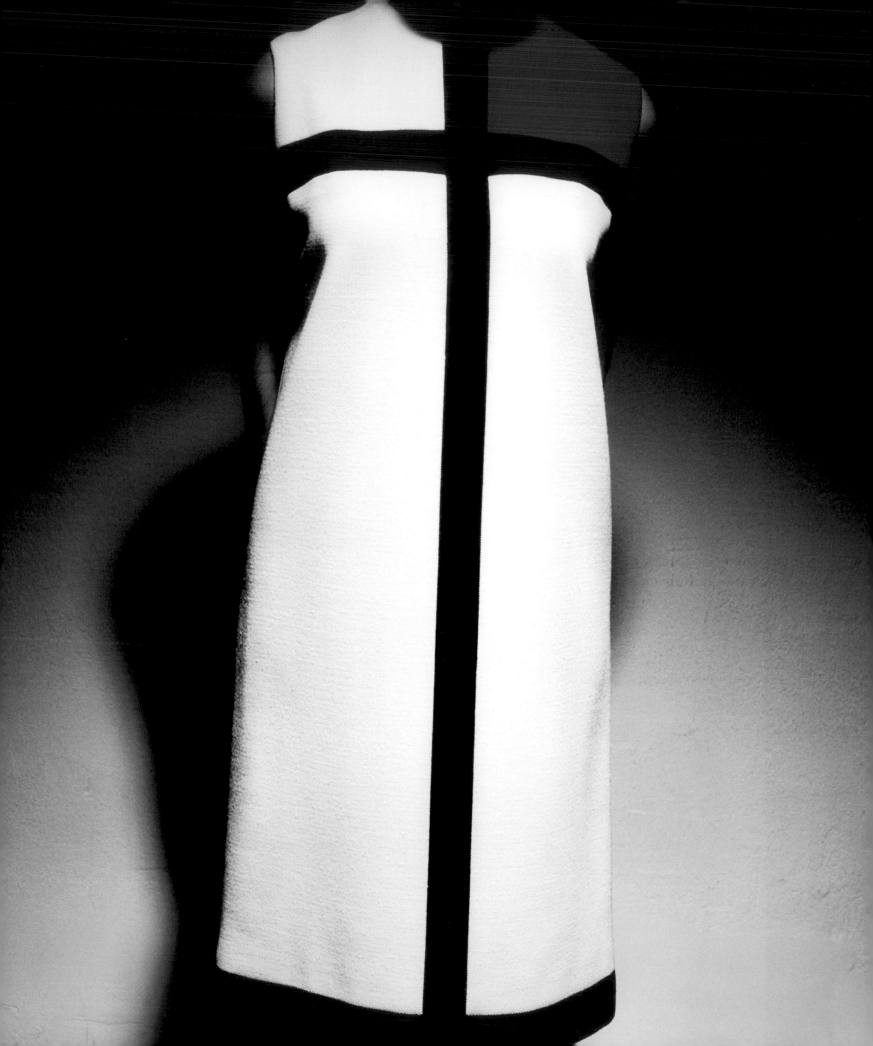

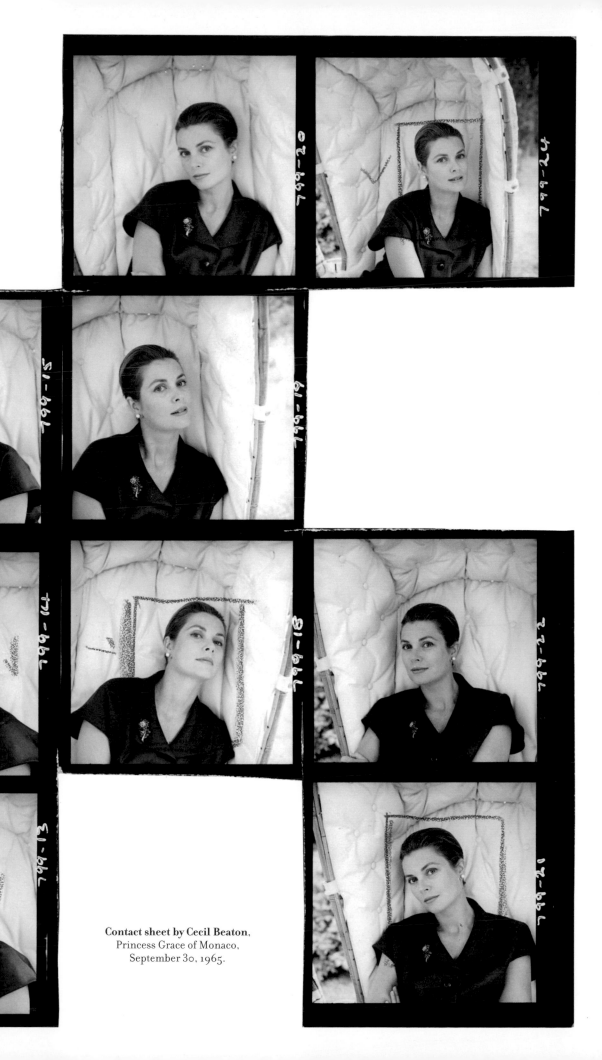

Contact sheet by Cecil Beaton,
Princess Grace of Monaco,
September 30, 1965.

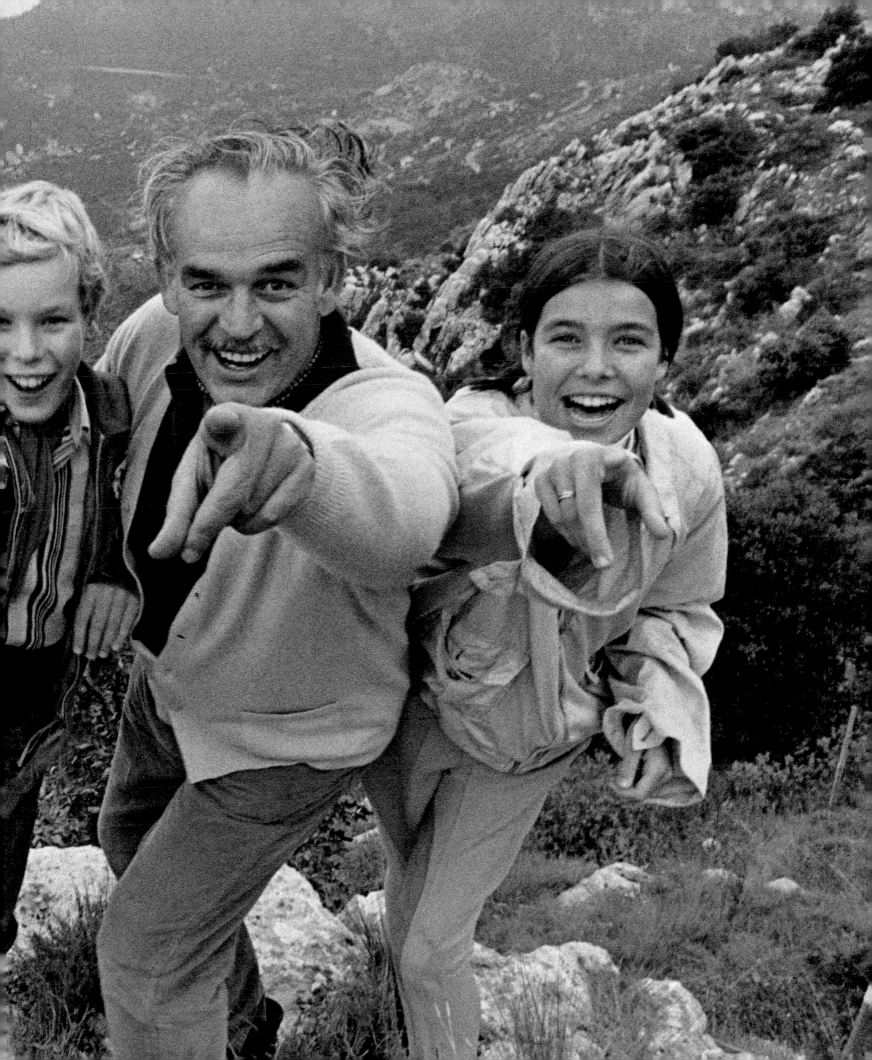

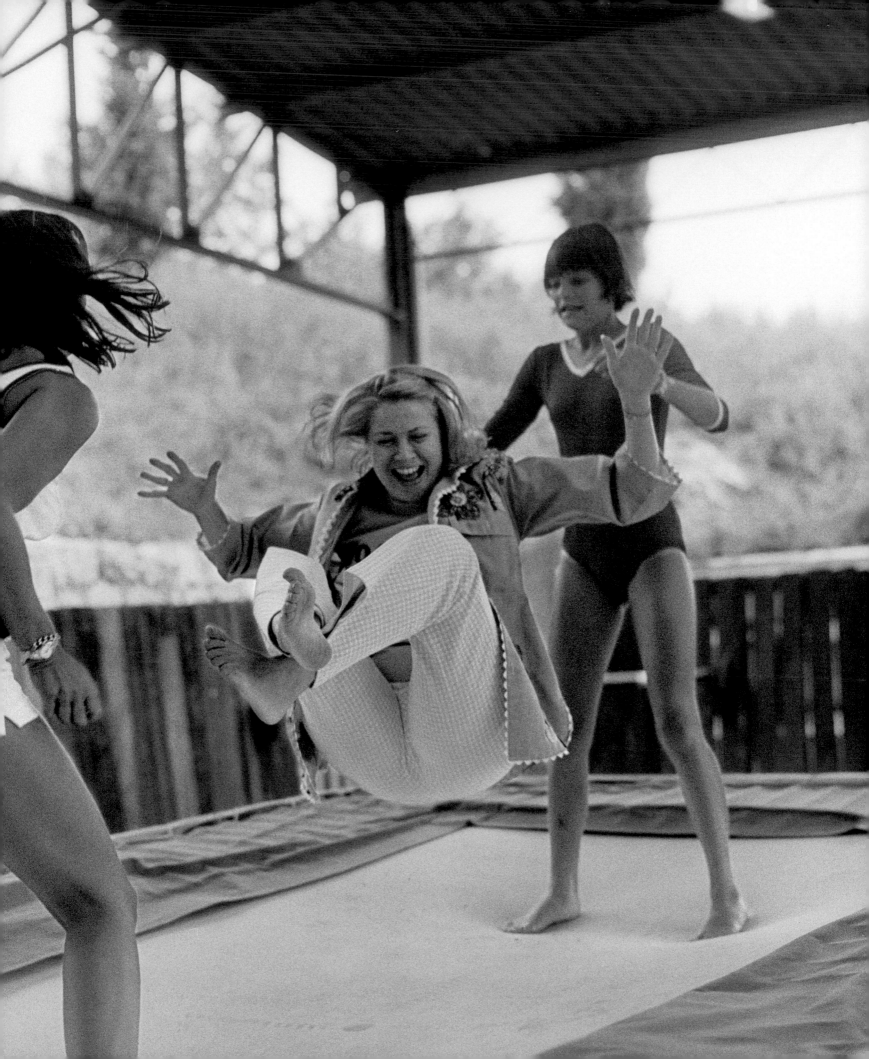

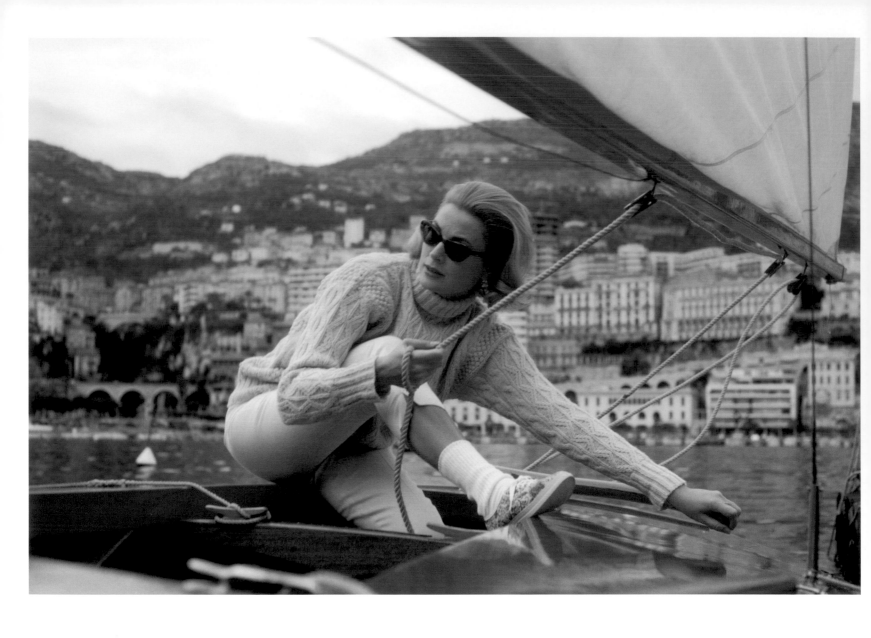

Howell Conant, Princess Grace at the tiller of her sailing boat, c. 1960.
Previous pages: **Howell Conant**, Prince Rainier, Albert and Caroline at Roc Agel, the royal family's ranch overlooking Monaco, c. 1969.
Howell Conant, Relaxing with the family: the trampoline, Roc Agel, c. 1978.

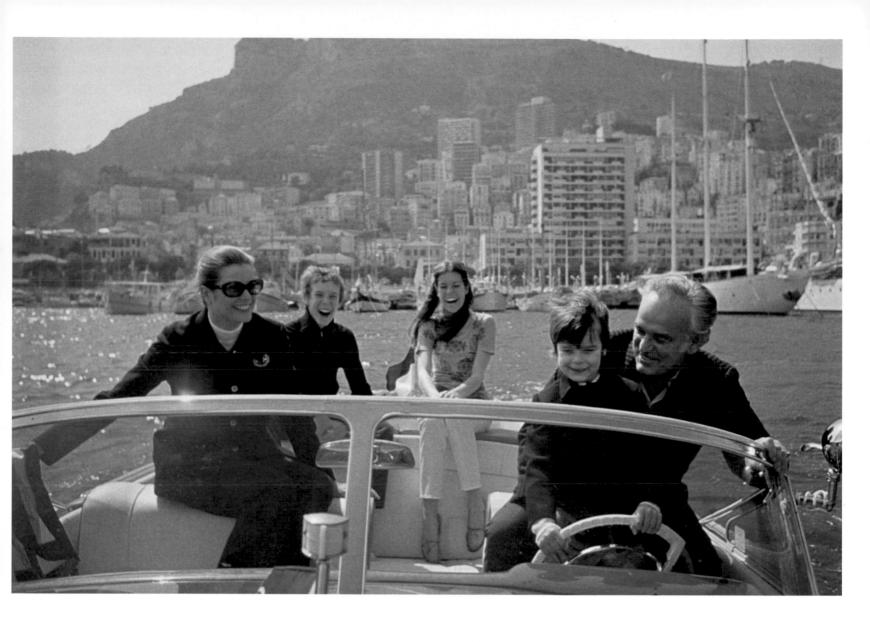

Lord Snowdon, The royal family relaxes in a motorboat, 1972.

Lord Snowdon, Prince Albert in judo kit, 1972.
Facing page: **Howell Conant**, Stéphanie, Albert and Caroline, Château de Marchais, August 23, 1979.

Jacques-Henri Lartigue, Photos of the royal family, August 6, 1981.

"The sometimes inquisitive and unhealthy interest that the media show in us is often the source of childish anxieties that are hard to allay. I do everything I can to protect my children from them."

"I avoid looking back. I prefer good memories to regrets."

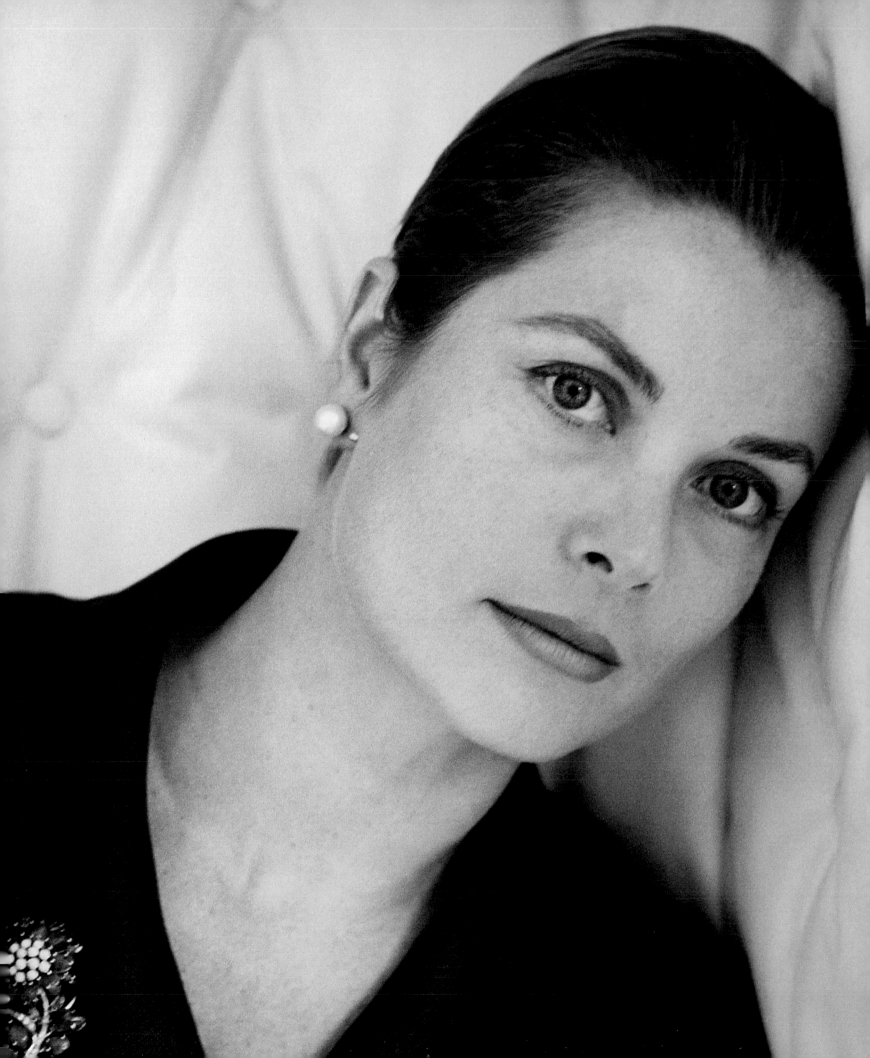

Howell Conant, Charity work of
Princess Grace of Monaco, c. 1962.

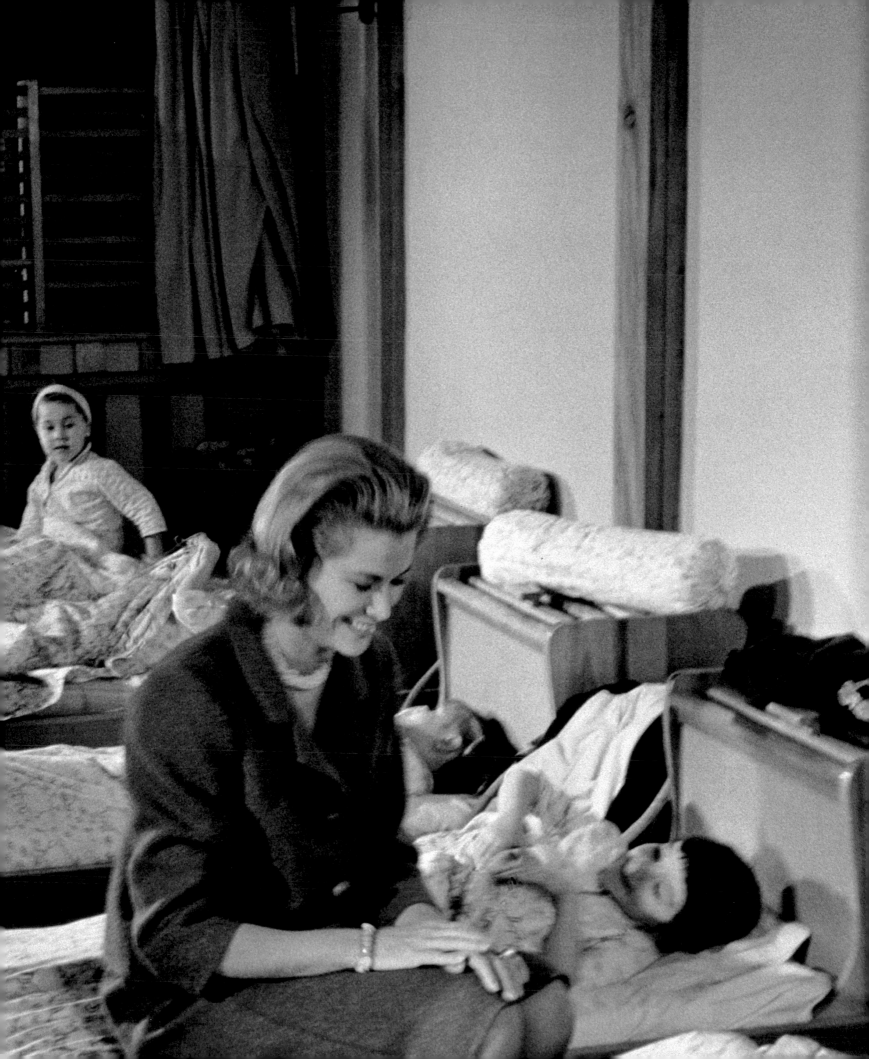

Dear Manou –

All of our
loving wishes for
a Holy Christmas and
a Bright and Happy New
Year – 1970 –

STÉPHANIE –

Grace

Albert

Caroline

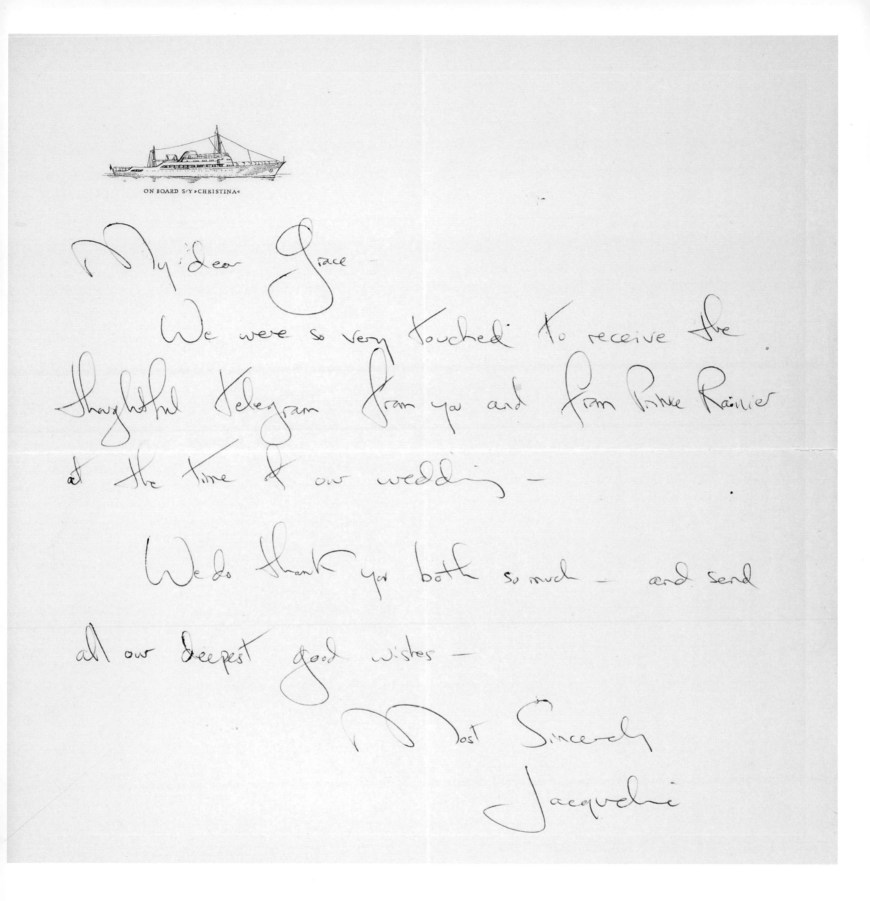

ON BOARD S/Y »CHRISTINA«

My Dear Grace —

We were so very touched to receive the thoughtful telegram from you and from Prince Rainier at the time of our wedding —

We do thank you both so much — and send all our deepest good wishes —

Most Sincerely
Jacqueline

Jean-Jacques L'Héritier, Letter from Jacqueline Kennedy on the Onassis letterhead. *(Prince's Palace Archives. Monaco)*
Facing page: **Jean-Jacques L'Héritier**, The royal family's Christmas card to "Mamou", Princess Charlotte of Monaco, mother of Prince Rainier. *(Prince's Palace Archives. Monaco)*

22/7 1965

Madame,

J'ai été très touché par votre attention.

Je vous remercie de tout cœur d'avoir pensé à moi. Je dois vous avouer que je mange ce saumon avec le plus grand plaisir.

Je vous prie de bien vouloir agréer, Madame, mes respectueux hommages

Marc Chagall

"Before my marriage, I didn't think about all the obligations that were awaiting me. My experience has proved useful and I think that I have a natural propensity to feel compassion for people and their problems."

Jean-Jacques L'Héritier, Letter from Marc Chagall, July 22, 1965. *(Prince's Palace Archives. Monaco)*

Mesdames - Messieurs

Il n'y a pas que des mots pour exprimer des sentiments - en particulier - la gratitude - Il y a aussi le geste simple et sincère qui traduit ce sentiment - et je vais avoir le grand plaisir d'accomplir ce geste -

Votre dévouement à l'idéal de la CR me procure la grande joie de vous exprimer mes re-merciments personnels et la re-connaissance de notre association pour votre fidèle action - afin que celle-ci soit toujours plus aggissante et efficace dans sa mission de soulagement des misères humaines -

Sans vous - il n'y aurait
pas de CRM - et sans CRM
il y aurait bien plus de
malheureux - et de misères -

C'est aussi au nom
de ceux qui ne sont plus
malheureux que je vous
remets les insigne de re-
connaissance de la CRM -
en vous disant du fond
du cœur - Merci ——

18 Nov 1972

C1219

Jean-Jacques L'Héritier, Grace Kelly manuscript for the Monaco Red Cross. *(Prince's Palace Archives. Monaco)*

215

GEORGE BALANCHINE

May 14, 1982

S. A. S. La Princesse de Monaco
Palais Princier
Principaute de Monaco

Dear Princesse Grace;

I thought you might be interested in the
School of American Ballet's anniversary,
and that you might wish to be "a member
of the family".

We all realize how busy you are, and the
various complications of the use of your
name, so we understand completely if you
are unable to accept.

It was good to see you again in Philadelphia,
and we are still confident about our plans
for a ballet company in Monaco.

Best wishes,

George Balanchine

GB/bh

June 7, 1965

Dear Little Princess,

You will never know how deeply touched I was to receive your letter. Your offer to me is unbelievably kind and sweet.

I have not been around much with human beings lately and I have been rather nervous about making plans, but recently I did accept an invitation to stay a while with a family I know in Paris, who helped me very much last year, hoping they would understand my being "upside-downy."

I do hope to come to Monte Carlo sometime this summer but do not know when, so I should not like to tie you down to anything. When I, Lord willing, may be there, and if you still are at the Palace, I hope that I will be able to see your lovely person again.

All my thanks to you and the Prince for having thought of me in this wonderful way.

My warmest thoughts and gratitude,

S.A.S. Princess Grace of Monaco
The Palace

Jean-Jacques L'Héritier, Letter from Greta Garbo, June 7, 1965. *(Prince's Palace Archives. Monaco)*
Facing page: **Jean-Jacques L'Héritier**, Letter from George Balanchine, May 14, 1982. *(Prince's Palace Archives. Monaco)*

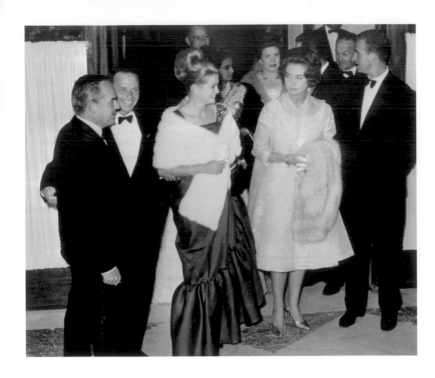

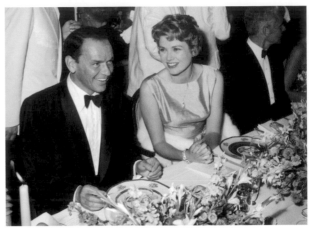

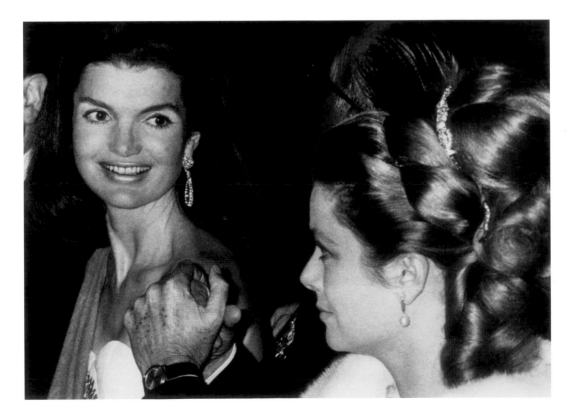

From left to right, top to bottom: Princess Grace, Prince Rainier III, Princess Sophie of Spain and her husband Prince Juan Carlos of Spain with Frank Sinatra just after his concert at the Monte Carlo Sporting d'Hiver, June 10, 1962.
Princess Grace and Frank Sinatra attend the gala dinner following the world premiere of *Kings Go Forth*, June 14, 1958.
Jacqueline Kennedy and Princess Grace of Monaco at the Spanish debutantes' ball, Casa de los Pilatos, April 17, 1966.
Facing page: **Robert de Hoé**, Princess Grace of Monaco and Maria Callas arriving at the gala dinner following the end of the 2nd Monte Carlo Television Festival, January 19, 1962. *(Prince's Palace Archives. Monaco)*

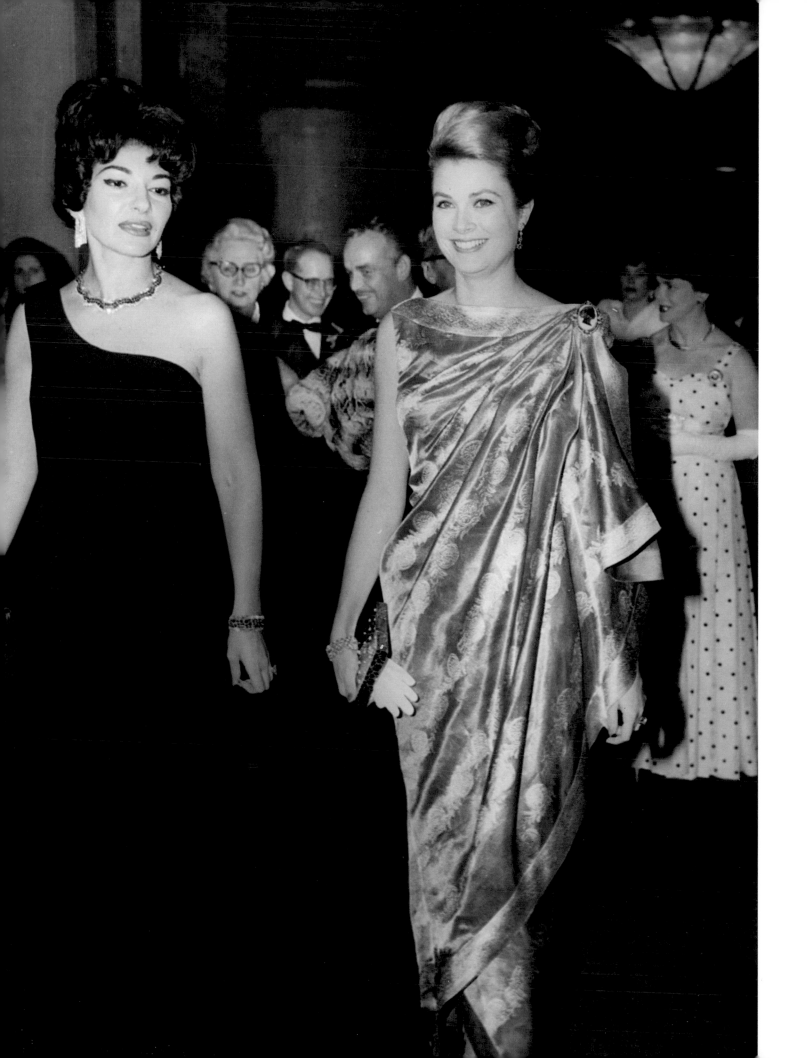

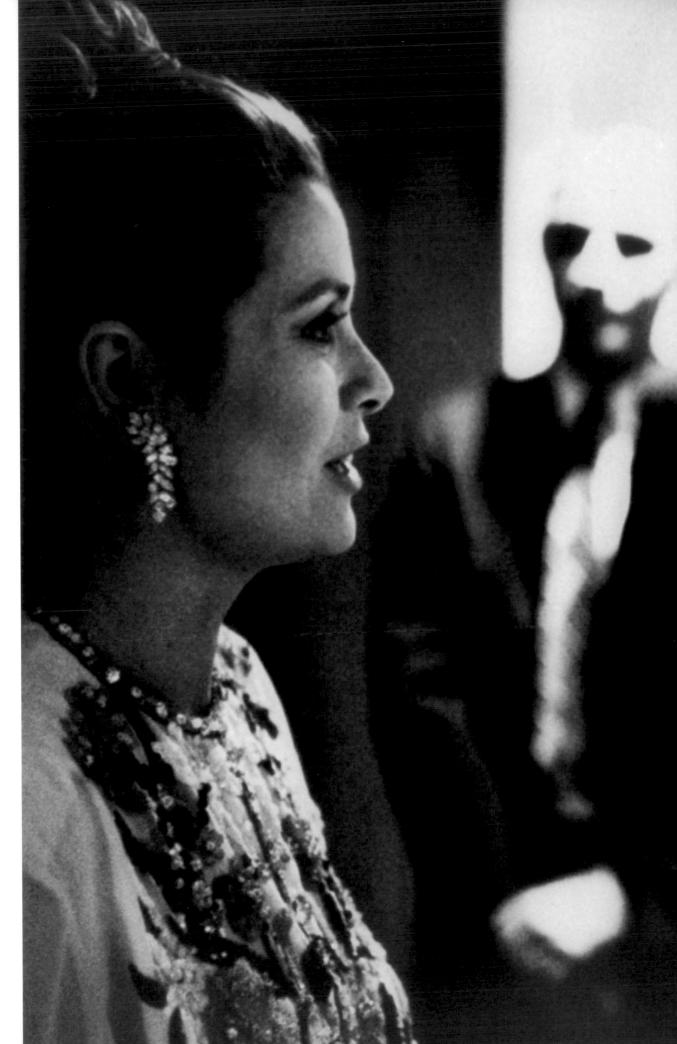

Princess Grace talks with her
friend, the singer Frank Sinatra,
on the occasion of his farewell
appearance, UCLA, June 1971.

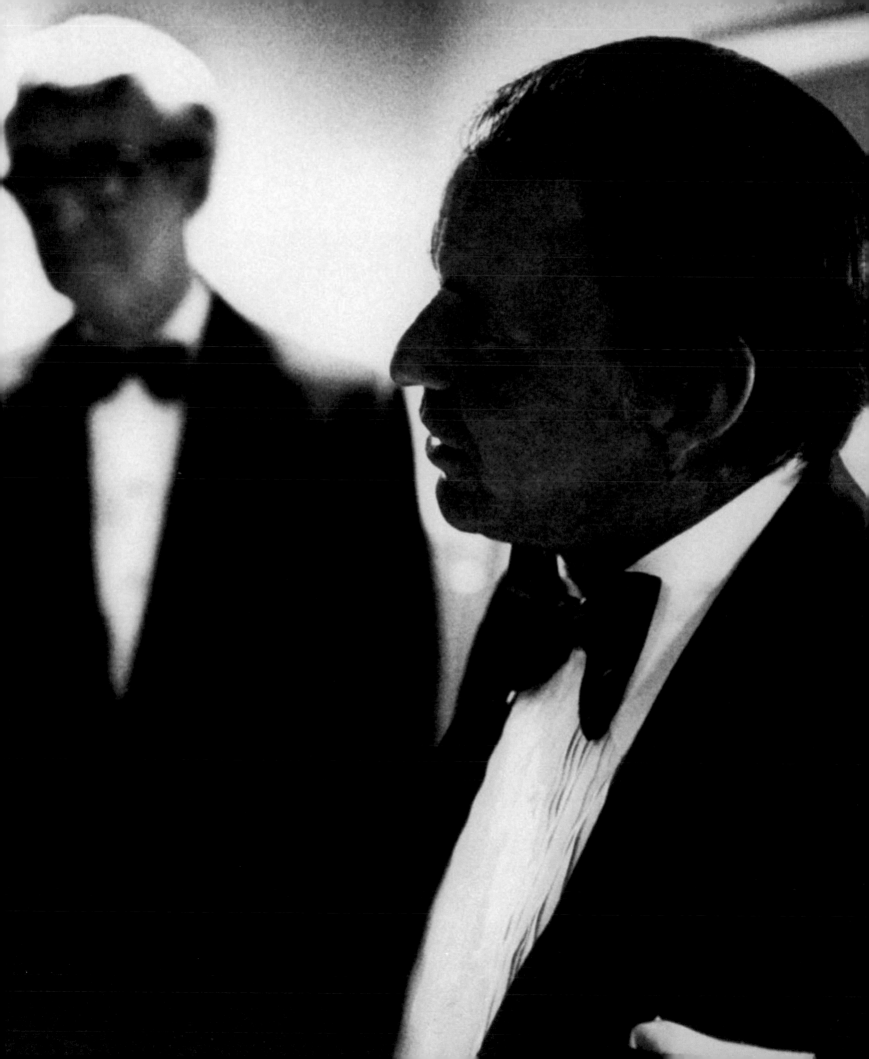

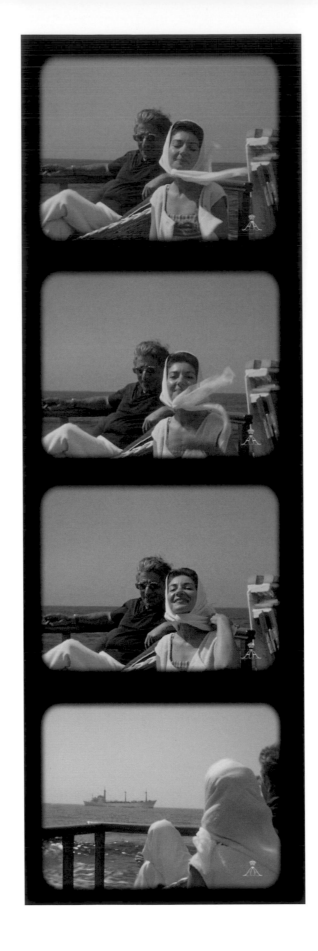

Maria Callas and Aristotle Onassis on board the *Christina*, the Greek ship-owner's yacht, summer 1961. Footage shot by Princess Grace. *(© Source: Prince's Palace. Monaco)*

"I'm basically a feminist. I think that women can do anything they decide to do."

Princess Grace with President John F. Kennedy during an official
visit to Washington, 1962.

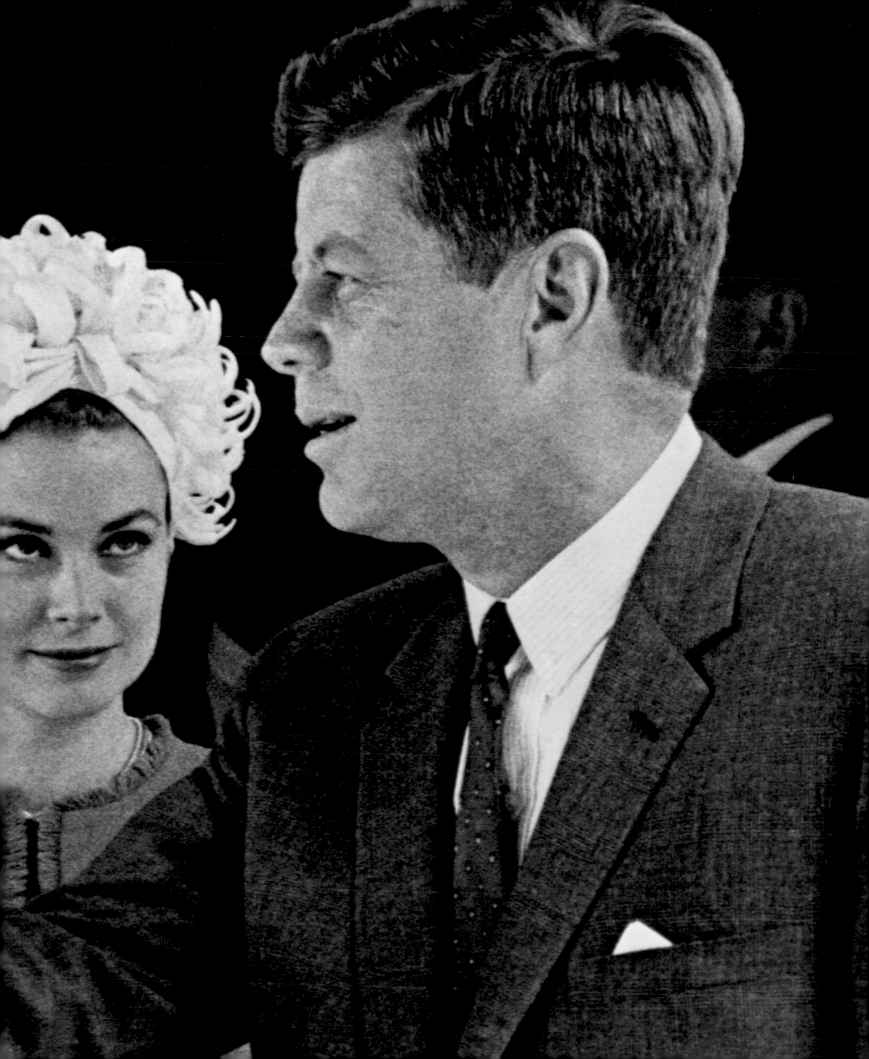

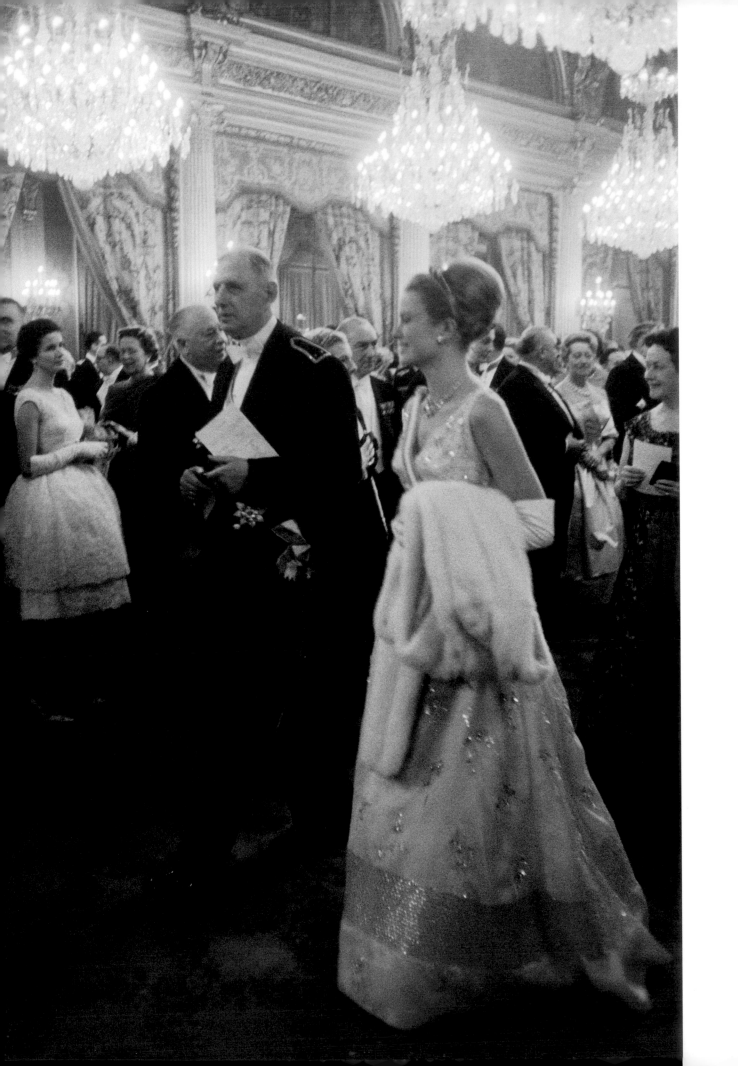

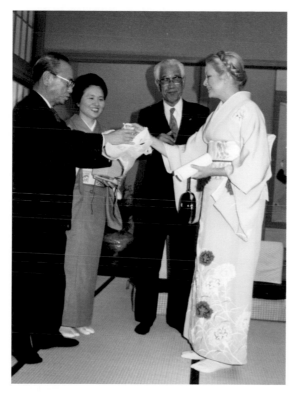

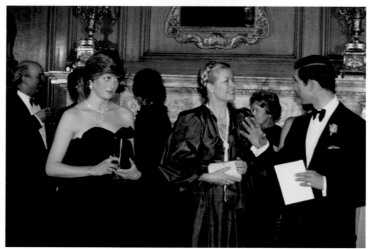

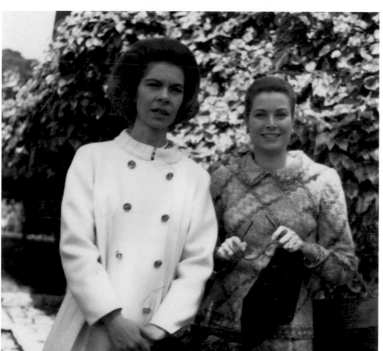

From left to right, top to bottom: **Felici**, Official visit to Japan, April 1981. — Official visit to Pope John Paul I after attending his Coronation Mass, Vatican, September 1978. — **Prince Rainier III**, Princess Grace and Queen Irene of Greece, c. 1968. *(Prince's Palace Archives. Monaco)*
Lady Diana, Prince Charles and Princess Grace, 1981.
Facing page: **Manual Litran**, The President of the French Republic, Charles de Gaulle, welcomes the royal couple to a gala evening at the Elysée Palace, October 13, 1959.

"You tell me that journalists are as crazy about me as about Pelé. And yet they haven't seen me play soccer . . ."

Françoise Huguier, Fancy dress for "1900" Ball. (Loan: Prince's Palace. Monaco)

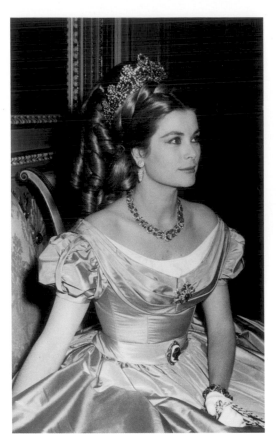

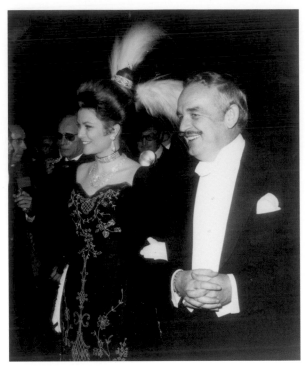

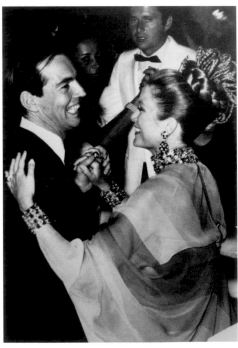

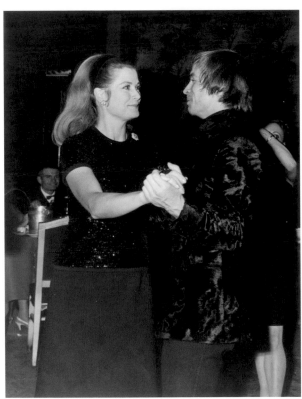

From left to right, top to bottom: Prince Rainier III and Princess Grace of Monaco at the "Bal des Coiffes", Monte Carlo Casino, March 17, 1969.
Georges Lukomski, Centenary Ball, May 27, 1966. *(Prince's Palace Archives. Monaco)* — Princess Grace and Prince Rainier III make their entrance at the "1900" Fancy Dress Ball,
March 17, 1968. — H.S.H. Princess Grace dancing with Dr. Christian Barnard, Red Cross Ball, August 9, 1969.
H.S.H. Princess Grace dancing with Rudolf Nureyev, c. 1970. *(Prince's Palace Archives. Monaco)*
Facing page: **Françoise Huguier**, Centenary Ball gown. *(Loan: Prince's Palace. Monaco)*

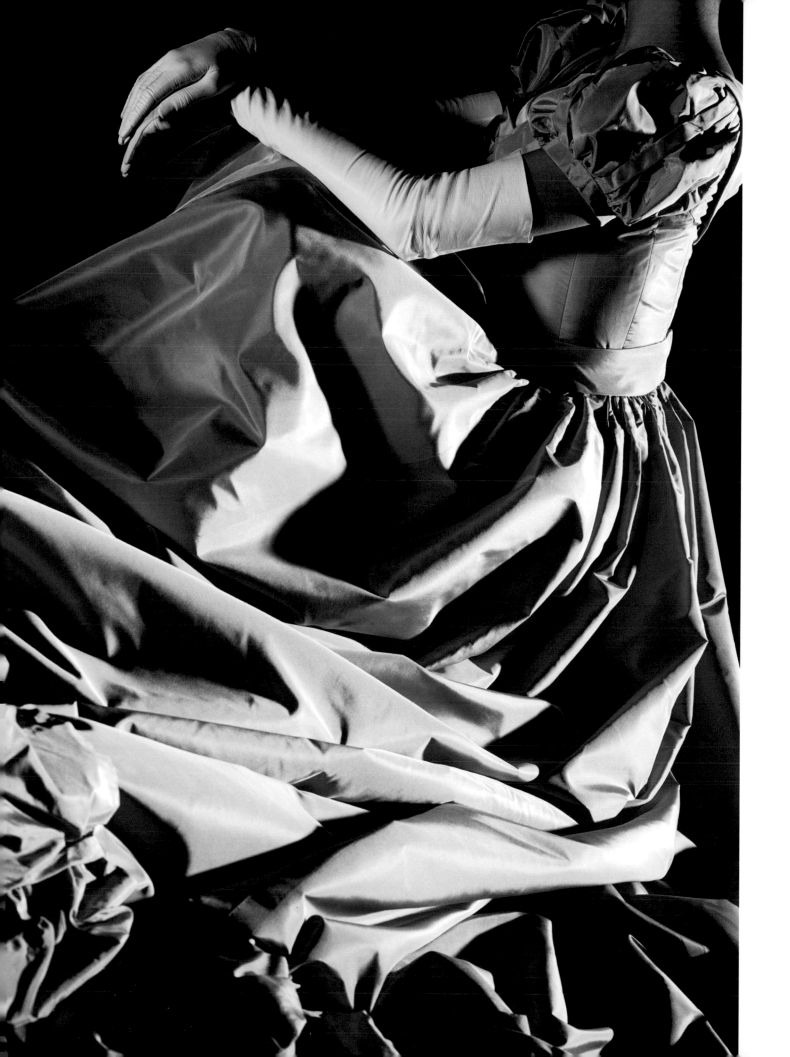

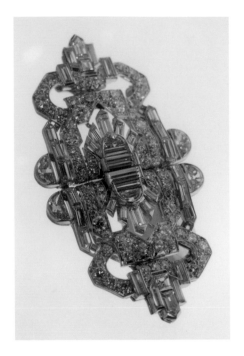

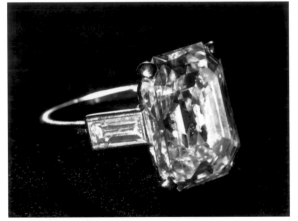

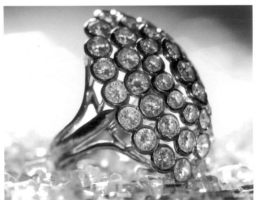

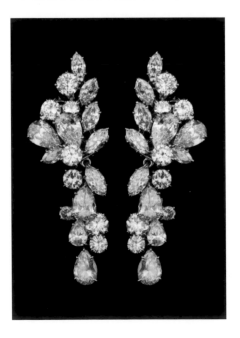

From left to right, top to bottom: **Sebastian Rosenberg**, Art deco diamond and platinum brooch.
Sebastian Rosenberg, Engagement ring with emerald-cut diamond, 1956.
Sebastian Rosenberg, Marquise ring by Cartier.
Antfarm photography, Pair of earrings with diamonds by Van Cleef & Arpels. *(Loan: Prince's Palace. Monaco)*

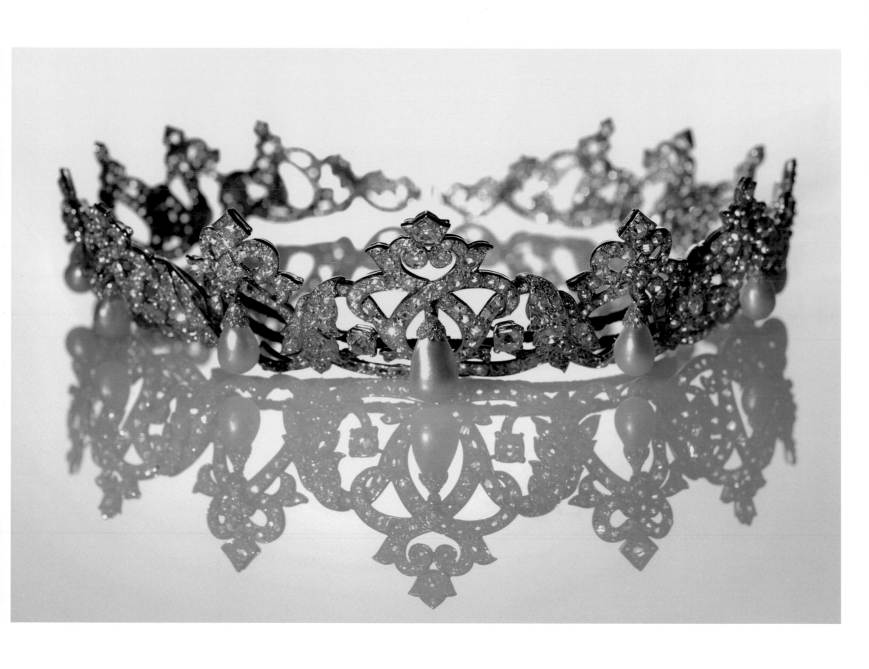

Sebastian Rosenberg, Diadem in platinum and white gold by Cartier, from Princess Charlotte's collection, worn by Princess Grace of Monaco at the Centenary Ball in 1966. *(Loan: Prince's Palace, Monaco)*

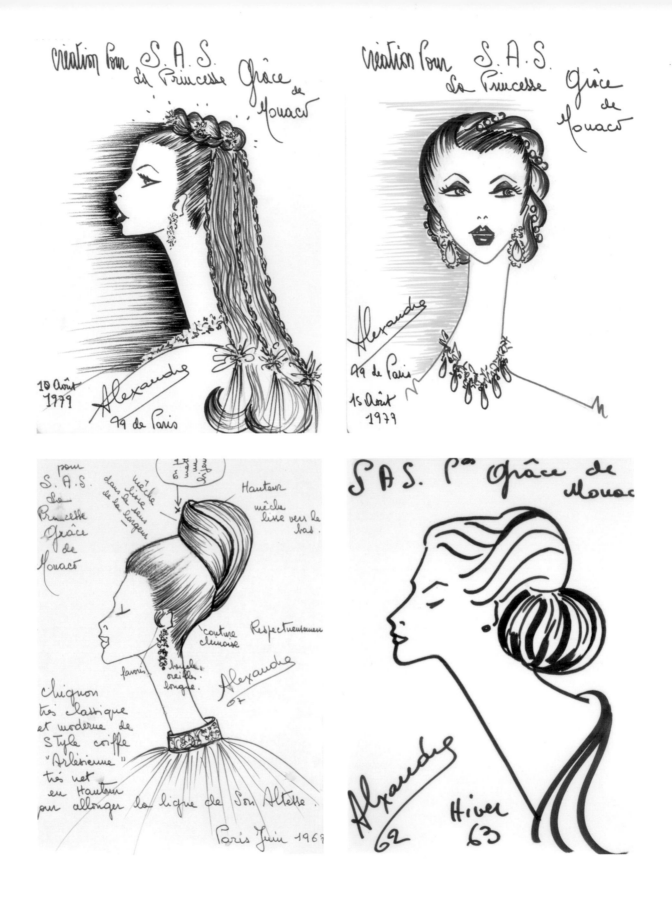

From left to right, top to bottom: **Sebastian Rosenberg**, Sketch of Alexandre de Paris "Creation for H.S.H. Princess Grace of Monaco", August 10, 1979.
Sebastian Rosenberg, Sketch of Alexandre de Paris "Creation for H.S.H. Princess Grace of Monaco", August 15, 1979. *(Prince's Palace Archives. Monaco)*
Sketch of Alexandre de Paris for a "very classical yet modern chignon in the "Arlesienne" style, very tall so as to lengthen H.S.H.'s outline", Paris, June 1967.
Sketch of Alexandre de Paris, "Creation for H.S.H. Princess Grace of Monaco", winter 1963. *(Loan: Prince's Palace. Monaco)*

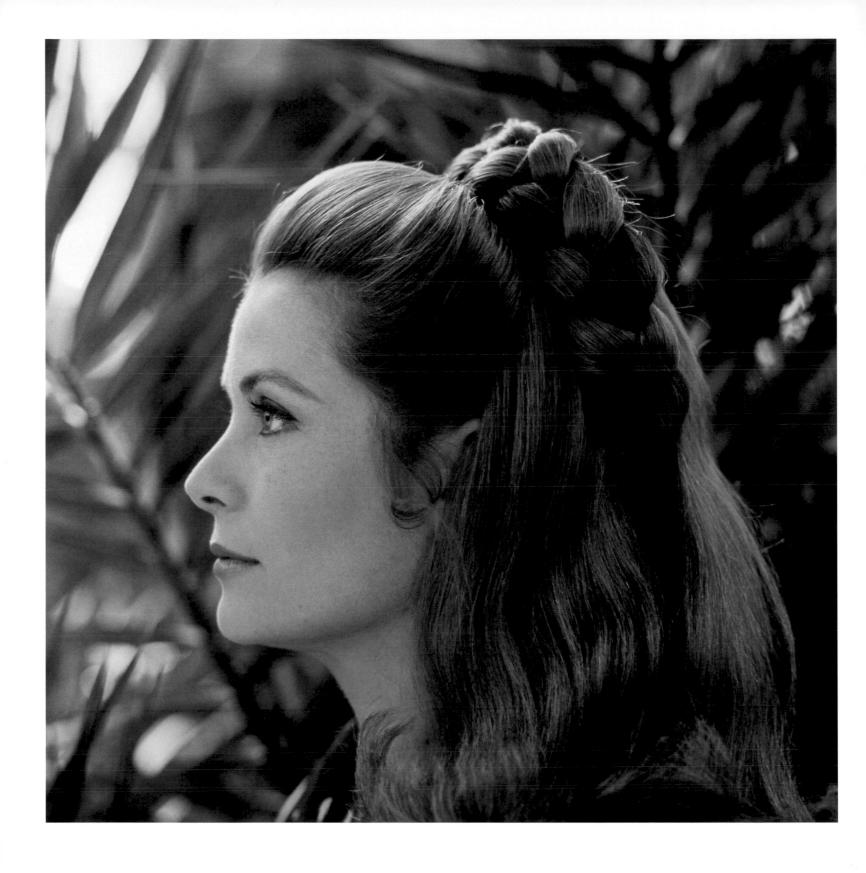

Lord Snowdon, Portrait of Princess Grace of Monaco, Monaco, 1972.

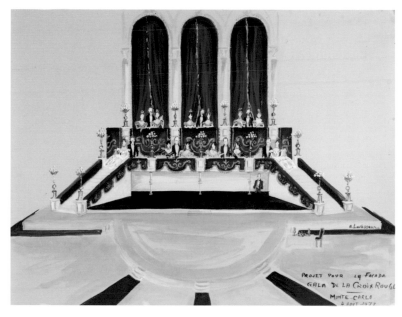

From left to right, top to bottom: **Sebastian Rosenberg**, Sketch by the set designer André Levasseur for the Summer Sporting Club, 1956.
Christian Dior's former assistant André Levasseur was the set designer for all the receptions organised by Princess Grace, who admired his talent and generosity. He was responsible for many wonderful temporary tableaux; the models and sketches made for them speak of an enchanted world inspired by the creations of Jean Cocteau and Christian Bérard.
Sebastian Rosenberg, Sketch by the set designer André Levasseur for the Red Cross Gala, 1969, Sketch by the set designer André Levasseur for the Red Cross Gala, "The grand cabaret".
Sketch by the set designer André Levasseur for the façade of the Red Cross Gala, August 4, 1972. *(Jean-Bernard Collection Fournaise)*
Facing page: **Jean-Jacques L'Héritier**, Glass engraved with the figures of the royal family. *(Loan: Prince's Palace. Monaco)*

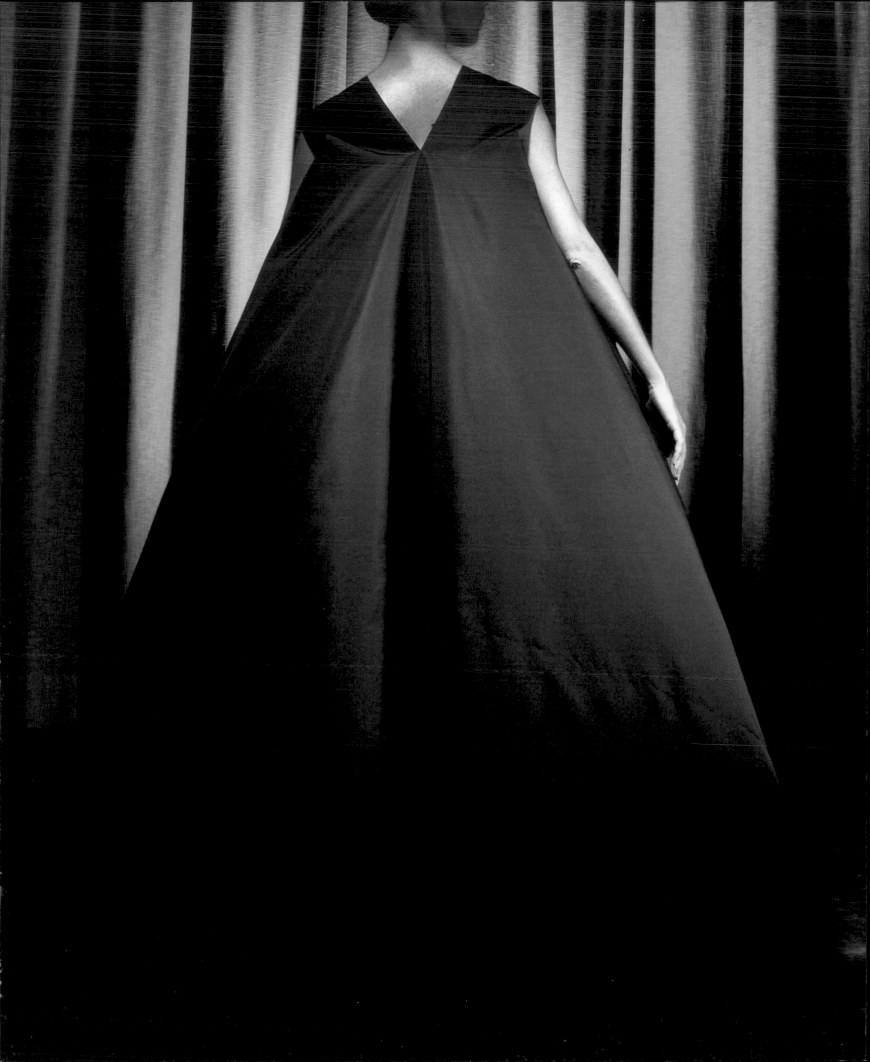

Previous pages: **Françoise Huguier**, Silk ottoman dress by Grès. Jersey dress by Grès. Hanae Mori dress. *(Loan: Prince's Palace. Monaco)*
Facing page: **Françoise Huguier**, Organza dress by Christian Dior, 1973. *(Loan: Prince's Palace. Monaco)*
Following pages: **Françoise Huguier**, Silk muslin dress by Chanel. Silk muslin dress by Christian Dior with ostrich feathers, 1965. *(Loan: Prince's Palace. Monaco)*

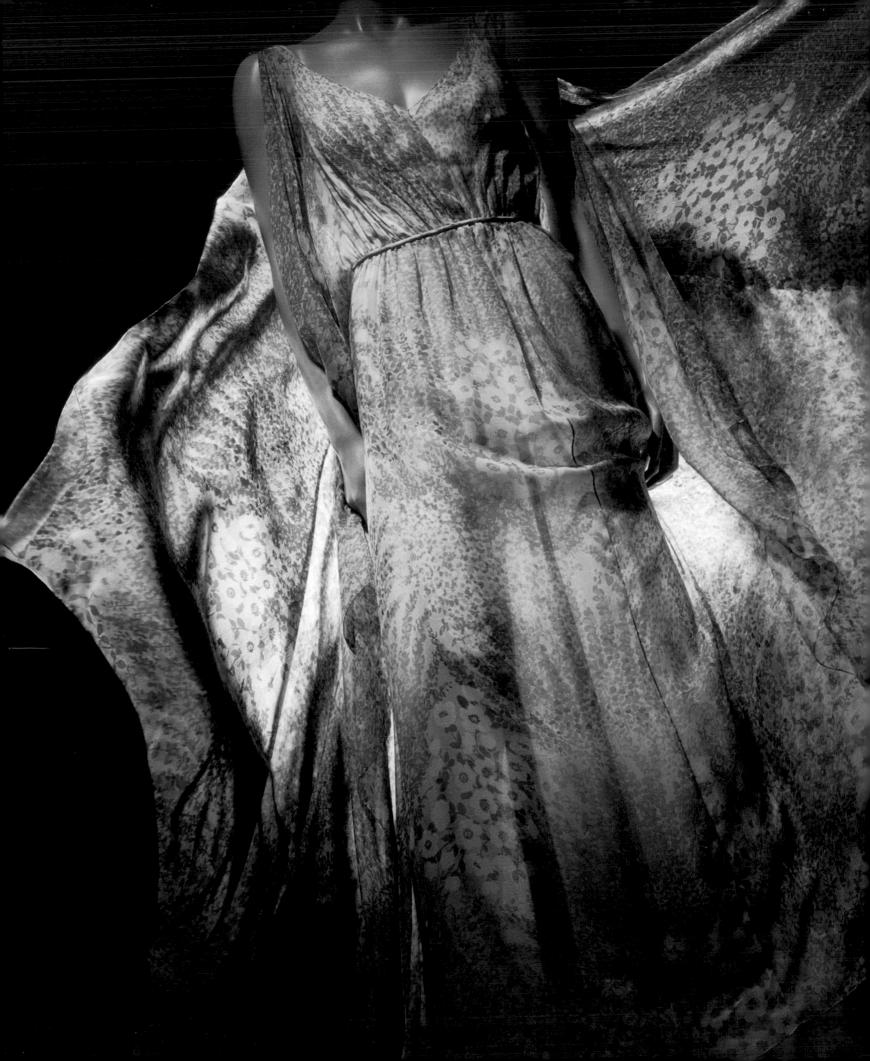

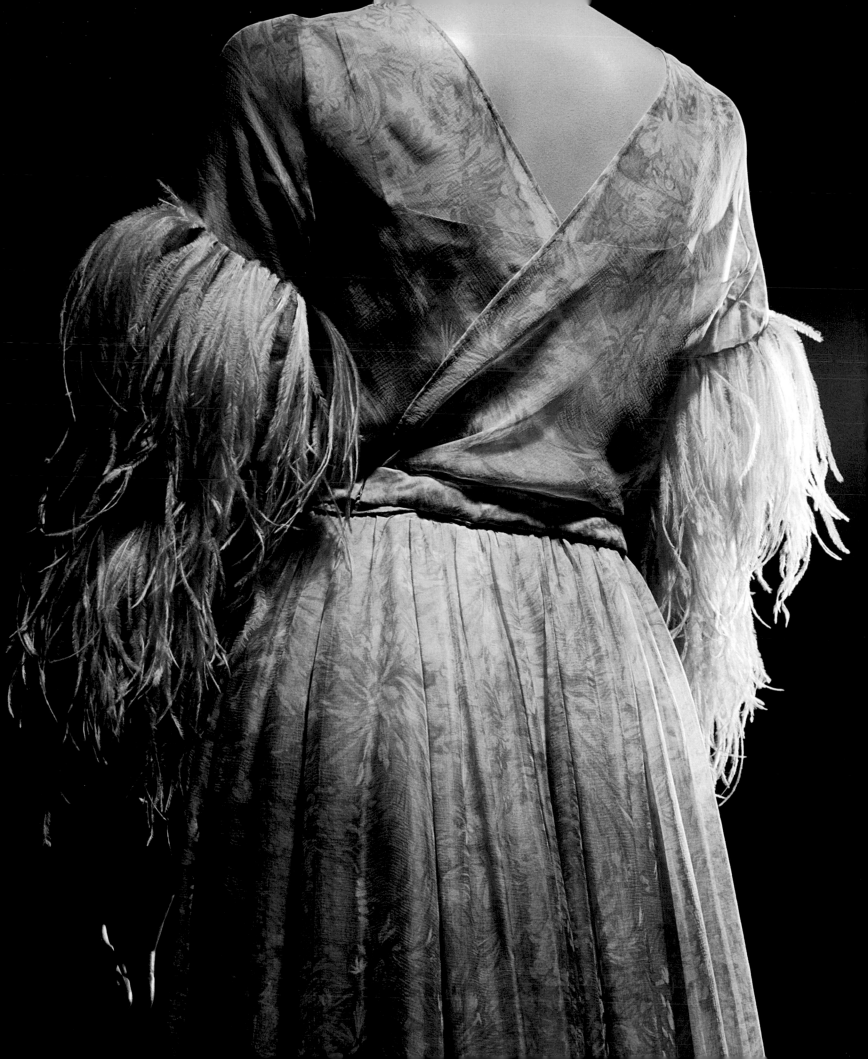

BUCKINGHAM PALACE

9th June 1960.

Dear Princess Grace,

　　　　　I am indeed grateful to you
and Prince Rainier for your kindness in
giving my son Andrew the beautiful diamond
studded watch.

　　　　　It is a charming present, and I
am sure that when he grows up he will come
to value it as greatly as I do now.

　　　　　With many thanks and with best
wishes to you both,

　　　　　　　　　Yours sincerely

　　　　　　　　　Elizabeth R

Her Serene Highness
　　The Princess of Monaco.

Jean-Jacques L'Héritier, Letter from Queen Elizabeth, June 9, 1960. *(Prince's Palace Archives. Monaco)*
Facing page: **Françoise Huguier**, Still life with white gloves and hat. *(Loan: Prince's Palace. Monaco)*

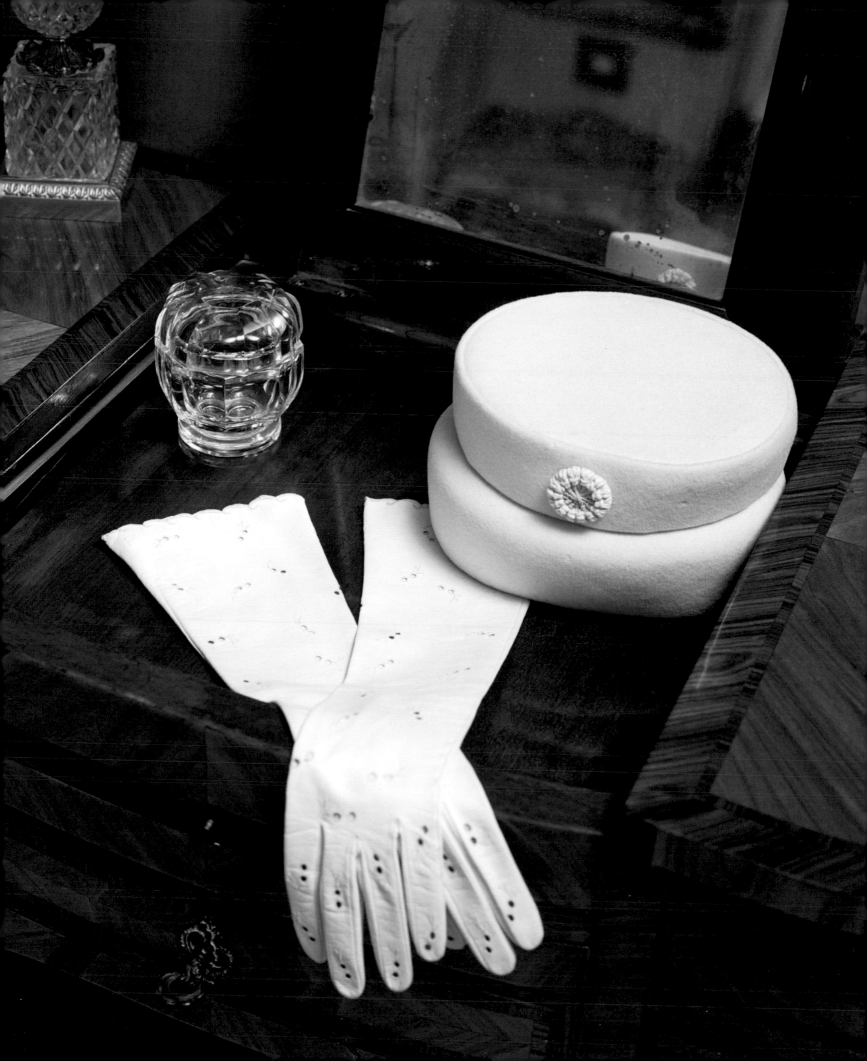

The "Kelly Bag" is one of the twentieth century's finest poetic metaphors, expressing the radical transformation of women's lives in winning their independence and needing such an indispensable accessory for their activities, and at the same time the continuation of the luxury craftsmanship tradition of France which the Maison Hermès has consistently embodied, and the secret of true elegance: simplicity and beauty in all things functional.

An object of desire, envy and sometimes, unfortunately, plagiarism, it remains peerless and irreplaceable; its story has escaped from fashion and from time, and like all other legends it lends itself to a range of interpretations which, mischievously but with exquisite taste, the Maison Hermès has brought out, and to which Leïla Menchari has now given a magnificent setting in its famous shop windows in the Faubourg Saint-Honoré. Starting with the original and unchanging pattern, the "Kelly Bag" now plays with new colours, textures, motifs and even occasions on which women may dream of carrying such a bag and awakening the admiration of their menfolk. A number of special editions have been issued to honour the memory of Princess Grace: in organdie, in Plexiglas, in different colours, with embroideries by Lesage — never forgetting, of course, the classic leather bag Grace Kelly herself regularly used.

The origin of the name "Kelly" is rather mysterious. The "Kelly Bag" was invented in the thirties by Robert Dumas, its ancestor a nineteenth-century saddlebag; but it was only when one was bought by Grace Kelly, heroine of Alfred Hitchcock films and Oscar-winning Hollywood star in the full glory of her youth and celebrity (before she became Princess of Monaco), that its international popularity was ensured, as shown by countless magazine pictures and newsreels. The prestige and style of its ever-faithful celebrity have combined to give it an unshakeable identity: the "Kelly Bag".

Leïla Menchari — of whom Michel Tournier wrote in a superb portrait that "her marriage with Hermès is not only long-standing, but also a love-match", and whose decisive contribution to the fame of this great Paris fashion house he quite rightly celebrated — could not fail to offer this exhibition a number of versions of the "Kelly Bag". And so we honour this combination of two icons of our age: the masterpiece of many decades of refinement, and the destiny of a quite exceptional woman.

Dennis Stock, Grace Kelly in her Hollywood dressing-room with the famous Hermès "Kelly Bag". *(Hermès Archives)*

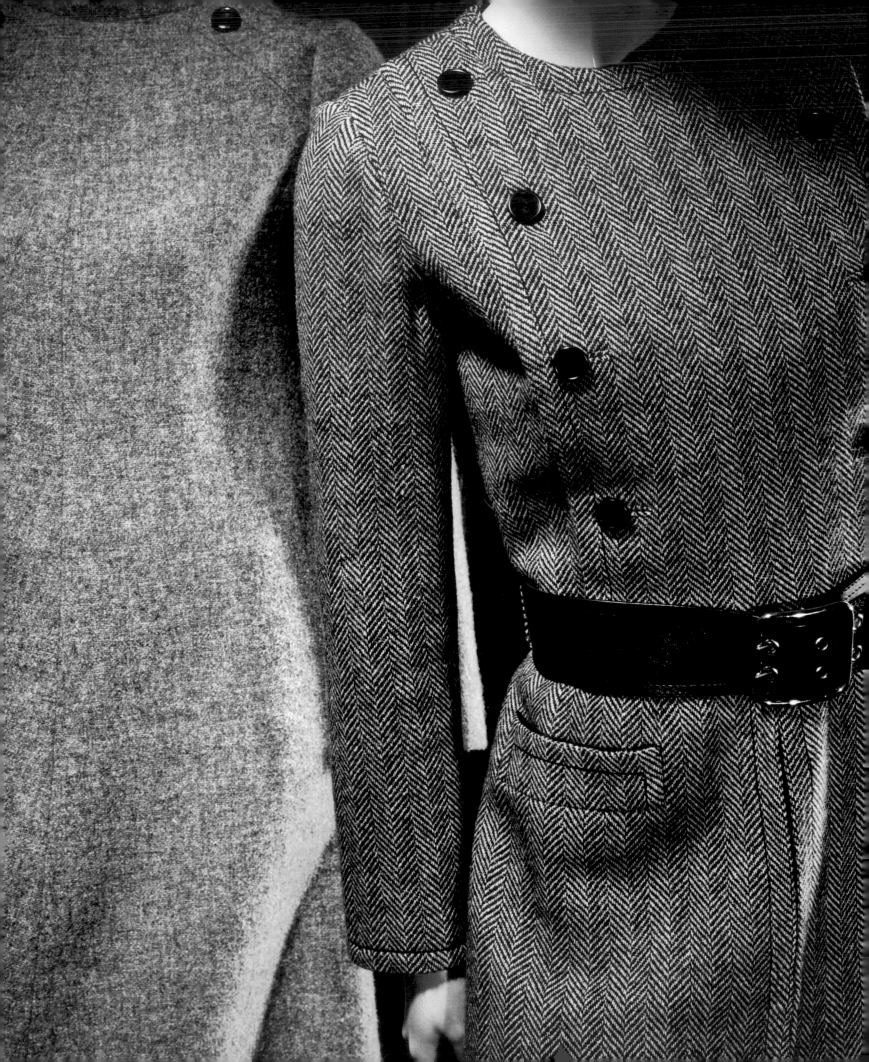

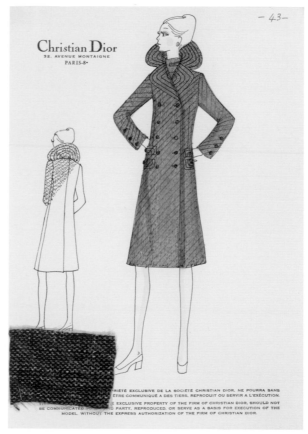

Sebastian Rosenberg, Dior clothes: winter collections 1972–1973. *(Prince's Palace Archives. Monaco)*
Facing page: **Françoise Huguier**, Dresses by Christian Dior. Princess Grace always remained faithful to Marc Bohan, the soul of the Maison Dior. *(Loan: Prince's Palace. Monaco)*

"If there is one thing that is foreign to me it is shopping for pleasure. On the other hand, I believe that it is right to honour all those who create beautiful things and give satisfaction to those who see me wearing them."

Françoise Huguier, Pair of shoes. *(Loan: Prince's Palace. Monaco)*

252

Françoise Huguier, White hat with ribbon. Box for glasses. *(Loan: Prince's Palace. Monaco)*
Facing page: **Françoise Huguier**, Blue hat on a green chair. *(Loan: Prince's Palace. Monaco)*

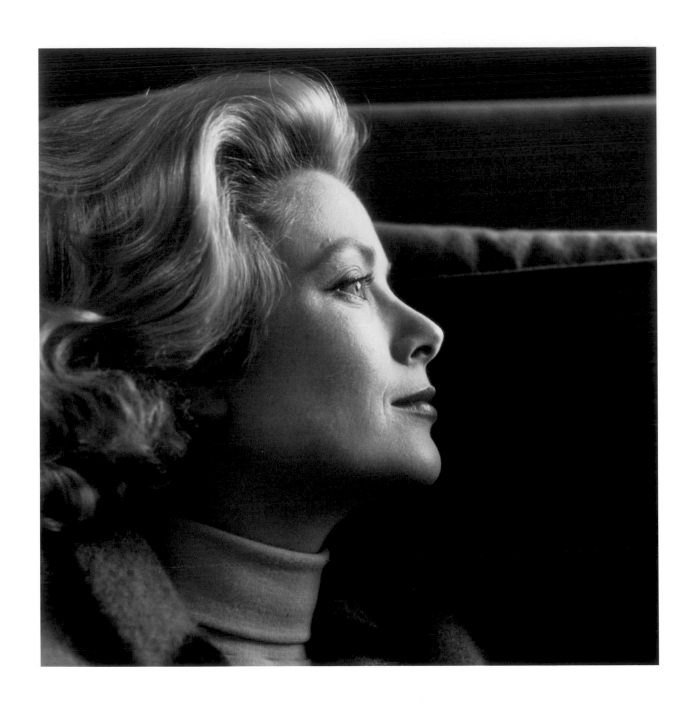

Philippe Halsman, Princess Grace at Gstaad, Switzerland, 1962.
Facing page: **Yul Brynner**, Portrait of Princess Grace. *(Prince's Palace Archives, Monaco)*
Yul Brynner was a remarkable photographer, as well as a famous actor and a man of highly cultivated taste. Princess Grace agreed to pose for him with a poppy
when shooting a cameo part in Terence Young's film *Danger Grows Wild*, made to counter the ravages of heroin.

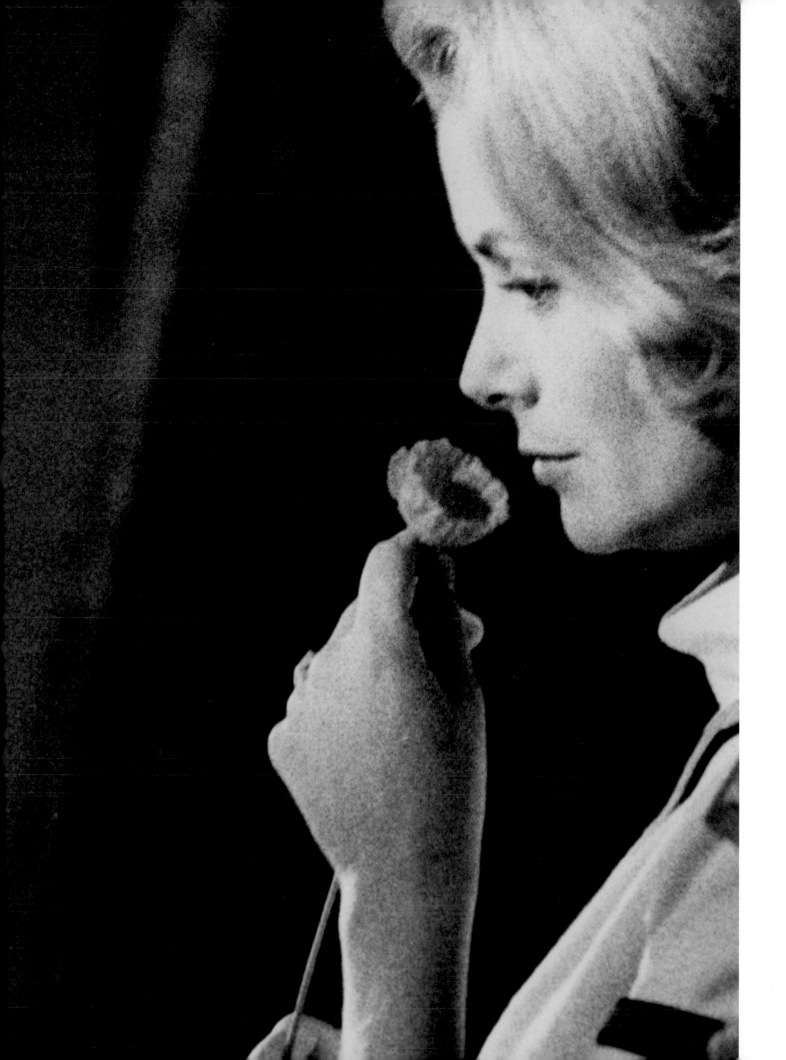

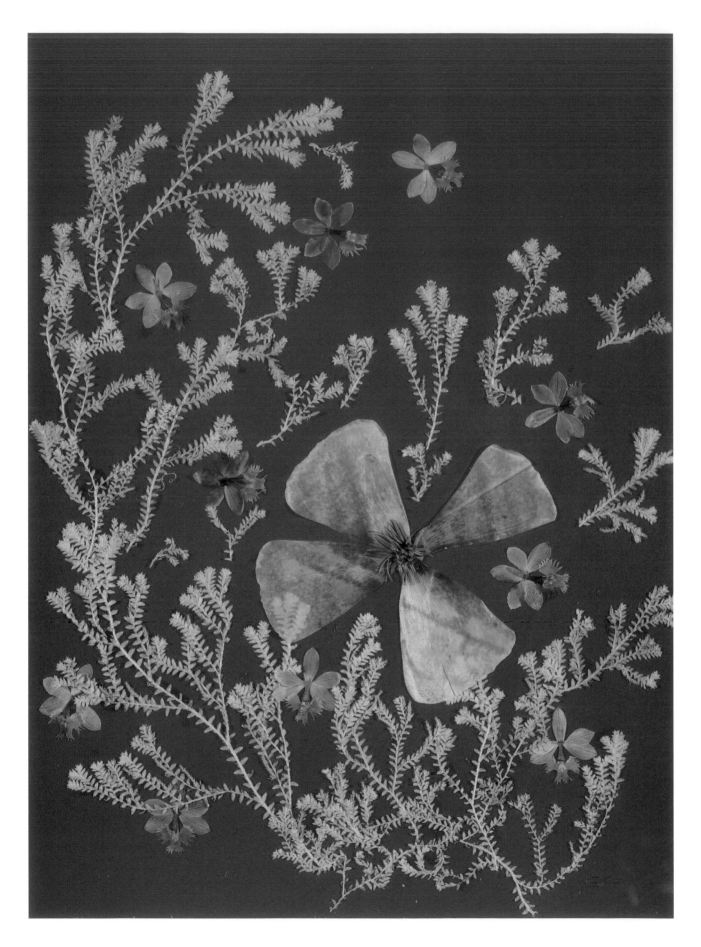

Pressed flower painting by H.S.H. Princess Grace. *(Loan: Prince's Palace. Monaco)*

"My love of flowers opened a lot of doors for me. I've made many friends because of their passion of flowers and their vast knowledge in this field."

"LOVE", pressed flower painting by H.S.H. Princess Grace.
Often exhibited with great success at Drouand's Paris gallery, these pressed flower paintings were more than a hobby for Princess Grace, who put a great deal of careful work into them in her workshop at Roc Agel. *(Loan: Prince's Palace. Monaco)*
Facing page: **Howell Conant**, Prince Rainier III and Princess Grace at Roc Agel, August 23, 1979.

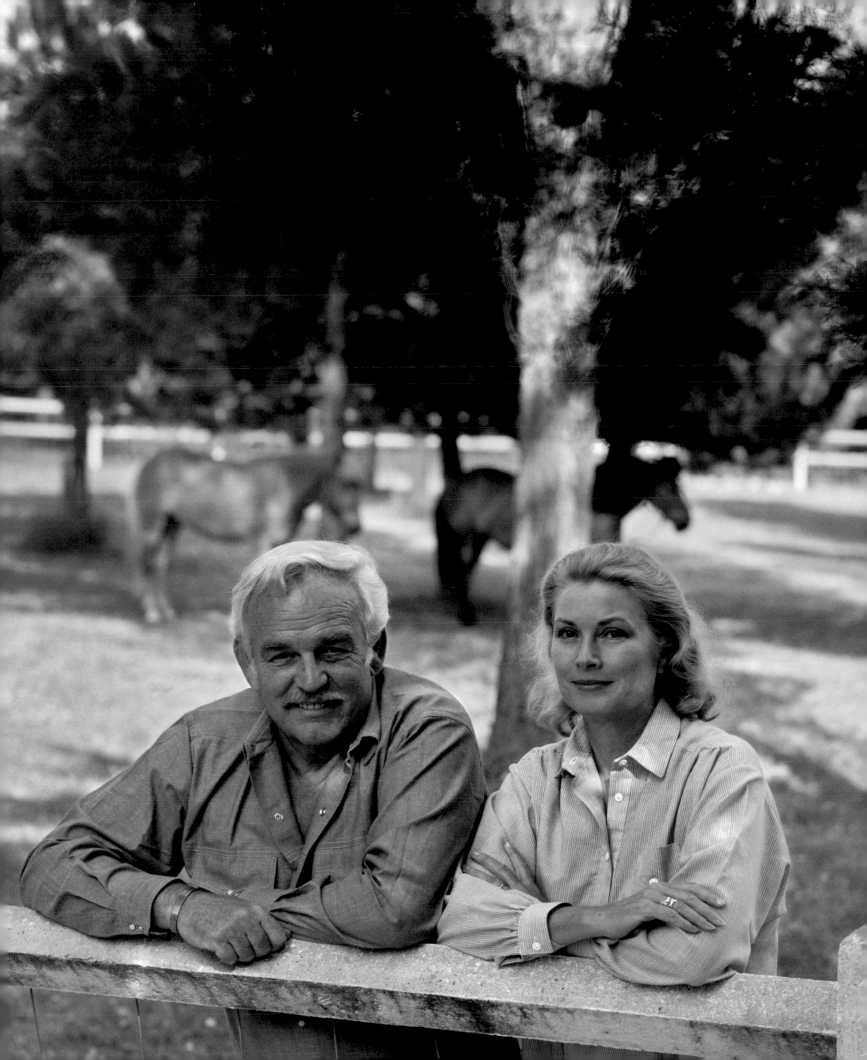

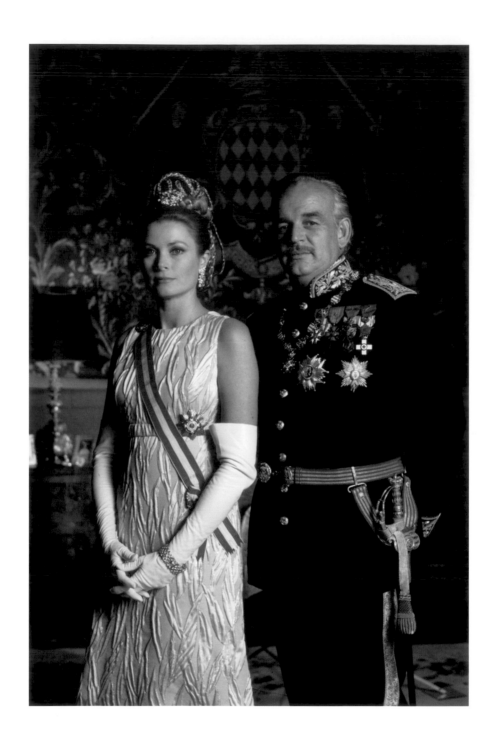

Howell Conant, Official portrait of Prince Rainier III and Princess Grace of Monaco.

"Fairy tales tell imaginary stories. Me, I'm a living person. I exist. If the story of my life as a real woman were to be told one day, people would at last discover the real being that I am."

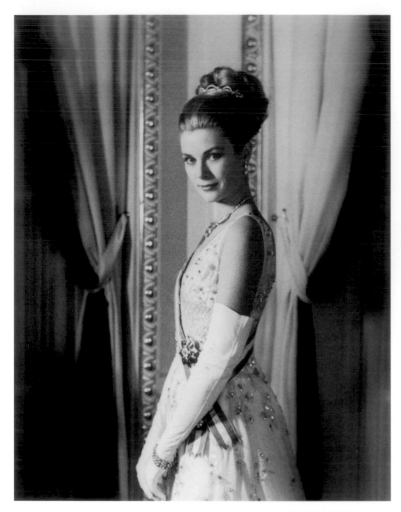
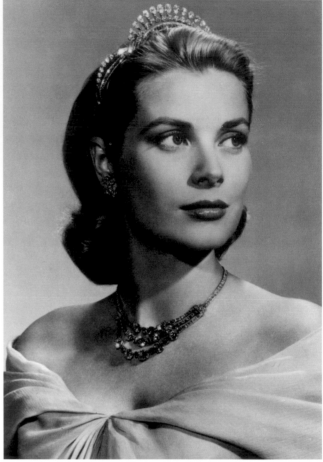
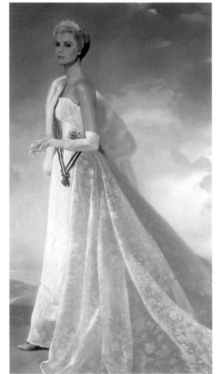

From left to right, top to bottom: **Howell Conant**, Official portrait of Princess Grace of Monaco.
Yousuf Karsh, Portrait of Princess Grace wearing a necklace by Van Cleef & Arpels. *(Prince's Palace Archives. Monaco)*
Ralph Wolfe Cowan, Painting of Princess Grace, 1956. *(Loan: Prince's Palace. Monaco)*
Ricardo Macaron, Painting of Princess Grace, 1977. *(Loan: Prince's Palace. Monaco)*
Facing page: **Philippe Halsman**, Royal portrait of Princess Grace of Monaco, 1963.

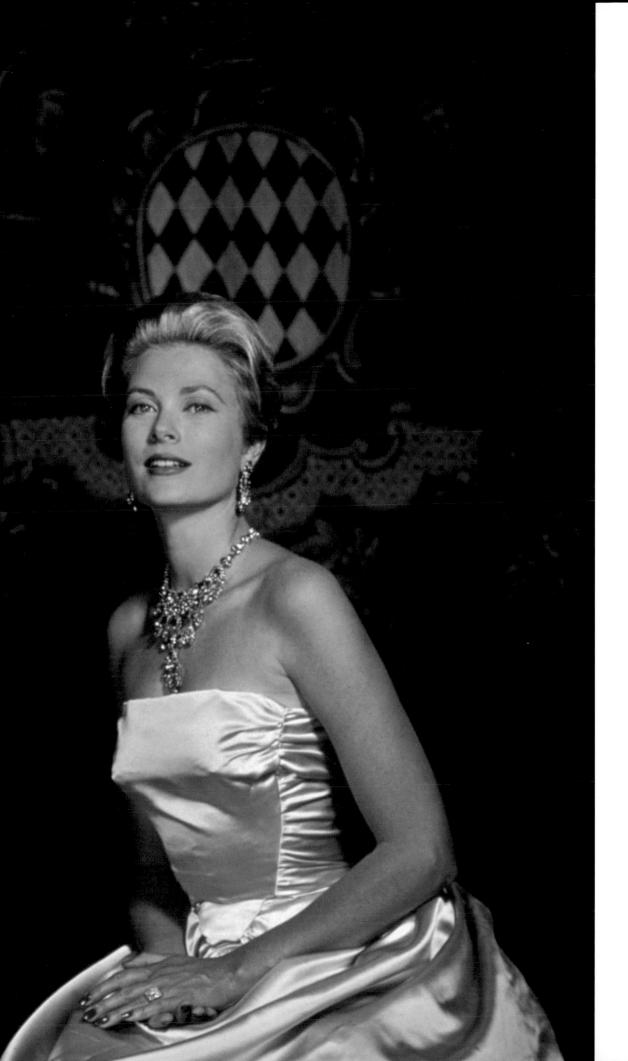

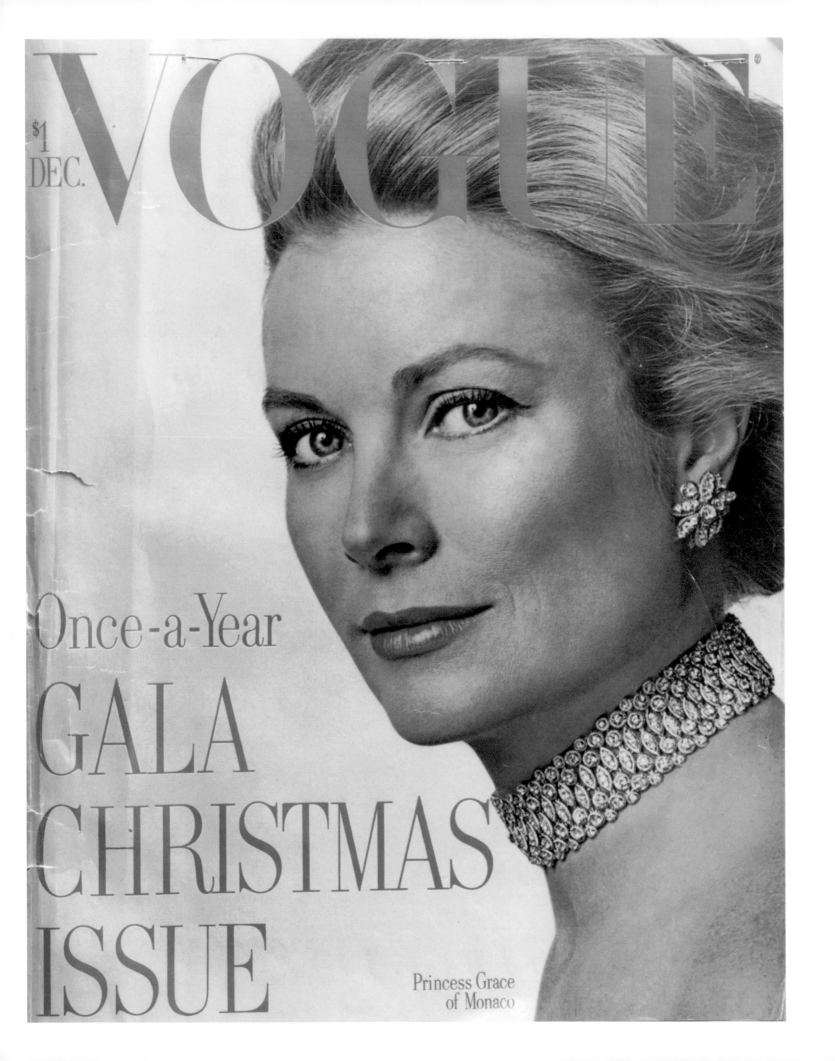

VOGUE

$1
DEC.

Once-a-Year
GALA
CHRISTMAS
ISSUE

Princess Grace
of Monaco

"When I married Prince Rainier, I married the man and not what he represented or what he was. I fell in love with him without giving a thought to anything else."

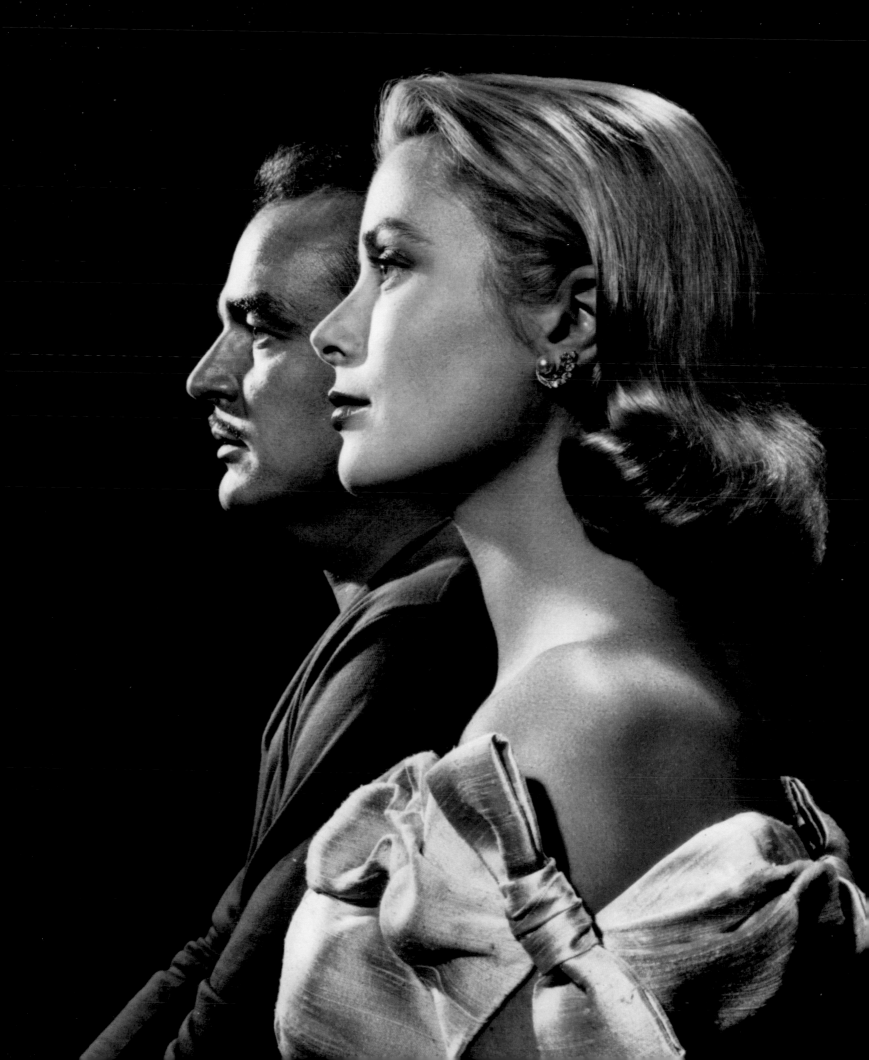

THE LANDMARKS OF A LIFE

From Grace Kelly to Grace of Monaco, from Philadelphia to the Principality, from Star to Princess, one of the goddesses of Hollywood met with an unexpected destiny: Irish roots, a studious childhood in the high society of the East Coast, a debut on Broadway and a brief but glittering film career crowned by three masterpieces directed by Hitchcock and a number of remarkable films that will forever have a place in the history of cinema.

But what really made her a legend was becoming the Princess of Monaco. Her marriage to Prince Rainier, in 1956, remains one of the most prestigious and extensively covered events of the twentieth century.

From that time on, she played her new role with verve: mother of three beautiful children and Princess of a State that enjoyed an extraordinary boom. The art of appearances and a dazzling charisma allowed her to wear the diadem of the Grimaldi to perfection. With her beauty and her radiance, she was forever illustrating the covers of magazines all over the world. So many mirrors for the most elegant of all ambassadresses and the most effective of public relations.

The Princess will remain one of the most admired figures of her time and one of the icons of the twentieth century. With her multiple activities, she refused to become an inaccessible Princess and gave the Rocher back its place in the world. Her ties of friendship with the biggest names in the world of the arts, constantly in the limelight, did not make her forget an infinity of unknowns to whom she never ceased to lend assistance, always with the greatest of discretion.

Foremost social worker of the Principality, tireless Minister of Culture, she embodied the state of grace for the Monegasques.

A tragic accident prevented her from completing her work. But twenty-five years after her death her memory remains indelible.

PHILADELPHIA ROOM

The Kelly clan is of Irish origin, and it was Grace's grandfather John Henry who, by leaving for the New World in 1867, opened the American saga. One of his sons, John B. (nicknamed "Jack"), quickly came to represent thc self-made man par excellence. His force of character, combined with out-of-the-ordinary physical gifts, allowed him to become an Olympic rowing champion in 1920 and to make his brickwork contracting company the most important on the East Coast. In the end, Philadelphia high society accepted him as one of its own.

His marriage, in 1924, to the beautiful Margaret, of German origin, put the finishing touches to this brilliant career. They had four children: one son (John B. Jr.) and three daughters (Margaret, Grace and Lizanne). All were going to symbolise the image of an American-style success, that of a gilded family nurtured on sound Catholic principles.

Grace Patricia Kelly came into the world on November 12, 1929 and occupied a difficult place in the family: the third-born, wedged between an adulated brother (as sole heir to the name) and a pampered little sister.

During her childhood, the most delicate of the Kelly girls always kept in the background. Even as an adult, she would never completely lose her manner of seeming ready to shy at anything; it would give her the charm of a young fawn. Her personality emanated a subtle sort of distance that set her apart from the hustle and bustle of a family dominated by stubborn fighters. Would she inherit the artistic gifts of Uncle George, a playwright who had won the Pulitzer Prize? Her love of theatre revealed itself in her adolescence. At the age of twelve, she made her debut in amateur drama and, after attending a performance of the Ballets Russes, dreamed of becoming a *prima ballerina*. She quickly grew into a slender girl filled with charm. If she turned men's heads, it didn't make her at all vain. Her childhood and her upbringing had inculcated a modesty that she would never lose.

Yet she was drawn by the demon of the stage. In 1947, at the end of her high-school studies, she confessed her artistic calling to her perplexed parents. The only place she wanted to continue her studies was the American Academy of Dramatic Arts in New York. With their agreement, she sailed through her audition with flying colours on August 20, 1947. She was on her way to New York!

NEW YORK ROOM

In October 1947, Miss Kelly was admitted to the city's very serious American Academy of Dramatic Arts. Her parents supervised her installation in the comfortable and strict *Barbizon Hotel for Women*. The fledgling actress then embarked on a two-year course entailing all sorts of lessons: in literature, diction, performing . . .

The timetable of the course left her with time on her hands, which she filled by working as a model. She earned from seven to twenty-five dollars an hour posing for fashion and advertising photos: cigarette brands, shampoos, beauty creams, etc. Her milky complexion, the perfect oval of her face, her manageable blond hair and her dreamy blue eyes reflected a healthy image of middle America. Grace Kelly already showed a real photogenic talent, backed up by a flawless professionalism.

If her work as a model proved profitable, her debut as an actress remained modest. Miss Kelly had a particular handicap: her height! She was too tall for the ingénue roles that her face and her light-coloured eyes suggested to directors. She also needed to train her voice. Finally, in November 1949, Broadway offered her the part of Raymond Massey's daughter in Strindberg's *The Father*. She was a hit with the critics, but the play did not have a long run. She soon moved to an apartment in the heart of Manhattan and saw the doors of the emerging medium of television thrown open for her. Like James Dean and Steve McQueen in the same period, she entered the world of weekly televised dramas. Thus, it was on the small screen and in around fifty live broadcasts that she learned the fundamentals of the actress's craft.

The camera liked her and she had a strong presence and "style". Her agent, Edith van Cleve, had such faith in her that she managed to land her a small part in Henry Hathaway's *Fourteen Hours*. Grace Kelly arrived at Metro-Goldwyn-Mayer in white gloves and refused to give her vital statistics. In the land of would-be stars, her timidity was astonishing, her simplicity was misunderstood and her shortness of sight imposed on her a reserve that was seen, quite wrongly, as arrogance. As soon as the shooting was over, she went back to New York.

But on August 10, 1951, a telegram from the producer Stanley Kramer arrived on her agent's desk: "For the attention of Grace Kelly. Be in Los Angeles on August 28. Lead role with Gary Cooper. Title of the film: *High Noon*." Her tryst with Hollywood had begun.

HOLLYWOOD ROOM

From 1951 to 1955, Grace Kelly appeared in eleven films. In particular the MGM, Paramount, United Artists and Warner studios hired her for *High Noon*, *Mogambo*, *The Country Girl* (which won her the Oscar for Best Actress in 1954), *The Swan*, *High Society* and three of Hitchcock's thrillers.

The press unanimously praised her talent. The public, which was not short of symbols and pin-ups, immediately took a liking to her. She had the gift of winning people's affection not just for her talent and her beauty, but also for her human qualities. In the Mecca of cinema, agents and gossips tried to penetrate the secret of her reserved personality. Who really was this Grace Kelly, a rich and famous woman who went back to New York as soon as the shooting was finished, who could be found at Mass every Sunday morning and showed not the least sign of having an intimate relationship? No one dared to take advantage of her. Her discretion was respected and the press agents did not risk linking her name with actors for the purposes of publicity.

At the same time as the brunette Audrey Hepburn, the blonde Grace Kelly imposed her own canons of beauty on Hollywood, where the quip soon began to circulate: "All men dream of spending the night with Marilyn Monroe, but of spending their life with Grace Kelly."

Over the years Joan Crawford, Lauren Bacall and Ava Gardner had incarnated the dangers, the frenzies of a passion that threatened male supremacy . . . Grace Kelly turned these images on their head: she represented a calm that concealed the storms. As one photographer put it: "She is the sort of woman that you place on a pedestal; you walk around her and then you go out of the museum!"

Right from the start, she stood out without trying to, by her presence alone. Her natural dignity cloaked her like a protective cocoon and she fascinated her celebrated partners: Gary Cooper, Clark Gable, James Stewart, William Holden, Cary Grant and Alec Guinness.

But it was no bed of roses in Hollywood. The actress felt trapped by her contract with MGM and obliged to shoot one film after another without a break (she acted in six of them over the period 1953–1954). Her Californian blues hinted at a possible dramatic turn of events in the movie of her life.

HITCHCOCK ROOM

In the spring of 1953, Alfred Hitchcock came onto the scene. After Joan Fontaine and Ingrid Bergman, he was on the lookout for a new and ideal actress. He fell in love with Grace Kelly immediately. The fairness of her hair, her class and her refined coolness were ideally suited to the kind of heroine of whom he dreamed. He confided: "She has exactly what I have long been looking for. She is seductive without being sexy. Under an icy surface, she seems to burn with an inner fire that will do wonders on the screen." And indeed the majority of the English director's films star a blonde actress of glacial, almost unreal beauty, who seems to be an incarnation of good in the face of evil, but at the same time embodies the desires of the master of suspense.

Their double act commenced with the delightfully diabolical *Dial M for Murder*. It continued, in October 1953, with the thrilling *Rear Window*, and then, in the summer of 1954, unfortunately came to an end with *To Catch a Thief*, a charming detective comedy set against the backdrop of the Riviera and stolen jewels. Finally, in 1962, Grace's new royal status would prevent the director from hiring her for *Marnie*.

Through Hitch's talent, Grace Kelly achieved a tremendous presence on the screen. The shot in which she plants a kiss on James Stewart's forehead in *Rear Window* or the one in which she appears with Cary Grant against a background of fireworks in *To Catch a Thief* are classic scenes.

Dressed in costumes designed by Edith Head, Grace Kelly offered a delightful cocktail of charm, class, mischievousness and seduction in the service of a stunning science of the cinematographic narrative. She had found her Pygmalion and the director his favourite actress.

FIRST MEETING ROOM

On April 26, 1955 the eighth International Film Festival opened in Cannes. Invited for the presentation of *The Country Girl*, Grace Kelly had intended to stay for only three days, with a busy schedule. On the *Train Bleu* that took her from Paris to Cannes, she travelled in the company of Olivia de Havilland and her husband, Pierre

Galante, a journalist for *Paris Match*. The man of the press had an original idea for a story: "It would be fabulous to take pictures of you with Prince Rainier of Monaco!"

The star seemed hesitant. But Pierre Galante insisted: the celluloid Princess of Hollywood meeting a real Prince, in flesh and blood, in front of the lens . . . What a scoop! A meeting was arranged on the Rocher, at three in the afternoon, on May 6, 1955. When Miss Kelly arrived at five to three, the Palace was gleaming in the spring sunshine. A hoisted flag announced the presence of the Prince, even though he was not actually there yet! To pass the time, Grace was shown around the place. Rainier eventually turned up at the wheel of his sports car. One last time, Grace practised her curtsey. A waste of time: in front of the sovereign, she confined herself to a vague gesture. Besides, the Prince's unaffectedness and youthful smile surprised her and soon put her at her ease. There was nothing starchy about him and she quickly fell under his spell!

The couple strolled for a while in the Palace gardens. The Prince showed her his private zoo and his big cats. The two of them felt alone in the world. He put his arm through the bars of a cage and caressed a tiger. Grace observed the scene with attention. The visit came to an end and they took leave of one another with regret.

In the car that took her back to the festival, Grace said not a word. But, for the first time in her career, the most scrupulous star in Hollywood arrived late for a reception. As if to excuse herself, she declared that same evening to Olivia de Havilland: "He is very, very charming!" The next day, she sent a thank-you note to her host. The first exchange of letters in a correspondence that was going to forge a secret bond in the months that followed . . .

WEDDING ROOM

The conspiracy had begun and the secret was absolute. While the actress was finishing the shooting of *The Swan*, Prince Rainier arrived in New York on December 15. Was it by chance that the sovereign was invited to spend Christmas with the Kelly family in Philadelphia?

It was not until New Year's Day that the Prince asked for the Star's hand. The official announcement was made on January 6, 1956, during a gala at the Waldorf-Astoria attended by everybody who was anybody in New York, as well as the international press.

On the Rocher, the news was received with jubilation and the future Princess became the darling of all the editorial offices. In Hollywood, where for the first time a Star was going to marry a reigning monarch, Grace Kelly was on everybody's lips. Did she really intend to give up the cinema for love? As an elegant farewell to Hollywood, she shot the very chic *High Society* with Frank Sinatra, Bing Crosby and Louis Armstrong at a frantic pace and, on April 4, finally left New York aboard the *Constitution*, accompanied by the Kelly family and over sixty guests.

On April 12, Prince Rainier's yacht came out to meet the ship. The whole of Monaco lined the quays and watched the reunion of the husband and wife to be underneath a shower of red carnations dropped from a seaplane.

Finally, at the end of a real marathon of official festivities, the civil marriage took place in the throne room of the Princely Palace on April 18, 1956. Grace Kelly became Her Most Serene Highness Princess Grace of Monaco, one of the most titled women in Europe.

The next day, the new Princess entered the cathedral, dressed in a gown of lace, silk, taffeta and tulle designed by Helen Rose. She had the hieratic and touching beauty of a medieval Madonna and was paralysed with emotion when the time came to say "yes". Thirty million viewers watched this religious ceremony on Eurovision, and it was described by *Time* magazine as "the most romantic event since Romeo and Juliet!"

From that moment on Grace of Monaco, sustained by the trust and love of Prince Rainier, established a relationship of intense affection with the Rocher that was to last for over twenty-six years.

BALL ROOM

Through her presence, her keen sense of organisation and her public relations, Princess Grace revived the tradition of grand balls in Monaco. She sought the unfailing support of the great decorator André Levasseur, former assistant of Christian Dior and poet of the temporary setting, who would be responsible for the staging of each soirée.

A few weeks after her marriage, the Princess made her first appearance at the gala of the Monaco Red Cross. She was dazzling. Very rapidly she became the consummate organiser of this summer event. A perfectionist through and through, she left nothing to chance. Among the guests: Danny Kaye, Zizi Jeanmaire, Ella Fitzgerald, Charles Trenet, Maurice

Chevalier, Line Renaud, Charles Aznavour, Lena Horne, Harry Belafonte, Frank Sinatra, Sammy Davis Jr., Nat King Cole . . . and Josephine Baker for her final comeback. The other great event of the year was the Rose Ball, marking the return of spring. A hundred violins greeted the guests.

She gave each of these celebrations a glamour that fascinated even her most prestigious guests. The memorable Ball of the Scorpios (November 15, 1969) welcomed Richard Burton and Elizabeth Taylor. Full-dress Ball, Chinese Ball, Ball of the Centenary of Monte Carlo where she appeared as Empress Eugénie: Princess Grace had a knack for staging dazzling festivities to which international high society flocked.

ROOM OF FRIENDS

Two years after her marriage, the family scene was as harmonious as could be wished. Princess Grace had assured the succession in her adopted country and brought the Palace and the grand Monegasque soirées back to life.

Faithful to the model that she had set for herself, the Princess always did her best to preserve the ties of friendship with her former colleagues and friends in Hollywood and with numerous actors and performers. The Palace staff had the privilege of encountering in the corridors people like David Niven, Greta Garbo, James Stewart, Cary Grant, Rudolf Nureyev and Margot Fonteyn.

The friends of the Prince and Princess included not just movie stars like Ingrid Bergman or Peter Ustinov, but also sportsmen like Jackie Stewart, musicians like Arthur Rubinstein or Nadia Boulanger, writers like Anthony Burgess, composers like Leonard Bernstein and statesmen like Winston Churchill.

The Princess practised the art of the hostess with warmth and an Anglo-Saxon sense of perfection. Kings, heads of state, industrialists or film stars . . . they all loved coming to the Palace. They felt at their ease there, far from any stuffy protocol, and flattered to be its guests. Matchless hostess and loyal friend, the Princess never forgot an anniversary or a birthday. Princess Grace's friendship was always sincere. This is reflected in the extraordinary help she gave Josephine Baker right up to her last breath, or her presence at the funeral of Maria Callas, where she was the only international figure who came to pay her respects.

PRINCESS ROOM

Grace deeply loved her job of Princess, just as much as that of actress. Her years in Hollywood had been busy but brief, while she played her part of Serene Highness for a quarter of a century.

But the fact that she had been a performer proved of use to her on many occasions. Discipline, an awareness of the role that had to be played, the ability to project an image to the public, all that had been part of her life before Monaco. Thus, the former Grace Kelly had learned how to appear and conduct herself in public better than had certain heiresses of the aristocracy.

And yet, while in the formal portraits taken at the beginning of her marriage the majesty is apparent, with her large eyes fixed on the lens, in those of her last years, on the contrary, it is her warmth and her ease that strikes you much more than her charisma. To such an extent that even the incorrigible Andy Warhol made her one of the subjects of his celebrated screen prints, and she never ceased to inspire the greatest photographers.

NURSERY AND FAMILY ROOM

It was in the blossoming of motherhood that Princess Grace experienced her happiest years. The birth of three beautiful children – Caroline (January 23, 1957), Albert (March 14, 1958) and Stéphanie (February 1, 1965) – overjoyed her as well as her husband.

The Princess decided to raise her children herself. For her, this only stood to reason, and yet there was nothing obvious about such a decision. The majority of royal families do not have the time to play the role of parents and so entrust their offspring to nannies. Grace wanted to watch her children grow up. She wanted to play with them and their very different personalities delighted her.

If Grace excelled in her role of Princess, she did equally well in that of mother. Among the images of the Princess that won the world's heart, one of the most endearing was without doubt the air of domestic happiness she radiated.

Very soon and in the most natural way in the world, Grace of Monaco chose to combine bringing up her children with her formal obligations. But her democratic spirit made her want them to be raised like other little Monegasques, without any privileges due to their rank. In the summer, at holiday camps in the United States, the children used to meet up with their American cousins.

She tried as hard as she could to protect them from overexposure to the media and gave them the finest of all gifts: a loving, well-balanced and happy childhood.

Grace was undeniably at her ease in her dual role of mother and Princess, and her husband used to mock her tenderly by calling her "my coordinator of domestic affairs!"

PRIVATE GARDEN ROOM

A lover of nature and fascinated by flowers, Princess Grace created the Garden Club of Monaco in 1968, and she would be its moving spirit and President until her death. She didn't miss a single course, played an active part in the bouquet competitions and supervised the Principality's floral decorations.

Advised by the Director of the Exotic Garden, she threw herself with passion during the last fifteen years of her life into the creation of collages of flowers that she signed with her initials, GPK: Grace Patricia Kelly. She showed them with success at a gallery in Paris.

She even went so far as to allow her creations to be reproduced on the tablecloths and sheets of a reputable manufacturer. She also wrote a botanical work in which she confided: "I have always been close to flowers . . . to have complete satisfaction from flowers you must have time to spend with them. Bonds must be forged between you and them. I talk to them and they talk to me."

Everyone in the Palace remembers with nostalgia that old telephone directories had never to be thrown away. They were assembled in the conservatory of the weekend retreat at Roc Agel, where the Princess used to press her beloved flowers between the pages of those directories, laid on the ground . . .

SECRET WOMAN ROOM

One secret desire always haunted her. It surfaced from time to time, over the course of her life, like a temptation: to go back to the floodlights, to act in films and plays again.

Not a year went by without someone asking the former Grace Kelly if she was thinking about going back to her first passion. Offers came from all over the world and the Princess actually took part in several documentaries on Monaco.

In 1976, she agreed to go further and be the narrator of a beautiful film on ballet, *The Children of Theatre Street*, which would be nominated for the Oscars. The same year, she took part in a poetry recital at the Edinburgh Festival. She was to repeat the experience several times with great success.

At the beginning of 1977, the Princess agreed to the making of a feature-length television programme about her. In 1978, she made a record for children and, in May 1979, appeared in a short film. Becoming a member of the Board of Directors of Twentieth Century Fox, she never missed any event celebrating Alfred Hitchcock, and in the spring of 1982, received the tribute of her city of Philadelphia.

One of her last appearances on the screen had the Vatican as its setting, when she was the narrator of *The Nativity*.

GLAMOUR ROOM

Dazzling beauties seen through the eye of a camera often give only a feeble idea of the original. This is the case with Princess Grace: only the most skilled photographers succeeded in capturing the exquisite fineness of her features and the incomparable radiance of her personality. With Monsieur Alexandre as hairdresser and admiring couturiers like Marc Bohan at Dior, Hubert de Givenchy, Madame Grès, Chanel or Cristóbal Balenciaga, the Princess was able to create a timeless style that made her an icon of fashion. Her Hermès bag, her turbans and her Cartier diadems became legendary and established a refined, feminine and distinguished tone. Class and a sense of style were second nature for her.

PATRON OF THE ARTS ROOM

With the Princess as Minister of Culture, the Rocher was sitting pretty! The princely couple had understood perfectly that it was indispensable to revive a cultural tradition which had been rendered illustrious in the past by the Ballets Russes, Ravel, Colette and Cocteau.

From 1959 onward, concerts of classical music with the world's greatest soloists were held at the Palace in the summer and the Monte Carlo Philharmonic Orchestra underwent a genuine renaissance.

In 1961, the first International Television Festival was staged and in 1970, the Princess created the Monaco Arts Festival, with a focus on dance (it was inaugurated by Rudolf Nureyev and Margot Fonteyn).

Seasons of opera, prestigious exhibitions, symposiums and literary prizes punctuated life in Monaco with, as a climax, the opening in 1981 of a theatre that will bear the Princess's name for evermore.

ROYAL ROOM

One of her friends has summed up the general opinion of Grace of Monaco: "There has always been something noble, royal about her. She was born for that!"

If no other sovereign has surpassed her in aristocratic elegance, it should not be forgotten that behind that perfect ease in the exercise of her role were hidden a delightful sense of humour and, at times, discreet bouts of melancholy. Protocol and duties weighed heavily on her existence.

It was possible to gauge, though alas with great sadness, the depth of the universal emotion stirred by her loss at the time of her funeral, which was attended by members of royal families and heads of state from all over the world.

Bertrand Meyer-Stabley, *La Véritable Grace de Monaco*, éditions Pygmalion.

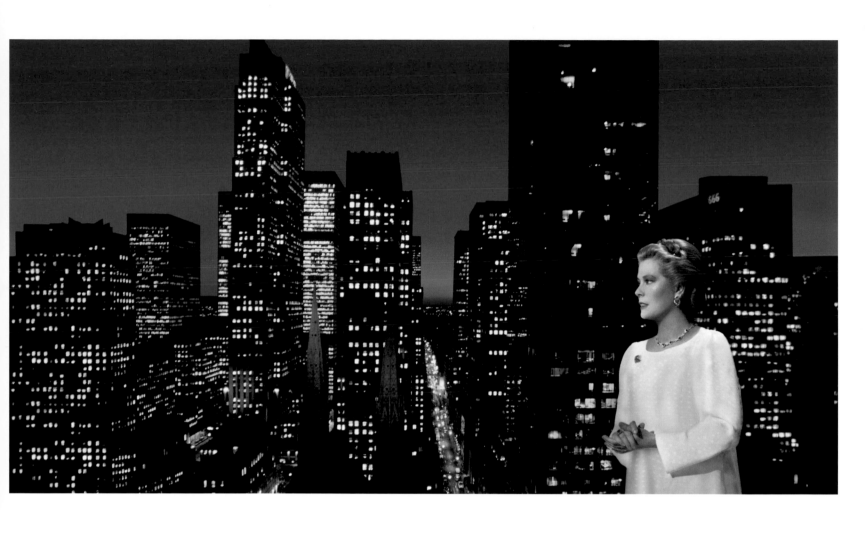

Gina Lollobrigida, *Princess Grace of Monaco with New York in the background*, 1982.
The famous Italian actress took splendid photographs of many famous people, showing a very sure compositional touch.

Excerpts from
"LA VÉRITABLE GRACE DE MONACO"
(Éditions Pygmalion)

HER DEBUT AT THE THEATRE

Little by little, certain encounters proved fruitful: walk-on parts, supporting roles (at the Bucks County Playhouse, the Fairmount Theater). Miss Kelly followed the classical path: "I began to play bit parts here and there, in the provinces and in the theatres on the outskirts of New York. I worked a lot, even on weekends. No longer any chance of going back to my family every week. My parents took the thing very well. Since I was working very hard, the Kellys trusted me . . . Finally, in 1949 – everything comes when you want it badly enough – they offered me my first important part in the theatre. I was to take, in Strindberg's play *The Father*, the role of the daughter of Raymond Massey, a British actor much in vogue at the time and luckily a man of great height."

Chosen after an audition at which she had to compete with around twenty other actresses, Grace was overjoyed. Yet she was aware of the precarious nature of her talent. ("If Raymond Massey and Mady Christian, who played the main characters, had been just a few inches shorter, they wouldn't have taken me!") She had almost no experience of the boards, but the whole cast, headed by Raymond Massey, treated her with great warmth, rallying round her and urging her on. After a month of rehearsals in which the young actress spared neither time nor energy getting into her part, the curtain of the Cort Theatre was raised on November 16, 1949, in an electric atmosphere. The premiere of this play marked Grace's debut on Broadway and the real beginning of her career. That evening, the entire Kelly family was in the audience, ready to cheer on their beloved child. The lights dimmed, the theatre filled. Grace was trembling with stage fright, happiness and excitement. She gave her character an intensity that all the critics would note but without panegyrics: "She has a naturalness that owes nothing to artifice. No airs, a simply charming freshness."

This naturalistic drama recounting the marital difficulties of a Swedish cavalry officer, adored by his daughter (Grace!), described as "angelic" in the script, was no more than half a success. *The Father* had a run of only two months.

It didn't matter, Grace Kelly had been born.

HER FRIENDSHIP WITH AVA GARDNER

Between Ava Gardner and Grace, whom the screenplay of *Mogambo* did its best to put at loggerheads, a surprising friendship was born, following an unhappy episode. Ava Gardner had lost her unborn child. She left Africa for London, where she was secretly admitted to hospital. As soon as she was on her feet again, she had to go back to the shooting of the film and her return was anything but triumphant. She had, in fact, wanted to have that child. The African heat and the hostile vegetation depressed her. Irritated by Clark Gable and accusing John Ford of showing a lack of consideration for actresses, she turned to the only woman on the set who seemed capable of understanding her. With the aid of a sense of female solidarity, the brunette and the blonde became firm friends. Both used to wake up at six in the morning, before sunrise. They had just enough time to wash and deliver themselves into the hands of the make-up artists and hairstylists before joining the crew for breakfast. Cheerfulness was the best thing that Grace had to offer to Ava. Her crying fits gradually gave way to a semblance of good spirits. She opened her heart to her new friend, telling her that she couldn't care less about success and fame, that she dreamed of nothing but having a kind husband, beautiful children and dogs playing in front of a nice house, all very far from Hollywood! Words which left Grace thoughtful . . .

The different courses taken by their careers would separate them, but the two women kept up their friendship for a long time. Ava came to Grace's wedding and stayed in Monaco several times. She would always remember Grace's kindness and the support she had given her during the weeks of nightmare she had lived through on the set of *Mogambo*.

HER FRIENDSHIP WITH ALFRED HITCHCOCK ON THE SET
OF THEIR FIRST FILM, "DIAL M FOR MURDER"

From the red lace dress she wore at the beginning of the film, Grace changed into a maroon one, and then she put on the famous transparent negligee of the murder scene before donning a deep blue dress and then an even more sombre outfit. The actress had chosen that wardrobe herself: "Hitchcock wanted me to wear a velvet dressing gown for

the scene of the crime so he could play with the effects of light and shade on the velvet. I didn't like the idea and I told him of my reservations. He responded that he wanted to obtain a special effect. Then I made the following remark to him: 'I don't think this woman would put her dressing gown on when she had to get up in the middle of the night to answer the telephone, if there was no one in the apartment.' He asked me: 'What would you put on to answer the phone?' I wouldn't put anything on. I'd get up and I'd go to the phone in my nightdress. He agreed. After he had viewed the scene, he very kindly told me that I had been right. I have always had his confidence in matters of dress."

A MEDIA-FRIENDLY WEDDING

It also has to be said that, quite apart from the incredible fatigue that this wedding represented for the young couple, the ceremony was marked by an inevitable incompatibility between its very "old-Europe" formal pomp and customs on the other side of the Atlantic. A reigning Prince can't marry a Hollywood Star and expect to have everything his own way. Even Grace's father had remarked that the wedding had the look of a Cecil B. De Mille spectacular. According to Steven Englund, the small Principality resembled a ship about to sink beneath the weight of guests and journalists. The Palace chamberlain fainted and had to be taken to hospital. The police were on tenterhooks because of the importance of the guests and the fortune in jewelery ("several hundred thousand dollars") that was assembled for the occasion, which might have attracted all the "cats" of the Côte d'Azur, in the manner of Cary Grant in *To Catch a Thief*. Over the course of the ceremony, Father Tucker, having to deal with a large number of people who had no knowledge of the Catholic rite, gave commands like a sergeant-major during Mass: "Stand up! Sit down!" There were journalists who disguised themselves as priests to get into the cathedral. Grace's sister, interviewed by an Italian reporter and wanting to make a joke, shouted into the microphone the only word of Italian she knew: "Spaghetti!"

Travel was, of course, an integral part of the Grimaldi family life. They paid regular visits to Paris, London and New York, and the dividing line between formal duties and personal leisure was hard to discern. Prince Rainier explained in 1966: "Every time we go to London . . . we inform the Queen of our presence. She usually has us over for tea and it's all very agreeable. And she and Prince Philip often ask one of their children to join us . . . We have also met Princess Margaret and Lord Snowdon on board with them and then we've gone fishing . . . There is a marvellous *esprit de corps* among royalty. As soon as you arrive somewhere and one of them lives nearby, they get in touch with you. When the Princess and myself went to the Connaught Hotel in London, Constantine of Greece, who wasn't king yet, learned of our presence and asked us: 'Can I come and see you?' He came and we had lunch together . . ."

Grace and Rainier always liked to offer hospitality to members of other royal families. The only exception to this often too formal existence: the cruises at sea. The Grimaldis have always been fascinated by the sea. One of Rainier's ancestors was an admiral of France and the influence of Albert I, the Navigator Prince, made itself felt for a long time in the Principality. It was on their various yachts that the Grimaldi family spent their holidays. After the *Déo Juvante II*, immortalised by the honeymoon, came, in 1957, the *Costa del Sol*, and then, in 1961, the *Albercaro* (named, in the American way, after the first parts of their two children's names). This was followed by the *Carostefal* (now from the names of all three children), the fourth yacht with a top speed of 27 knots, thanks to two 600 HP engines . . . Rainier often spoke of this yacht: "I can get to in Corsica in five hours . . . When we go out to sea, we take the children along, sometimes a few friends. It has three cabins, each with its own bathroom, and a pleasant sitting room with a small galley. That creates an intimate atmosphere. Everybody makes his own bed in the morning . . . The first to get up prepares breakfast for the others . . . The Princess is very fond of the sea and never gets really sick. The proof of this is that she has a Star that she steers herself, even when there's a strong wind."

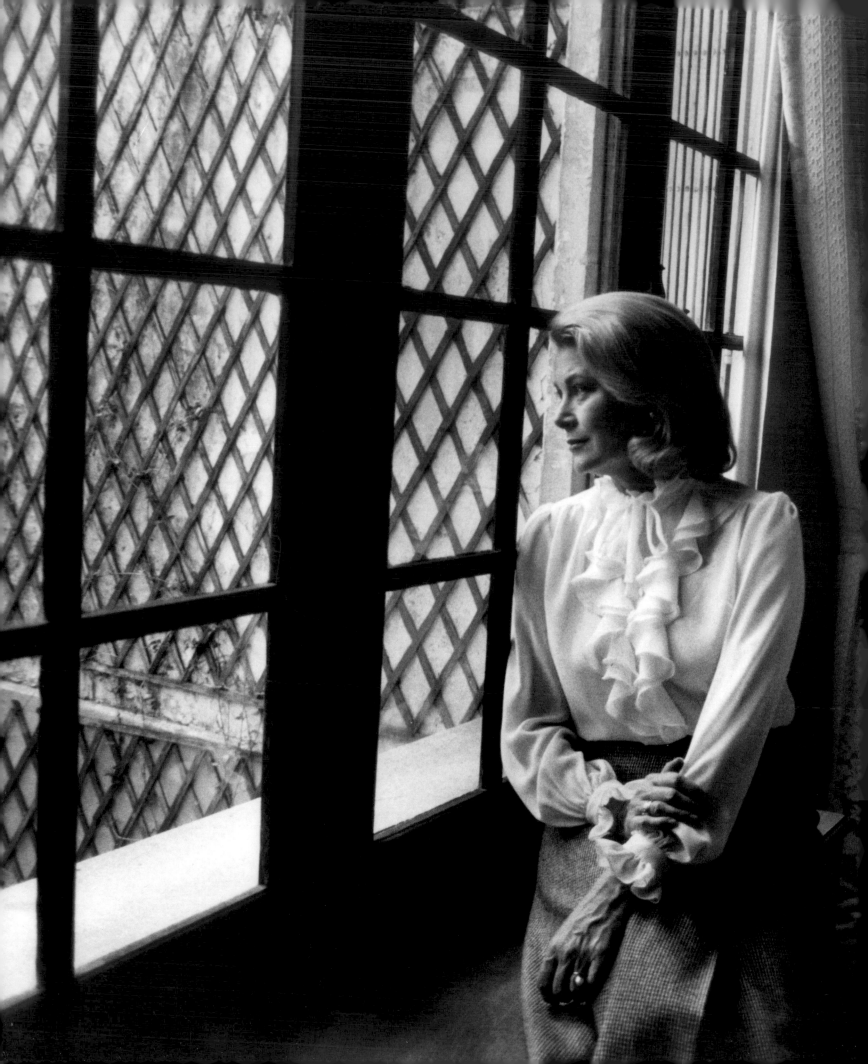

CHRONOLOGY

1929 **November 12**: Born in Philadelphia.

1941 Takes to the stage for the first time, in an amateur production.

1944 Enters the Stevens Academy.

1947 Travels to Europe during the summer.

1948 **September**: Enters the American Academy of Dramatic Art in New York, living at the Barbizon Hotel.

1949 Works as a model.

 November 16: Broadway debut.

1950 *Fourteen Hours*.

1951 Busy with TV work.

1952 *High Noon*.

1953 *Mogambo*.

1954 *Dial M for Murder*, *Rear Window*, *The Bridges at Toko-Ri*, *The Country Girl*, *Green Fire*, *To Catch a Thief*, cover page of *Time* magazine.

1955 Oscar for *The Country Girl*.

 The Swan, High Society.

 May 6: Visits Monaco. Meets Prince Rainier.

 December: Rainier visits the United States.

1956 **January 6**: Grace and Rainier's engagement announced.

 April 4: Grace sails from New York on the *Constitution*.

 April 12: Arrives in Monaco.

 April 18–19: Wedding.

 October 15: Visits the White House and meets President Eisenhower.

1957 **January 23**: Birth of Princess Caroline.

 April: Official visit to Pope Pious XII.

1958 **March 14**: Birth of Prince Albert.

 May: Becomes President of the Monaco Red Cross.

1959 **June**: official visit to Pope John XXIII.

 August: Beginning of concerts at the Royal Palace.

 October: Official visit to France.

 November: Official visit to Italy.

1960 **October 23**: Official visit of General de Gaulle to Monaco.

 November: Official visit to Switzerland.

1961 **May 24**: Lunch at the White House with President Kennedy.

 June: Official visit to Ireland.

 July: Pilgrimage to Lourdes.

1962 Film comeback announced (in *Marnie*), but quickly cancelled.

1963 **May 18**: Convention between France and Monaco.

 June: Grace President of the AMADE.

 November: Creation of the Grand Prix International for modern art.

Previous pages: **Harry Benson**, Princess Grace looking through a window beside a piano. *(Prince's Palace Archives. Monaco)*

1964	**November 10**: Prince Pierre, father of Prince Rainier.
1965	**February 1**: Princess Stéphanie born.
	April 27: Prince and Princess of Monaco received at the Elysée Palace by General de Gaulle.
	Creation of the Princess Grace Foundation.
1966	Centenary of Monte Carlo.
1967	Official visit to Canada.
1968	Grand Ball for the Casino's reopening.
	Takes part in the London-Brighton race.
	October: Inauguration of the Garden Club of Monaco.
1969	**October 29**: Chairs YMCA centenary in Philadelphia and takes part in a debate on feminism.
	November 12: Celebrates fortieth birthday with a grand reception.
	December 4: Presides at a major gala for UNICEF.
1970	**January 13**: Prince and Princess of Monaco received at the Elysée Palace by President Pompidou.
	Launches the International Festival of the Arts.
	November 16: Gala at the Festival Hall, London, with Lord Mountbatten.
1971	**June**: Attends Frank Sinatra's farewell concert in Los Angeles.
	October: Attends the celebrations commemorating 2,500 years of Persia, Persepolis.
	July 16: Speech in Chicago for the International La Lèche League.
1972	**March**: chairs the Irish American Cultural Institute, Saint-Paul.
	May: Establishment of the Principality's National Museum.
1973	**June**: chairs meeting of the Vieilles Maisons françaises (French historic buildings trust) at Compiegne.
	December: Launches the first colour broadcast of Télé Monte Carlo.
1974	Twenty-fifth jubilee of Rainier III.
	April 29: Attends an event at New York's Lincoln Center in homage to Hitchcock.
1975	Becomes International Chairman of the Irish American Cultural Institute.
1976	Joins the Board of Directors of 20th Century Fox.
	September 6: First poetry reading in Edinburgh.
	Narrates *The Children of Theatre Street*.
1977	Another poetry reading, in England.
	June: Dried flower pictures exhibited in Paris.
1978	Takes part in the Aldeburgh Festival.
	Poetry reading tour, United States.
	Makes two records.
	June 29: Caroline marries Philippe Junot.
1979	Makes a short film for the International Bouquet Competition.
	November 12: Poetry gala for the Queen Mother at Saint James' Palace, London.
1980	**June**: second exhibition in Paris.
	Fiftieth birthday.
	My Book of Flowers published in the United States.
1981	**March 16**: poetry reading at the Chichester Festival.
	April: Twenty-fifth wedding anniversary celebrations.
	Attends the *Night of 1,000 Stars* in New York.
1982	**September 13**: Road accident.
	September 14: Princess Grace dies following road accident.

FILMOGRAPHY

FILMS / FEATURES

HIGH SOCIETY (1956)
Director: Charles Walters
2 Oscar nominations

THE SWAN (1956)
Director: Charles Vidor

TO CATCH A THIEF (1955)
Director: Alfred Hitchcock
Oscar for best cinematography

THE BRIDGES AT TOKO-RI (1954)
Director: Mark Robson
Oscar for visual effects

GREEN FIRE (1954)
Director: Andrew Marton

THE COUNTRY GIRL (1954)
Director: George Seaton
Oscar for best actress to Grace Kelly
Oscar for best screenplay

REAR WINDOW (1954)
Director: Alfred Hitchcock
4 Oscar nominations

DIAL M FOR MURDER (1954)
Director: Alfred Hitchcock

MOGAMBO (1953)
Director: John Ford
2 Oscar nominations

HIGH NOON (1952)
Director: Fred Zinnemann
Oscar for best song
Oscar for best scoring of a dramatic picture
Oscar for best film editing
Oscar for best actor

FOURTEEN HOURS (1951)
Director: Henry Hathaway
1 Oscar nomination

FILMS / SHORTS

REARRANGED (1982)
Director: Robert Dornhelm
unreleased

THE WEDDING IN MONACO (1956)
Director: Jean Masson

TELEVISION

"KRAFT TELEVISION THEATRE"
(5 episodes of the TV series, 1948–1954)
Directors: Fielder Cook and George Roy Hill
The Thankful Heart (1954)
Boy of Mine (1953)
The Small House (1952)
The Cricket on the Hearth (1952)
Old Lady Robbins (1948)

"THE PHILCO TELEVISION PLAYHOUSE"
(5 episodes of the TV series, 1950–1953)
Directors: Garry Simpson and Ira Skutch
The Way of the Eagle (1953)
Rich Boy (1952)
Leaf out of a Book (1950)
Ann Rutledge (1950)
Bethel Merriday (1950)

"LUX VIDEO THEATRE"
(3 episodes of the TV series, 1952–1953)
Directors: Norman Foster and Nate Watt
The Betrayer (1953)
A Message for Janice (1952)
Life, Liberty and Orrin Dudley (1952)

"STUDIO ONE"
(2 episodes of the TV series, 1950–1952)
Directors: Anthony Barr and Yul Brynner
The Kill (1952)
The Rockingham Tea Set (1950)

"ARMSTRONG CIRCLE THEATRE"
(3 episodes of the TV series, 1951–1952)
Directors: William Corrigan and John Fitchen
Recapture (1952)
City Editor (1952)
Lover's Leap (1951)

"GOODYEAR TELEVISION PLAYHOUSE"
(1 episode of the TV series, 1952)
Directors: Delbert Mann and Robert Mulligan
Leaf out of a Book (1952)

"SUSPENSE"
(1 episode of the TV series, 1952)
Director: Robert Mulligan
Fifty Beautiful Girls (1952)

"ROBERT MONTGOMERY PRESENTS"
(1 episode of the TV series, 1952)
Directors: Ira Cirker and Tad Danielewski
Candles for Theresa (1952)

"LIGHTS OUT"
(2 episodes of the TV series, 1950–1952)
Directors: Fred Coe and Kingman T. Moore
The Borgia Lamp (1952)
The Devil to Pay (1950)

"DANGER"
(1 episode of the TV series, 1952)
Directors: Yul Brynner and Tom Donovan
Prelude to Death (1952)

"HALLMARK HALL OF FAME"
(1 episode of the TV series, 1952)
Directors: Fielder Cook and David Greene
The Big Build Up (1952)

"CBS TELEVISION WORKSHOP"
(1 episode of the TV series, 1952)
Directors: Curt Conway and Richard Franchot
Don Quixote (1952)

"NASH AIRFLYTE THEATRE"
(1 episode of the TV series, 1951)
A Kiss for Mr. Lincoln (1951)

"THE PRUDENTIAL FAMILY PLAYHOUSE"
(1 episode of the TV series, 1951)
Berkeley Square (1951)

"SOMERSET MAUGHAM TV THEATRE"
(1 episode of the TV series, 1950)
Directors: David Alexander and Martin Ritt
Episode (1950)

"THE WEB"
(1 episode of the TV series, 1950)
Mirror of Delusion (1950)

"BIG TOWN"
(1 episode of the TV series, 1950)
Directors: William Asher and Busby Berkeley
The Pay-Off (1950)

"ACTOR'S STUDIO"
(3 episodes of the TV series, 1950)
Directors: Yul Brynner and Alex Segal
The Swan (1950)
The Token (1950)
The Apple Tree (1950)

VARIOUS

THE CHILDREN OF THEATRE STREET (1977)
Directors: Robert Dornhelm and Earle Mack
Documentary on the school of the Ballets Russes
at Kirov, narration by Princess Grace

MONTE CARLO: C'EST LA ROSE (1968)
Director: Michael Pfleghar
Documentary, appearance by Princess Grace

POPPIES ARE ALSO FLOWERS (DANGER GROWS
WILD, THE OPIUM CONNECTION, 1966)
Director: Terence Young
Film, appearance by Princess Grace

A LOOK AT MONACO (1963)
TV documentary on Monaco, shot around Princess
Grace

GLÜCK UND LIEBE IN MONACO (1959)
Director: Hermann Leither
Documentary, appearance by Princess Grace

TRANSLATION OF CORRESPONDENCE

(p. 32)
John B. Kelly Jr. (Jack) would sign his letters to Grace with a different pseudonym each time, taken from the world of celebrities. This one, Yamagochi, was a Japanese diving champion. Others were Bette Davis, Eleanor Roosevelt, Felix The Cat, Betty Boop, etc . . .
The "negotiations" referred to concerned the political crisis affecting relations between Monaco and France at the time.

(p. 109)
Princess Grace is referring to her decision not to play Marnie in the film which Alfred Hitchcock was planning in 1962. Marnie – a violent and frigid liar of a heroine, fitting all the female fantasies of the master of suspense – was a tough challenge for the Princess, but she would have overcome her husband's scruples, and those of the people of Monaco, if the Principality had not at that time been passing through a major crisis in its relations with France: as General de Gaulle was threatening a blockade because of disagreements over tax. Tippi Hedren finally got the part of Marnie; and from then on Princess Grace gave up any idea of a Hollywood comeback.

(p. 108)
Hitchcock's dejected but affectionate reply. Alma was his wife. The recording mentioned is still a mystery.

(p. 141)
Grace Kelly was just leaving for Monaco on the *SS Constitution*.

(p. 145)
Princess Charlotte, Prince Rainier's mother, was delighted at her son's marriage to Grace Kelly, some of whose films she had seen. The romantic aspect of this idyll did not bother her at all, let malicious gossip do what it might. Princess Charlotte was a free spirit, blessed with a strong personality.

(p. 148)
Prince Rainier sent Grace Kelly many telegrams similar to this one during the crossing.

(p. 176)
Frank Sinatra had been one of Grace's faithful Hollywood friends ever since the shooting of *High Society*. He often visited Monaco and made himself available for many different charity galas at the invitation of his former partners. He was also the ex-husband of Ava Gardner, who was a very close friend of Princess Grace as well.

(p. 177)
Cary Grant had made Grace Kelly an ideal partner in *To Catch a Thief*. Now aged seventy-eight and still benefiting from the aura of his sparkling movie career, he was president of a cosmetics company. He very often visited the Palace of Monaco. Barbara was his fourth

wife, towards the end of a love life that had often been suspect, but never mired in scandal; and so he had a daughter late in life, the same age as Princess Stéphanie.

(p. 210)
Greetings card to **Princess Charlotte**, Prince Rainier's mother, who normally lived in the Château de Marchais near Laon.

(p. 211)
The marriage of **Jacqueline Kennedy** to Aristotle Onassis in September 1969 raised a media storm. Despite gossip in the press, Princess Grace and President Kennedy's widow were on excellent terms, the more so as time went by. Prince Rainier and the Greek ship owner became reconciled after their serious financial disputes of the sixties.

(p. 212)
Madam,
I was very moved by your thoughtfulness.
I thank you with all my heart for thinking of me. I must confess that I am very pleased to eat this salmon.
With fondest regards, Madam,
Marc Chagall

Marc Chagall lived at Saint Paul de Vence and carried on a delightful friendship with Princess Grace.

(pp. 214–215)
Ladies and gentlemen,
There are things other than words with which to express one's feelings – particularly the feeling of gratitude.
There is a simple and sincere gesture which can convey this feeling,
and it will be my great pleasure to make such a gesture.
Your dedication to the ideals of the MRC fills me
with joy in expressing my own gratitude and that of our organization for your loyal efforts to make it more active and effective in fulfilling its mission and relieving human woes.
Without you, the MRC would not exist, and without the MRC, there would be much more unhappiness and misery.
It is therefore in the name of those who are no longer in dispair, that I
present you with this token of gratitude from the MRC and thank you from the bottom of my heart.
Thank you.

An example of the countless messages penned by Princess Grace on behalf of the charities for which she worked. Among other tasks, the Princess took great trouble over her presidency of the Monaco Red Cross.
The original hand-written text in French, which the Princess now spoke perfectly, but always preferred to put down on paper first when she was going to need to use it in public.

(p. 216)
Princess Grace had revived the Art du Ballet in Monaco, along the lines of the heritage of the Ballets Russes and the Ballet de Monte Carlo. Her friendship with the great choreographer **George Balanchine** was a matter of particular concern to her. Princess Caroline has now taken over this artistic activity to brilliant effect.

(p. 217)
Greta Garbo, to whom Grace Kelly was sometimes compared, often stayed at Cap D'Ail with her companion George Schlee. When he died, his wife, the Russian-American fashion designer Valentina (who had not objected to this liaison), banned "the Goddess" from her villa, and she resumed her wanderings between New York and Paris, where she stayed with her friend Alex de Rothschild.

(p. 246)
Queen Elizabeth, who for a long while
regarded the Grimaldi family with typical
Windsor coolness, came by degrees to
recognise the royal qualities of Princess
Grace; her children, Lord Louis Mountbatten
and the Queen Mother spoke of her as "One
of Ours". Lord Mountbatten, last Viceroy of
India, was indeed a frequent guest at the
Palace and corresponded regularly with
Princess Grace, signing himself with a
familiar "Dickie".

BIBLIOGRAPHY

BALABAN QUINE (Judith), *The Bridesmaids: Grace Kelly and Six Intimate Friends*. Weidenfeld & Nicolson, New York, 1989.

BALL (Gregor), *Grace Kelly*. William Heyne Verlag, Munich, 1983.

BARTOLOMEI (Martine), *Grace de Monaco*. Éditions Soline, Paris, 1993.

BERNARDY (Françoise de), *Histoire des Princes de Monaco*. Plon, Paris, 1960.

BRADFORD (Sarah), *Princess Grace*. George Weidenfeld and Nicolson, London, 1984.

CASSINI (Oleg), *In My Own Fashion*. Simon & Schuster, New York, 1987.

CLARK (Dennis), *The Irish in Philadelphia*. Temple University Press, Philadelphia, 1979.

DHERBIER (Yann-Brice) and VERLHAC (Pierre-Antoine), *Grace Kelly: Les images d'une vie*. Éditions PHYB, Paris, 2006.

EAMES (John Douglas), *The M.G.M. Story*. Crown Publishers, New York, 1974.

ENGLUND (Steven), *Grace de Monaco, an Interpretive Biography*. Doubleday, New York, 1984.

GAITHER (Gant), *Princess of Monaco: The Story of Grace Kelly*. Holt, New York, 1957.

GALLOIS (Jean-Pierre), *Les vingt-cinq premières années de règne du Prince Rainier III de Monaco*. Imprimerie de Monaco, Monaco, 1974.

GLATT (John), *The Royal House of Monaco: Dynasty of Glamour, Tragedy and Scandal*. St Martin's Press, New York, 1998.

HART-DAVIS (Phyllida), *Grace, The Story of a Princess*. St. Martin's Press, New York, 1982.

HAWKINS (Peter), *Prince Rainier of Monaco: His Authorized and Exclusive Story*. W. Kimber, London, 1966.

LACEY (Robert), *Grace*. A Contrario, Paris, 1994.

LEWIS (Arthur H.) *Those Philadelphia Kellys: With a Touch of Grace*. William Morrow, New York, 1977.

MAC CALLUM (John), *That Kelly Family*. A.S. Barnes and Company, New York, 1959.

MEYER-STABLEY (Bertrand), *La Véritable Grace*. Éditions Pygmalion, Paris, 1999 and 2007.

PERROUD (Frédéric), *Rainier III - Grace Kelly: Conte de fées sur le Rocher*. Solar, Paris, 2000.

PRINCESS GRACE OF MONACO and ROBYNS (Gwen), *My Book of Flowers*. Doubleday, New York, 1980.

ROBERT (J.B.), *Histoire de Monaco*. P.U.F., Paris, 1973.

ROBINSON (Jeffrey), *Rainier and Grace: Their Intimate Story*. Belfond, Paris, 1991.

ROBYNS (Gwen), *Princess Grace*. D. MacKay Comp. Inc., New York, 1976.

SPADA (James), *Grace. Les vies secrètes d'une princesse*. J.C. Lattès, Paris, 1988.

SPENCER (Joanna), *Grace, une princesse désenchantée*. Payot, Paris, 2004.

SPOTO (Donald), *The Dark Side of Genius: The Life of Alfred Hitchcock*. Little, Brown, Boston, 1983.

WAYNE (Jane Ellen), *Grace Kelly's Men*. St Martin's Press, New York, 1992.

CREDITS

REPRODUCTIONS

SOURCES

Printed in June 2007